Contemporary
Art of Africa

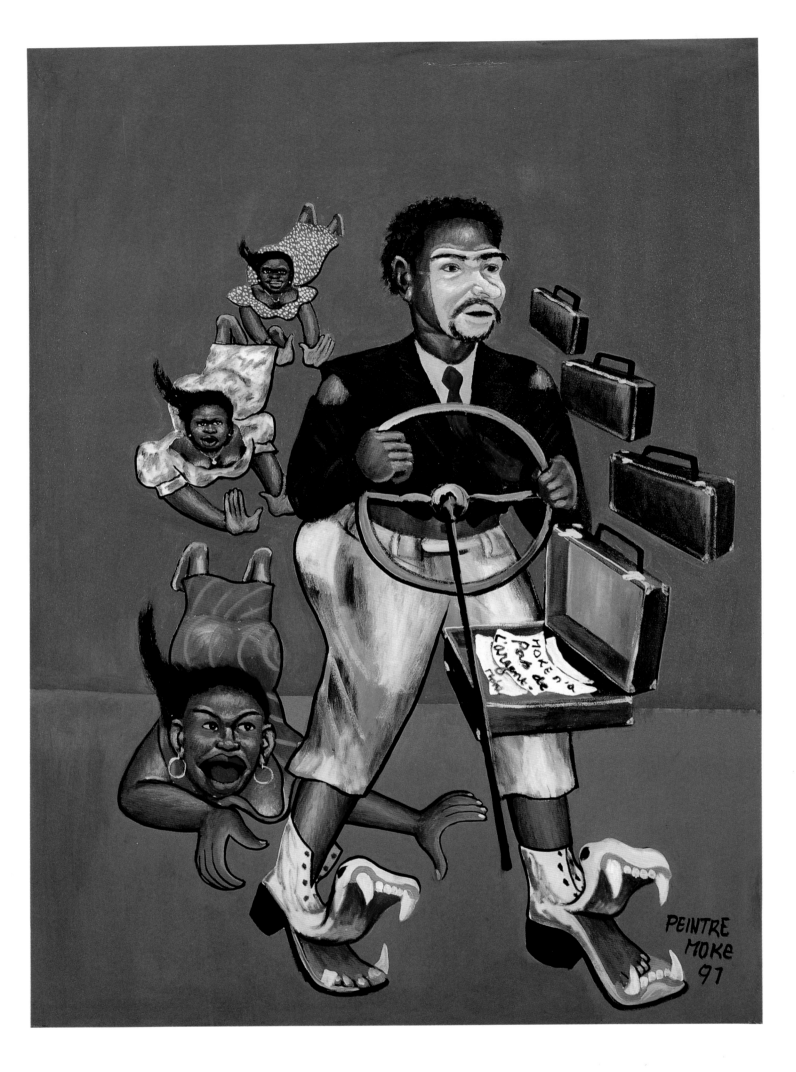

Contemporary Art of Africa

Edited
by
ANDRÉ
MAGNIN
with
Jacques
Soulillou

HARRY N. ABRAMS, INC., PUBLISHERS

Editor: Phyllis Freeman
Editorial Assistant: Rachel Tsutsumi
Designer: Ellen Nygaard Ford
Maps: Christine Edwards

Library of Congress Cataloging-in-Publication Data

Contemporary art of Africa / André Magnin,
Jacques Soulillou, editors.
 p. cm.
 Includes bibliographical references.
 ISBN 0–8109–4032–9
 1. Art, Black—Africa, Sub-Saharan. 2. Art, Modern
 —20th century—Africa, Sub-Saharan. I. Magnin,
 André. II. Soulillou, Jacques.
N7391.65.C66 1995
709'.67—dc20 94–42674

Contents

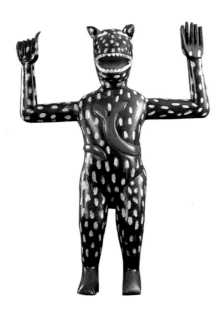

World

ᧈ ᧈ ᧈ

An asterisk (*) is used throughout to indicate
words that appear in the Glossary

Preface

In 1989, in Paris, *Magiciens de la Terre* (Magicians of the Earth) introduced a new kind of exhibition that exploded the accepted definition of contemporary art.[1] For the first time, an important Western institution offered to display the work of Third World artists chosen not for their conformity to the so-called international—that is, Western modernist or post-modernist—aesthetic but for their ability to express and communicate the imaginative aspects of their culture not yet fallen prey to adulteration, compliance, and compromise in the effort to emulate imported models.

In the wake of this adventure, we two author/editors—although arriving from different directions—felt compelled to embark on a study that led us to sub-Saharan Africa. The idea for this book grew out of prolonged stays in several countries of the region and the conviction, reinforced by a plethora of evidence, that except for specific and circumscribed local successes, the predominant perception of sub-Saharan African art was largely postcolonial; it is held that the period following the golden age of "classical" African art has been marked by the absence of original works—apart from folk art or exotica. This view arises in part from a misunderstanding of the concept of contemporary art. Through the dual power of its market and its institutions, the West has determined the norms of contemporary art. It is one of our intentions to show that that label cannot be transposed from the West to the sub-Saharan context without causing distortions, a welter of frustrations, and missed connections.

The first departure this book makes from previous undertakings on this subject is to focus on the artists and their work rather than on an abstract stylistic classification that the artworks would illustrate.

We have divided the book into three parts—"Territory," "Frontier," and "World"—as a way of organizing the rich material with emphasis on the artist's own choice of milieu and influences. We thus attempt to present each work dynamically, not statically, in a way that displays its particular spirit. To emphasize even further the powerful identity of each process, we have called on several experts (Africans, Americans, and Europeans), artists and anthropologists, to clarify certain works either from a scientific point of view, which involves placing a work in its specific cultural context, or from a subjective point of view, which brings into play the artistic sensibility. The art of Louise Bourgeois, for example, calls to mind that of Seni Camara (see pages 54–57), despite the gulf that seems to separate them. Other examples of similar sensibilities that leap the gulf are Alighiero e Boetti and Frédéric Bruly Bouabré (see pages 174–79), and in fact their work was shown together by the Dia Center for the Arts in New York in 1994–95, Ettore Sottsass and Bodys Kingelez (see pages 170–73), and Emmett Williams and Richard Onyango (see pages 159–61).

This book does not purport to be exhaustive or to give the last word on art in Africa today. We want above all to define a way of seeing that focuses attention on the sub-Saharan part of the African continent. From Dakar to Cape Town, from Abidjan to Nairobi, from Bamako to Kinshasa, we regularly visited more than twenty-five countries and hundreds of artists to give form to this book. The choices arose from commitment, often with the complicity of the artist. On the model of Marcel Duchamp, we envisioned "art like a secret to be shared and passed on among conspirators." We accept full responsibility for the subjectivity of our choices. We place no stock in the kind of self-analysis that attempts to articulate a scientific basis for the inclusion of one artist over another. Were it necessary to come up with such a criterion, we might formulate it thus: we have selected the artists whose work seemed to demonstrate a *faithfulness to a strength* or a *capacity to give substance to an insight*. These traits are actually uncommon, which is undoubtedly why the book appears to be selective.

Why concentrate exclusively on sub-Saharan Africa? Doesn't the division of artistic creations into geographic parcels smack of artificiality? Does art suddenly change its nature when it crosses a border? Clearly, it does not. Nevertheless, the northern part of the continent—the Maghrib—presents a unity and an identity that distinguish it from, and at the same time connect it to, certain regions of the Mediterranean. This phenomenon is largely explained by the fact that this area draws its cultural identity from a single source, Islam, which has held sway over the Arab world since the eighth century, with all that implies in the fields of architecture, music, and literature, as well as religion and language.

In contrast, the sub-Saharan landscape features an extraordinary diversity: many hundreds of different languages are spoken; to the numerous traditional religions were added those from outside (mainly Christianity and Islam); various political structures obtain, ranging from empires or centralized kingdoms to a scattering of societies that live without benefit of government. Even its precolonial and colonial history evidences considerable variations among the western, eastern, and southern portions of the region. All of these factors contribute to an art that does not present a homogeneous face.

We have not included here the many African artists who live and work in the West (Europe or the United States), where they have developed their art, among them Sokari Douglas Camp, El Loko, Mo Edoga, or Ouattara. The very nature of the problems raised by their works demands a separate investigation.

Finally, at the end of the book there is a list of artists whose work is known to us and valued but whom we decided not to feature because we felt that they did not fully correspond to the guiding principles of this book, which we outline in the Introduction that follows.

A. M. and J. S.

Introduction

Even while African music, dance, literature, and theater have entered the international scene, the visual arts, aside from some isolated successes such as Makonde and Shona sculpture, remain largely unknown. This is all the more surprising in light of the great importance assigned to African art by influential Western artists who contributed decisively to the creation of the vocabulary of modern art.

However, it is also true that interest in the art of sub-Saharan Africa is on the rise. This is evidenced by the participation of African artists in such important international venues as Documenta in Kassel and the Venice Biennale. On the African continent itself, exhibitions are held regularly that contribute to the development and strengthening of a community of African artists that goes beyond ethnic or regional lines: the Dakar biennial; the biennial of contemporary Bantu art at Libreville, Gabon; Grapholies of Abidjan; and the Afrikus in South Africa in February 1995.[2] An even more significant number of publications have begun to show the work of African artists, and new periodicals are continually appearing.[3]

Such encouraging developments should not mask the fact that African art is still marginal in terms of the world scene, both in the art market and in recognition from institutions that play a major role in the process of legitimation—the leading museums of contemporary art, international art galleries, the great private collections of contemporary art. The modern and contemporary art of Latin America and Southeast Asia has suffered much less from this phenomenon.

I.

Western art depends on the accumulation and the contemporaneity of numerous earlier systems: religious, magical, symbolic, mythological, or craft. Together, they make a whole whose meaning could not have been in the minds of those who worked to establish these elements. "All this takes place," wrote the late philosopher Jean-Marie Pontévia, "as if we were capable of rooting out the elements common to art in works without anything in common."[4] Similarly, Westerners have studied traditional African art of the past—mystical, metaphysical—from the viewpoint of socioeconomic and religious principles. Far from being the anonymous servant of his or her art, as we have for so long believed, the identity of the artist was known, sometimes well beyond the boundaries of his own locale; his works were readily identified by his particular style, and his creations were considered marvelous and regarded with a combination of respect, fear, and admiration—similar to the renown enjoyed by certain artists in Western societies today.

The phrase "African art" is too often defined by means of restrictive and reductive characteristics. In fact, African art today is founded on numerous systems. Many contradictory representations and functions collide, like, for example, the too

often cited opposition between traditional and modern or "contemporary." Traditional art, whose legitimacy has arisen from its durability, holds a profound spiritual significance that feeds the thinking of artists from the north to the south of the continent. In order to appreciate it, certainly, it is often necessary to experience it directly, as the local, regional, or national context carries an importance crucial to its reading. Traveling in Africa has the effect of creating a mental inventory of images that counter the stereotype of Africa as either paradise or chaos: it brings into relief, as well, the considerable differences from one country to another. Those sincerely interested in understanding the artistic situation in the countries they have visited will inevitably face certain questions: What is tradition? What belongs to the past and what to the present in this Africa whose artistic landscape has never been so diversified—traditions revived, sometimes completely reinvented, new figuration, mural painting, expressionism, abstraction, "appropriation" of objects, agit-art, and so on? The works illustrated here reflect this explosion, whose fallout has included the emergence of strongly individualized perceptions.

Directed by rules of unanimity, supported by ceremonies, feasts, and dances, traditional art acted like a glue, contributing to the stability of social structures by means of collective participation in the culture. With the breakdown of traditional structures brought about by colonization and independence, art has been removed from its traditional functions. Its increasing individualization, along with the weakening of its social aspect, has facilitated the loss of a collective sense of unity. (And it should be remembered that not until sometime between 1920 and 1930 was the movable canvas or paper support on which to paint scenes of colonial life introduced into sub-Saharan art.)[5] As a result, artistic production has greatly changed, to the extent that contemporary society may no longer recognize itself in the culture created by this minority of artists—a situation familiar in the West as well. Art has become the privileged province of a group that seeks through it a private, inner satisfaction. The art object has come to roost primarily in private homes in the large urban centers, where it is "on exhibition." The case of the *aloalos* of Efiaimbelo (see pages 24–26) illustrates the point: because of the high prices of the works, only a few collectors can have access to them. Another phenomenon in play is that of dual individualization, which Claude Lévi-Strauss brought to light: of the creator, on the one hand, who no longer or rarely conceives for the group, and of the clientele, on the other hand, who no longer expect the artist to offer them works of art that respond to collective criteria of appreciation.

However, this preliminary evaluation requires some qualification. Even though it has distanced itself from the role it used to play, art today remains no less concerned for the collective. Recognition of the community comes through in many of its

manifestations. This is particularly clear in the work of Bruly Bouabré, who views writing as having a civilizing effect. He makes his graphic works the privileged vehicle for the transmission of knowledge related to both his ethnic group and the world. Sitting in front of his house, where he can always be consulted, the old sage Bruly Bouabré works in full view of the community. Similarly, Cheri Samba (see pages 162–63), Cheik Ledy (see pages 121–23), and many other folk artists of Zaire who have followed in their wake translate the hope of social, economic, and political progress into their paintings. They exhibit their latest works on the outer walls of their studios, attracting crowds and provoking unending discussions. And if Bodys Kingelez does not display his "extrêmes maquettes" (extreme models) to the first comer, his extravagant architectural works (*Zaïre Motema, Kinshasa la Belle, Papillon de Mer, Barcelona Post,* among them) are conceived with the idea of community use continually in mind. According to his or her country of origin, each artist has introduced us to collective issues through the agency of his or her artworks, as in the case of the Mali artist Konate (see pages 144–45) or of the South Africans David Koloane (see pages 146–48) and Willie Bester (see pages 155–58). From this perspective, it can be said that the concern for the community demonstrated in contemporary art takes the place of the social function of "traditional" objects, as the artist uses different means to perpetuate a form of collective language that has nothing to do with the expression of individual experience or mere documentation.

If the community no longer has a direct hold on the African artist "liberated" by the way of life that prevails in the large cities, there yet remains a lively interaction between artistic individuality and the community, whether tribal, national, or transnational. Although expressed in an apparently private way, this can be seen in a kind of social interaction that the mask (which in African custom is always a combination of a facial mask and related attire) formerly generated through certain events—"critical" or satirical—as in the Gelede* masks of the Yoruba, which stigmatize various antisocial behaviors. Even when the painting no longer operates in the sphere of ritualization, the community links have not been lost, only transformed under the pressure of new conditions of life. Certainly a mask cannot be "sold" the way a painting can be, and it is true that in a painting the artist condenses into a single figure that which the mask splits in two, between the creator and the wearer, but the painting and the mask converge in their capacity for social communication.

Georges Adeagbo (see pages 168–69) exemplifies the transition that is very much in evidence today, with his "installations," which constitute a sort of unspoken response to the conflict with his circle of family and friends he experienced on his return from Europe to Benin. While his art displays on its face the break with this community, his installations reveal many ties to that very community. To begin with, many of the objects that they contain come from the community. Furthermore, as the written material that accompanies the installations makes clear, the way in which they are composed is a means of symbolically

Representation of Legba.* Abomey region, Benin. 1987

grappling with these communal problems in an effort to explode their traditional packaging. As he engages in the risky exercise of throwing a rope bridge between history (*l'histoire*) and stories (*les histoires*), Adeagbo embodies today's evolving African artist, the forger of a new "contract" with his community. He is no longer the producer of symbolic goods that the community can appropriate (through the intermediary of the ritual and the feast) but, rather, a kind of Sphinx that interrogates the community and provides a visual formulation of its disorder by reintroducing a certain order in odds and ends of materials and objects that are no more than the waste products of the community.

II.

It would be a mistake to think that artists can be found only in the large urban centers—Nairobi, Lagos, Kinshasa, Abidjan, Dakar, and so on. In fact, artists in the same country may be separated by distances of hundreds of miles, with little or no opportunity to meet. The working conditions of those who live in the capital and those who inhabit the interior are very different. The former may have access to small structures already in existence, thereby easily profiting from the tourist trade or the presence of cooperatives, while the latter, who usually work by commissions, often need to work at something else in order to make a living.[6] Exchanges between countries are infrequent, except those under the auspices of foreign cultural centers.

As a general rule, artists rarely have occasion to travel; for example, the Makonde sculptors of Tanzania have little contact with the Shona sculptors of neighboring Zimbabwe, a few hundred miles away.

With the exception of those in South Africa, there are no museums or centers of contemporary art as such.[7] The Ivory Coast, with its National Museum, and above all, Nigeria, with a wealth of museums, display some works of living artists, and more can be found among foundations, private galleries, cultural magazines, and collectors, but these countries stand out in a sparse landscape.

In certain centers—like Harare, in Zimbabwe, with its National Gallery and private galleries (Chapungu Village), or Nairobi (National Museum, Watatu Gallery, Paa ya Paa Arts

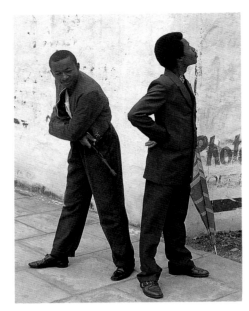

*Sapeurs.** Kinshasa, Zaire. 1988

Center), or Dar es Salaam (Nyumba ya Sanaa, Karibu Arts and Crafts)—whose characteristic art (Makonde, Shona) has drawn strong international recognition, some people[8] have come forward to promote and spread the art of their country by exhibiting the most prestigious artists while remaining on the lookout for the works of younger local artists.[9]

However, most artists find it exceedingly difficult to have their work shown, even to have it mentioned, for lack of infrastructure adapted to the purpose. Mitigating the scarcity of professional outlets, public or private (museums, galleries, specialized periodicals, private collections), or, more simply, of interest on the part of the public or government, the artists manage to attract a potential clientele through the stratagem of decorating the facades of their studios and putting up signs that spell out their purpose (Moke, Twins Seven-Seven, Cheri Samba, Cyprien Tokoudagba, among others). These studios thus function as sales centers. In Zaire, Senegal, Mali, the Ivory Coast, and Nigeria, a local market is evolving; several collectors and private undertakings support contemporary work through commissions and galleries.

III.

At first, in the context of Africa today, the term "contemporary" appears to have two aspects: on the one hand, it is an art that benefits from institutional support through the system of commissions and exhibitions of national or international talents, bolstered by a critical discourse whose panoply of references enable a cultivated public to recognize the figure of the modern artist: school, style, personality, placed in perspective by comparison with a famous figure in Western art (a Van Gogh, for example). It must be stated, however, that this art, "contemporary" according to current notions, cannot easily attain the recognition that the West grants to "contemporary" art, either in its homeland or abroad, through participation in prestigious international exhibitions, appearance in their catalogues, or articles published in specialized periodicals. On the other hand, this is an art that

cares little for the processes of legitimation, deliberately side-stepping the official circuits, an art that prefers to ignore its possible claim as "contemporary," an art often practiced by artists without any formal schooling, many of whom have no ambition beyond satisfying a local community. One is led to wonder at the source of the turmoil that this phenomenon provokes among so many in African art, who perceive it as the latest slight by the West; the shortest road to recognition by the contemporary art world in its most international aspect seems to go by the path of those artworks that persist single-mindedly in their individuality, paying no attention to labels like "Pop," "Minimal," "Conceptual," "Dada," "Surrealist," or "readymade." What is the source of the bitterness aroused by what many view as the deliberate decision by the West to prolong the marginalization of contemporary African art by putting a sort of premium on a "postmodern primitivism" and a form of historic "naïveté"? Contrary to academicism, which more or less happily—and with an inevitable time lag—recycles forms of visual expression taken from outside itself, the more original ways of proceeding, pursued by their creators with no thought of recognition or of participation in debates on aesthetics that obey the "international" code, sometimes mesh more effectively with what the West agrees to call "contemporary art."

Many artists formed in the schools of art, where they acquired a solid background in modern art of the West and its pictorial representation, produce work that all too often stays well within the realm of that tradition, not seeking to change the surface or to question the aesthetic principles under which they operate or even to change the subject matter. Most of the "academic" painters (from all over the world) who emerge from the schools have adopted a *style*, a kind of generalized mannerism, the product of an academic gristmill that passes for good painting. For them, the field of art basically remains confined to technical issues and begs the more fundamental question of the purpose of that technique. Can this good painting deal with the question "Why paint?" Painting or sculpture cannot be reduced to the desire to create a canvas or a sculpture indirectly aimed at the state of mastering how-to techniques. Such recourse to these characteristic styles and techniques of Western modern art inevitably favors a hybridization (which means not the abdication, but the coexistence, of experiences) ceaselessly fueled by its sources. Unhappily, such a fuzzy aesthetic in which confusion reigns, which refuses to strike out in unknown territory, runs the risk of being fatal to art.

IV. Imaginary Maps
The map is open and connectable in all of its dimensions.
— Gilles Deleuze and Félix Guattari

We have divided this book into three regions: Territory, Frontier, and World. Within each of these there are two subdivisions, although they are not formally indicated: one in which the works of certain artists fall within groups (school, tendency, genre, and so on); and another in which the artists function as individuals, and they are designated by name. Yet, as will be

seen, in both subdivisions the artists do not stay strictly within the defined boundaries.

Among the schools of work are the folk painting of Zaire, cement funerary sculpture, and Shona and Makonde sculpture. Cheri Samba, Moke, Cheik Ledy, Richard Onyango, and Almighty God are other independents all within the highly dynamic movement that could be called *urban folk painting* (which has been flourishing, especially in Zaire). Sunday Jack Akpan is among dozens of sculptors along the coast of western Africa who produce polychrome sculptures in cement intended for funerary and other uses. The art of Henry Munyaradzi is individualistic yet falls within the genre of Shona sculpture, along with that of Nicholas Mukomberanwa and Bernard Matemera. John Fundi is an individualist within Makonde sculpture, whose powerful plastic forms are extremely moving.[10]

Independent artists include Frédéric Bruly Bouabré, Bodys Kingelez, Kane Kwei, Hazoume, and Mor Faye.

We must emphasize that these areas are not rigid. For every area of the individualist one can always come up with a corresponding cluster: in the case of Bruly Bouabré, the inventors of writing; of Kane Kwei, funerary sculpture; of Hazoume, the tradition of the mask.

Between group and individual can also be found an entire spectrum of gradations. Such work never belongs solely to either area. Returning to the example of Bruly Bouabré, we note that he occupies a unique place because he realizes themes in the form of small drawings on cards where he combines image and text, but he also is part of a tendency by virtue of his invention of a Bete writing, which falls within the rich tradition of the inventors of writing who have been working throughout the twentieth century to codify spoken language—particularly in western Africa (Vai writing and Mande spelling books). Similarly, as singular as it appears to be, the work of Abu-Bakarr Mansaray belongs to the broad group of *fantasy machinery*, which reveals the imprint of all those toys made by adolescents or adults throughout Africa, some of them utilizing gears and electricity. This also holds for the series of paintings by Richard Onyango entitled Tropical Machines or the sculptures of the Dakpogan brothers, whose production cannot be separated from the machine, especially the automobile, through the fatal transformation it undergoes in the road accident. These works can be understood as both technical and sacred when placed in the context of the worship of the *orisha** Ogun, god of iron in the Yoruba pantheon.

Many of the kinds of works from the Territory or Frontier sections are perpetuated through a school of artists or, as with Agbagli Kossi and Kane Kwei, who died in 1991 and 1992 respectively, through their sons who have taken up their work. Many of the pieces in the category of World, on the other hand, appear to be solitary, without a line of descent.

Our investigations have led us to draw a map which we have creased twice to define three areas: Territory, Frontier, and World. These categories are not meant to create a new stylistic taxonomy, like the terms "traditional," "urban," "international," "neo-Pop," "neocolonial," and so on. To begin with, we do not consider these categories hard and fast. A Territory could be overrun suddenly with forces that push it toward Frontier. A World could equally suddenly narrow to the confines of a process, of a stock of recipes intended to satisfy a market that demands the same old magic tricks.

While Territory is congruent with an area of *forces*, World is congruent with an area of *signs*. Frontier is the gray area between forces and signs.

Nevertheless, we must take care not to reduce Territory solely to a field of forces, nor to think of World exclusively in terms of signs.

It is worthwhile to take seriously the background stories that many of these artists, whether of Territory, Frontier, or World, assign to their creation when they evoke the *dream*. We may be tempted to shrug it off as a piece of agreeable folklore, or "personal mythology." An indicator of Territory, the dream breaks with the genealogical narrative of our contemporary artists, projecting them into the area of rival thought processes to explain their "trajectory" and to make them aware of their involvement with the choices and the exclusions that they imply. Conversely, the dream is pure beginning. It is found at the opposite pole from what we imagine when we conjure up the thought processes that have led the contemporary artist to become involved in a "work."

TERRITORY

Territory is not the realm of immobility, which would place it in neat opposition to World, the putative realm of mobility. Each has some characteristics of the other. There is, for instance, the case of Efiaimbelo, whose funerary posts—derived from age-old traditions—occasionally are topped with an object from the West.

Territory is not synonymous with Earth. The latter provides the former with its source of power, but it is in the way in which that power is modulated or filtered that Territory acquires its identity and separates itself from Earth.

The forces brace their backs against chaos, resisting its brutal irruption. The sculpture of John Fundi of Mozambique or that of Seni Awa Camara of Senegal strikingly embodies this expression of a conflict between chaos and forces that attempt

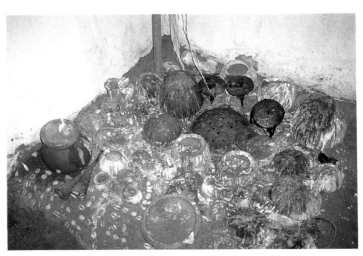

Vodun altar in a private house. Abomey, Benin. 1995

to arrive at a kind of equilibrium, a kind of recovered peace into which their works transmute the painful combat that preceded it.

The forces relate to the Earth as an interior space oriented toward the two major poles of sexuality and ancestry. In sexuality, we include not just human sexuality, subject to the double aspects of the forbidden and the transgression, but the more fundamental process of the uninterrupted transformation of the body—humans, vegetation, animals—a kind of metamorphosis that is seen in the paintings of François Thango, Emmanuel Ekong Ekefrey, and Georges Lilanga Di Nyama.

Ancestry is the other basic pole extending between myth and dream, living and dead. In this sense, we find the concept of the musical *ritornello*—an interlude between elements of an opera, a linking passage—helpful to describe the relationship between forces and Territory, in that the ritornello "always carries the earth with it, it has as its concomitant a spiritual earth, it has close bonds with a Natal, a Native."[11] The painting of Georges Lilanga and the sculpture of John Fundi, one from Tanzania and the other from Mozambique, respond to each other by means of the ritornello specific to the Makonde territory, intersected by the rhythms of the dances of initiation (*mapico*)*. The Makonde ritornello thus becomes a continuous plane on which *tempi* and musical sonorities, lines, sculptural blocks, pictorial colors, and finally, poses and gestures tied to the dance meet together, much as expressive qualities are articulated by the *shetani** world of the spirits, which belong to the plane of ancestry.[12]

Likewise, the work of Cyprien Tokoudagba has its own ritornello. In the paintings and sculptures made for the *vodou** rituals, each element that goes into them must be perceived as a *force-sign* symbolic of a *vodun**, or god—Da, Gu, Legba*, Sakpata, Heviesso, and so on—with whom is associated a constellation of expressive qualities: color, animal, plant, natural element and phenomenon, famous person, characteristic behavior, sex, myth, ritual, poetic verses. Each force-sign set down or erected, like an ideogram, designates the conjunction of physical and spiritual power. Territory is congruent with the unfolding of these categories, which may be narratives (each force-sign can be associated with a myth) but which also indicate other qualities: redness, iron, war, anger, and so on. *Vodou* is a demanding religion in which one can have faith only if one is possessed.

The greatest misreading of these expressive qualities consists of reducing them to the level of the decorative. The beautiful rainbow of the snake Da Ayido Hwedo, one of the incarnations of the celestial snake Da, which encloses the Earth with its bands of color, has no decorative value but on the contrary, it does have expressive value; each color assumes a meaning as much sexual as mythical: for example, red for the male pole, blue for the female pole. If, however, one thinks that the spatial embodiment of these qualities seems to have a decorative aspect, one need only go through the silent streets of Abomey and stop before the wall of a *vodou* temple painted by Tokoudagba with these ideograms (*not* pictographs) to be otherwise convinced. As it is linked to Territory, there is no decorative impulse in the ornamentation.

Paul Rabibisoa Ravoay evokes this concept in relation to the *aloalo* (funerary post) of the Mahafaly of Madagascar: the decorative can emerge only in the wake of a loss of connection with the native Territory, facilitated not only by the individual style of the artist but also by the way his work is received within society. If this art in effect reflects the well-defined beliefs of an ethnic group (for Tokoudagba, the Fon), this does not prevent the artist from achieving the expression of a cluster of stylistic traits that distinguishes him from his peers and is the starting point of a process of disconnection from native sources often hastened by market demand.

The painting and sculpture of Tokoudagba express a point of view about his Territory, a unique way of appropriating from it certain lines of force. One can imagine a great variety of other appropriations that follow a mode of operation that is artistic—one that leaves space for an expression of intensities. The theater unquestionably constitutes in this sense a splendid medium, as demonstrated in a different context by the "boxes" of Makhtar Mbaye (see pages 88–89), in which episodes in the precolonial history of Senegal are depicted in miniature, or again, in the sculptured scenes by Jackson Hlungwani (see pages 99–100).

Two errors lurk in connection with Territory. The first consists of thinking of Territory as an entity in itself, resistant to movement or extension of the geographical limits from which it gets its identity. Among the many lessons one can draw from the works of Robert Farris Thompson on relations between Africa and the New World through the idea of "Atlantic culture" is the fundamental idea that the Territory—say, the cultural entity "Kongo"—is distinguished above all by its ability to travel, to retain its identity as it spreads through other Territories—and this despite tremendous displacements on the surface of the Earth, such as those to which the slave trade gave rise. Territory comes into being as soon as a group of religious and cultural characteristics, tied to a geographic area, become capable of being transferred, and they maintain their cohesion in the face of rearrangements, transformations, or unexpected events in the course of the transfer. A Territory that is not capable of keeping itself whole while undergoing this long-distance displacement—from Congo to Cuba and from Cuba to South Carolina, for example—is no longer a Territory, properly speaking.

The second error is to believe that the determining factor in dividing Territory from World or Territory from Frontier is the presence or absence of objects or iconography from the West. In *The Four Moments of the Sun*,[13] Thompson gives numerous examples of tombs photographed in the Congo in 1949 and 1965 that include representations of airplanes and automobiles. This clearly indicates a Territory-area capable not only of traveling but also of integrating the signs—car, plane, telephone, motorcycle, and so on—that most fully represent modernity. These refer less to the conventional skyline of the "modern world" than to manifestations of energy—pure speed or instantaneity, for example—and to what they can connect between the Territory and its spiritual world (its ancestors and spirits, in the larger sense). On the plane of immanence, ancestry has a cosmic

dimension in relation to which the Territory selects certain tools that it considers as much spiritual as technical (airplane, car, telephone), tools that instantaneously link one world to the other. The appearance of buses, motorcycles, or planes on Efiaimbelo's funerary posts or of television antennae or electric light bulbs in the paintings of Esther Mahlangu or Francina Ndimande do not affect in the least their belonging to a Territory.

Territory has no intrinsic purity suddenly altered by the intrusion of foreign elements. Any "alteration" is of its own making and is substantial insofar as it "borrows from all the milieus, it chews on them, it wraps them in its arms. . . . It is constructed from aspects or portions of milieus."[14] The works of Efiaimbelo and Mahlangu demonstrate that a "territory is always on the path of deterritorialization, at least potentially, on the path of transition to different orders."[15] When Esther Mahlangu and Cyprien Tokoudagba start to paint the same things on stretched canvas that until then they have painted on the walls of a house or a temple in connection with a social or religious ritual, this constitutes a deterritorialization that can bring about a rearrangement of the devices that contribute to the powerful visual identity of their work. In other respects, it is possible to show that the traditional paintings of Mahlangu and Ndimande form residual islets in an Ndebele territory that has undergone an irreversible breakdown due to a concerted policy of uprooting carried out by the whites in power in South Africa—a policy that resulted in the creation of the artificial territories of the Bantustans.

Even in the most traditional-seeming forms of expression, like the puppet dramas in the *kwaghhir* celebrations of the Tiv in Nigeria, there are scenes mingling mythic characters and those taken from contemporary and secular events heard on the radio or seen on the television—for example, the execution of criminals by a group of soldiers. Territory is open to the World; a Territory that closes on itself is dead or on its way to death.

FRONTIER

It is only when we deal with the Frontier that the energy potentially present in the Territory intensifies sufficiently to make it possible to demarcate the intermediate area where the Territory is still very apparent but lines of flight begin to show up: secular themes that push their way into the funerary sculptures of Kane Kwei and Sunday Jack Akpan, the imaginary syncretic religious realm of Agbagli Kossi, who reveals a link between India and Africa. Artists working in the field of funerary rituals exemplify the hybrid nature of what we designate as Frontier. Kane Kwei and Sunday Jack Akpan are perfect examples of this section's artists, who disclose a line of flight between Territory and World. The naturalistic coffins invented by Kane Kwei refer as much to Territory, insofar as a body is *placed in the ground* and occasions a ceremony, as to World, since the envelopes that dress the body function as signs: the Mercedes-Benz coffin to signify the powerful businessman; a fish coffin to symbolize one who made his fortune through fishing; a cacao bean coffin for one whose wealth derived from the cultivation of that plant. Here, the connection of World (what more worldly reference than a

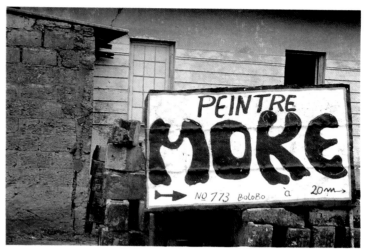

Sign advertising Moke's studio, Kinshasa, Zaire. 1992

trademark?) operates by means of the sign. It refers to all that is associated with it on a sociological level: prestige, cost, clientele, wealth. In addition, the sign is fated to disappear in the Earth. One can thus say that it gives up the World for the Territory.

Sunday Jack Akpan, unlike Kane Kwei, has not invented a new genealogy of signs but works in a preexisting tradition. The multitude of nonfunerary themes that Akpan deals with in his enormous studio express his willingness to liberate his statuary from its Territorial bonds in order to treat it as a sign complete in itself: eagle, military figure, nursing mother, soccer player, elephant, crocodile, snail, religious figure, and so on. However, Territory is always remaking the surface: in the form of a funerary commission that a family or a community gave him after seeing one of the sculptures in his studio or simply in the form of myths tied to certain of his sculptures.

Frontier is thus that area of pursuit between Territory and World, whose territory seems to have a protracted advance, so hard is it to escape its force of attraction.

In the Frontier area, the forces of deterritorialization are so intense—as, for example, in the case of Nicolas Damas, Kane Kwei, Sunday Jack Akpan, or the Dakpogan brothers—that they render the issue of Territory *problematic*.

In this respect, the issue of the assimilation or intrusion of elements foreign to the ethnic culture (generally, in Africa, from the West) is a false one that, in effect, reveals its incomprehension of the way in which the work operates; it is, rather, an assemblage of expressive qualities tied to a Territory but capable of springing from greatly varied horizons, near or far. The Ode-lay masks of Sierra Leone (see pages 84–87) thus play a social role among the young citizens, who perceive them simultaneously as a mark of identity, of distinction, and of competition. They could present themselves as easily in traditional masks devoid of all foreign references, strongly territorialized by virtue of their crown of porcupine needles, as in a mask inspired by a science-fiction movie which betrays the influence of a traditional Yoruba headdress from Nigeria.[16] The cosmic dimension conveyed by the movies here, which the sculptor John Goba reterritorialized to ritual ends by means of a theatrical prop borrowed from

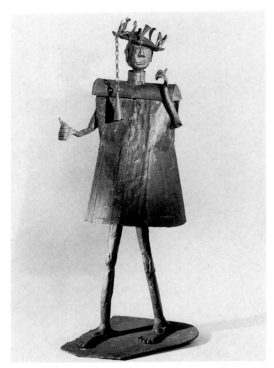

**The God Gu—Fon God of War, of Metal and of
All Who Use Iron.** Abomey, Dahomey (Benin).
c. mid-nineteenth century. European scrap iron,
height, 65″(165 cm). Musée de l'Homme, Paris

another African culture, does not make Territory fly into pieces.
On the contrary, it helps to enhance its amazing adaptability.

The fashionable concept of "Westernism," which claims to
describe the process by which African works of art capture and
assimilate elements from the West, evidences a misunderstanding
of the process of adaptation. This idea is obviously Eurocentrist
in origin.[17] Why be astonished if another region also practices
what seems natural and is practiced on a large scale in the West?
Without going back as far as Cubism, one need only think of
certain works by Robert Rauschenberg or Daniel Spoerri, among
others, to affirm that they integrate non-Western elements.
"Westernism" is a process used, to varying degrees, in the assem-
blage of all of art.

Despite what has sometimes been written, "primitivism" is
not the obverse of Westernism. Primitivism is a Western optic.
For the "primitive"—if such a being can exist outside of Western
mythicizing—primitivism is meaningless. Primitivism refers to
that moment in the history of Western art at the beginning of
this century when, for reasons connected with their own history,
radical artists recognized in the works of other radicals—"primi-
tives"—solutions to specific problems peculiar to Western devel-
opment. The exhibition *"Primitivism" in 20th Century Art,*
organized by The Museum of Modern Art in 1984, traded on
that change in Western perception in which the "primitive"
becomes both alibi and hostage.

The censuring of the "influence" seen in certain processes
used by African artists betrays that fear of seeing the World rap
on the window and at the same time denies the artist the ability
to make his or her own choices. The attitude that denounces
with a hue and cry the menaces facing identity and authenticity

belongs to a form of Zhdanovism.[18] Is it not obvious that the
artist, in whatever latitude he or she happens to be working, is
constantly bombarded by "influences"? The true artist will refuse
to ignore them in the name of a hypothetical purity and will, on
the contrary, welcome them in order to renew his or her identity.

When artists abdicate their identity in favor of a borrowed
identity through which they seek confirmation from some distant
other (as, for example, when sculptors make their works conform
to the Western aesthetic of their patrons), this is a perversion of
what we have labeled "Westernism," because in this case the
identical and the nonidentical cease to relate to one another in
a dialectic.

WORLD

Paradoxically, an artist who belongs to the World has not neces-
sarily abandoned the Territory. Any aspect of World can be
related to a part of Territory or Frontier, and vice versa. In
World, Territory will always be present, and it will continue to
nourish the work with its myths, its rituals, and the strength it
draws from its land. Yet, a threshold will have been crossed in
terms of the forces that penetrate this terrain: AIDS, corruption,
immigration, North-South relations, social problems of every
sort that are seen in the paintings of Cheri Samba, Moke, Cheik
Ledy, or Willie Bester; planetary signs and symbols in the pro-
tean works of Bruly Bouabré; worldwide monetary iconography
employed by Ngnetchopa. Even Bodys Kingelez, whose work
could be considered the most free of its roots, conveys some-
thing of Territory, as in *Kinshasa la Belle* and its overtly interna-
tional-style towers.

The interesting question is not which criteria are used to
place a particular artist in Territory, Frontier, or World but how
much interpenetration of one by another is possible before one
of the classifications forfeits its identity. To what extent can Ter-
ritory be deterritorialized and still be recognizable as Territory?
The work of the Kenyan painter Richard Onyango comes to
mind in this regard, as it combines a story that, on the surface,
has all the characteristics of a jet-set romance (palace, luxury
cars, easy money) with the fundamentally African roots of the
Mamy Wata* myth, which clearly inspired his story of Drosie.[19]

Among the aspects of Richard Onyango's story that confirm
this homology between the romance with Drosie, a young West-
ern woman, and a liaison placed under the sign of Mamy Wata
are, notably, the mystery, the lavish sums of money of unknown
provenance, the exclusive attachment to a lover that implies the
renunciation of all previous ties.

In World, Territory reemerges in the form of signs. As a
kind of synthesis between the soil and the street of a large African
metropolis, Territory reappears within a polemical debate on the
history of art which for the African artist formed in a Western-
type school functions as a mixture of dispossession and imperial-
ism, of deterritorialization as alienation from foreign values.
Thus, as soon as Territory becomes the object of reflection con-
cerning the conditions of its emergence, in World or Frontier,
the issue of borrowings from these other areas becomes prob-
lematic. The adaptability of Territory is called back into question

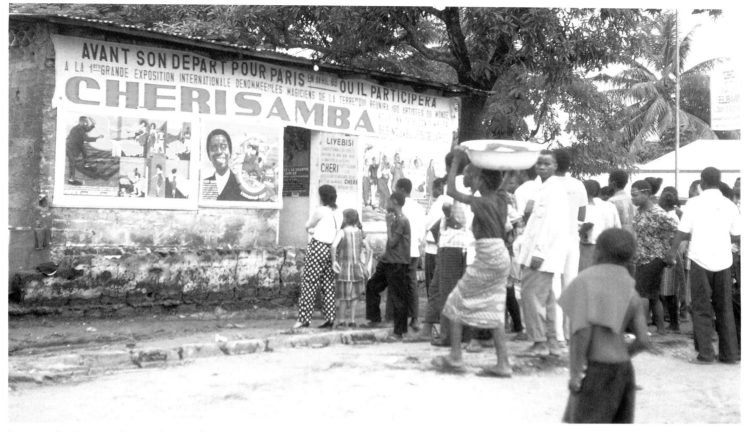

Sign outside Cheri Samba's studio, Kinshasa, Zaire, 1989: "Before his departure in April 1989 for Paris, where he will take part in the first great international exhibition *Magiciens de la Terre* (Magicians of the Earth), which will bring together 100 artists from throughout the world, Cheri Samba invites you to look at his new works."

in order to attempt a reformulation whose validity or "authenticity" is not owed to a certain "soil." Whence, we believe, that form of false understanding that marks African art insofar as it thinks of itself in the horizon of the contemporary.

How can involvement in the World be reconciled without cutting oneself off from Territory, which is considered the source of authenticity and power since it is supported by the Earth? This is one of the dilemmas expressed by the Ivory Coast artists of the Vohou-Vohou group concerning the *contemporary* African artist. "He is Negro-African, he is of the world," wrote Yacouba Touré in *Esquisse du manifeste technique du vohou-vohou* (Draft of the Technical Manifesto of Vohou-Vohou). The artist is contemporary insofar as he or she internalizes this dilemma, assuming that World appears under the guise of the "other": other culture, other history, other Territory. To inject World into Territory and to inject Territory into World, this may be the avowed program of the Vohou-Vohou.

It may appear paradoxical to place the work of Frédéric Bruly Bouabré in the World as it seems so firmly tied to the specific Territory of the Bete culture. One quickly understands that a reading focused on the so-called ethnicity of an artist can be extremely limited if one takes into account the fact that all the work of Bruly Bouabré is tied to writing. "Writing," he says, "is what bonds ideas together the best." Interestingly, the discovery of his own system of signs—whose purpose is to endow the Bete culture with an ideographic tool that will not, like the Latin alphabet, betray it—came about through an encounter with

pebbles gathered from the earth not far from his native village of Zéprégühe.[20] Their surface reveals natural geometric designs, which the artist claims stimulated the idea of creating a Bete writing from entirely original signs. The work thus has a double foothold in the Territory—from the specific ethnic area and the culture associated with it, on the one hand, and from the physical source of the system of signs that Bruly Bouabré has cultivated for more than forty years, on the other hand. Finally, the focus on writing, with its implication of inventiveness and autonomy in relation to a purely ethnic context, its implication of continuous attention to the *design* of letters, naturally fostered the gradual ascendancy of the sign in the work. Image and text constantly refer to one another and envelop in ever larger globes entire slices of life originating from non-African as well as African cultures. The discovery of the abstract power of the sign (a power of both combination and classification) constitutes the basic originality of Bruly Bouabré's work. To paraphrase the well-known formulation of Rimbaud, in speaking of Bruly Bouabré's work, one can point to a methodical disorder of all the signs, in the sense that the rules of agreement between drawing and text experience singular distortions due to the inventions of language, which makes it a verbal creation as well. With their power of poetic evocation, certain sentences no longer seem to maintain any connection with the space of the drawing in which they appear, as, for example, this splendid line that could have come from André Breton's *Nadja*: "I am the blue eye of a beautiful woman that draws the elect like a magnet."

The speed characteristic of World that we have previously described is evident particularly in the series by Bruly Bouabré in which the same element from the Territory—a porcupine needle, for example—is treated in drawing after drawing until it turns into a missile.

It is in the loss of all reference to a central source in the sense of a birthplace that Bodys Kingelez's "extreme models" declare the preeminence of World. They telescope the names of Territories from all over the Earth—*Mongolian Soviet, Hiroshima Palace, Barcelona Post, Zaire*—with no concern for a stylistic or symbolic relationship between the name and the model on which it appears. Such an extreme independence gives the work as a whole great speed in that the Territory is elevated to the rank of pure sign articulated through an architecture whose avowed program is to maximize the empty overload, to generate excess to the detriment of the structure, the cost to the detriment of the economy. The "extreme models" are truly decorative insofar as they are vectors of absolute alienation from their culture. It would make no sense—even though they could be completely imagined—to go ahead and build them. That would be tantamount to subjecting them to rationality, to moderation, to the very economy they call into question. They are extreme in that they carry to extremes what for John Ruskin distinguished architecture from construction: the nonfunctional.

It would be too simple to equate the artists of World with self-awareness and those of Territory with awareness only of the object, unable to think of themselves as simultaneously occupying a temporal continuity—a history of art—and a spatial totality—the artistic community. That model is too strongly tainted with Eurocentrism. We would like to put forward the paradox that one can belong to World while being completely uncontemporary. The artists of the Vohou-Vohou group are contemporary inasmuch as they pose fundamental questions about their procedures by the expedient of a world history of art to the extent that it makes reference to a center. This is a reactive stance. The contemporary always forms its point of view subject to a dominant centrality, which identifies itself here with the West. In this sense, it is not clear that such artists as Bruly Bouabré, Bodys Kingelez, Ngnetchopa, Kane Kwei, or Sunday Jack Akpan, even while participating in international exhibitions side by side with "contemporary" artists, are indeed *contemporary*, that is, that they comprehend their creations in relation to a temporality and a space that radiates from a center. From the moment that they no longer are part of Territory, these works tend to place in question the contemporary viewed as presence along with the outlooks by which the contemporary artist orients and justifies his or her procedures.

The sense of belonging to this world that is defined as "contemporary art" through the united agency of institutions, periodicals, and collections and that requires the artist to submit to constant confrontation is cruelly missing in Africa, with the exception of some international meetings that are still too rare or, at a more regional level, such gatherings as Pachipanwe I and II, organized in South Africa in 1988 and 1991.[21]

The artists of the World are also international because of their presence throughout the world—Europe, the United States, Japan—but not contemporary because of that presence, since, except for those who have gained access through academic schooling, they hold themselves aloof from the spectrum of the various components, historic as well as contemporary, that structure the field (the heritage of past artistic movements and coexistence of current issues that combine to make a "work" be seen as "interesting" or, on the contrary, "outdated"). Thus, these artists contribute toward a new map on the path to deterritorialization to the extent that the contemporary remains for the West a form of territorialization. The decontextualization of so-called traditional works, from which has flowed the interest of museums as well as other attention from the West, has facilitated this process. There no longer is a Negro art as a category of art history, the so-called *art nègre*, precisely because the territorial connections of the term have been broken under the influence of this decontextualization. One can certainly say that the artists presented in this book are caught up by the contemporary to the extent that they are known by virtue of a center. Through the choice that makes the artists the object of the authors of this very book, necessarily placing them within a certain logic of the art field known as contemporary, the contemporary overtakes these artists in return. Olu Oduigbe, writing of the relation between the West and the art produced in Africa today, put it well: "That which it does not know is unknown. That which it does not present is not represented, and that which it does not speak for cannot speak. The Other must be passed through the grid of their own frame for it to come into being and deserve recognition."[22]

One could spend a long time splitting hairs to determine the motivations of this recognition of works by artists who are largely unaware of entire chunks of art called "modern" or "contemporary."

The celebrated German anthropologist Leo Frobenius refused to believe that the Yoruba could create such splendid "Hellenistic" heads in bronze and clay as he found in 1909, and which could be admired until recently in the museum of Ile-Ife in Nigeria. He suspected—without, of course, being able to prove it—some Western, "central" influence, operating through time and space. To accept them as they are, the products of this people of merchants and farmers, would mean admitting the possibility that another center exists, autonomous, owing nothing to what Frobenius considered the central point of reference: classical Greece. It is important to keep such an attitude from surreptitiously infecting one's perception, classifying, for example, the paintings of Mahlangu or Ndimande as abstract painting, the masks of Hazoume in the readymade tradition, the bank notes of Ngnetchopa as Pop, or the models of Kingelez as the extension of a postmodernist approach. What these works ask is: At what point are we, the modern Frobeniuses, ready to admit that they establish in their own way a contemporary art that is not ours?

In the realm of intercultural relations, is there an irreducible core where elements would be found that can be recognized as

common to a great number of cultures, which would reach a level where they interact to produce a resonance that extends well beyond the original core?

A degree of attention and the encounters that it brings on the site of a living art based on the convergence of desired ends will have the effect of reforming ideas of art and enlarging its playing ground. Only dialogue has the power to explode the monopolies disguised under the name "international art," which grudgingly reserves a few seats in the back of the bus for representatives of the other world, and to support the emergence of a true liberation of cultural information centers.

An irreversible movement has taken off in the plastic arts of Africa today. A multipolar movement, it has burst the confines that contained it until now in overly restrictive categories (usually to appease the market): "naïve art," "traditional art," "urban painting," "objects," and so on. Opening several fronts at the same time, it announces a break with that conventional image that held it hostage to tradition and made it a wallflower in the dance of modernity. It refuses this deadly choice by inventing another modernity that is enslaved neither by the mythology of the avant-garde nor by the cult of the new. A different modernity that claims its share of recognition without resorting to the accepted labels among which "contemporary art" is one of the essential modalities, a modernity that lays claim to the idea of art in the full sense of the term without adapting it to an ideological model (the definitive Western idea of contemporary art) that could only perpetuate its lesser status.

Ernst Ludwig Kirchner said that art "raises itself above time, race, and epochs." In this fin-de-siècle, in a world whose direction seems more and more uncertain, a world that, contrary to all expectation, has not become a global village, it behooves us to speak less of a global art and more of a global recognition of the arts.

Notes

Preface
1. *Magiciens de la Terre* (Magicians of the Earth) was presented in Paris in June 1989 at the Musée d'Art Moderne and the Grande Halle de la Villette.

Introduction
2. For a survey of Third World biennials, see Thomas McEvilley, "Arrivederci Venice," *Artforum*, November 1993, pp. 114–16, 138.
3. See Selected Bibliography.
4. Jean-Marie Pontévia, *Ecrits sur l'Art et Pensées Detachées*, vol. 1 (Bordeaux: Editions William Blake, 1985).
5. The two artists responsible were Albert Lubaki and Tshyela Ntendu, relatives of the Zairian artist Moke (see pages 112–14).
6. Of course, this picture of the average artist actually varies from artist to artist and from country to country. A sculptor like Sunday Jack Akpan, of Nigeria, who has his studio in a small village far from any large urban center, nevertheless attracts a great many people who travel long distances to see him.
7. Unfortunately, the unique experiment of the Musée Dynamique of Dakar, launched in 1966, ended abruptly.
8. Frank MacEwen, Roy Guthrie, Tom Bloomfield, Carlos Carvalho (Maputo), Yaya Savane (Abidjan), Ruth Schaffner (Nairobi), Elimo Njau (Nairobi), Origines Uiso (Dar es Salaam).
9. Among the private galleries with an international outlook are also Goodman Gallery and Everard Read Contemporary in Johannesburg and, more recently, the gallery 8F ("Weeteff") in Dakar.
10. These are by no means all the individuals within these schools. Among the other Shona sculptors are John Takawira and Tapfuma Gutsà. Samaki, Christiano Madanguo, Dastani, Anagangola, and Kashimir are leading individualists among Makonde sculptors.
11. Gilles Deleuze and Félix Guattari, *Mille Plateaux* (Paris: Editions de Minuit, 1980). See particularly the chapter entitled "De la ritournelle," pp. 382–433.
12. Robert Farris Thompson emphasized this expressive continuity, which extends from Bakongo sculpture to the musical and choreographic motifs of black Americans. The *shetani** spirits, all of which are both good and bad, represent the assets and defects of humans, good happenings and catastrophes. They embody the traditions and myths of the Makonde culture. The term *ujama** is applied to works that symbolize human cohesion and solidarity ("tree of life"). Unlike the *shetani* "style," which is dominated by solitary figures, the *ujama* works display a mass of figures.
13. Robert Farris Thompson, *The Four Moments of the Sun, Kongo Art in Two Worlds* (Washington, D.C.: National Gallery of Art, 1981), p. 201.
14. Deleuze and Guattari, p. 336.
15. Ibid., p. 402.
16. As shown in John Nunley, "Images and Printed Words in Freetown Masquerades," *African Arts*, 15 (4): 42–46, 92.
17. The American artist Felix Gonzalez-Torres, originally from Latin America, has pointed out that artists labeled "minority" do not have "a right to metaphor, unlike their white, male American counterparts."
18. From the name of the Minister of Culture in the former Soviet Union, Andrei Zhdanov, who defined the precise elements that make up an authentic "Socialist" aesthetic.
19. See Richard Onyango, *The African Way of Painting* (Verona: Adriano Parise Stampatore, 1992).
20. It is curious to note that the word *calculate* derives from the Latin word *calculus*, or pebble.
21. See Elsbeth Court, "Pachipanwe II: The Avant Garde in Africa," *African Arts*, January 1992.
22. Olu Oduigbe, review of the exhibition *Africa Explores*, in *African Arts*, March 1993, p. 18.

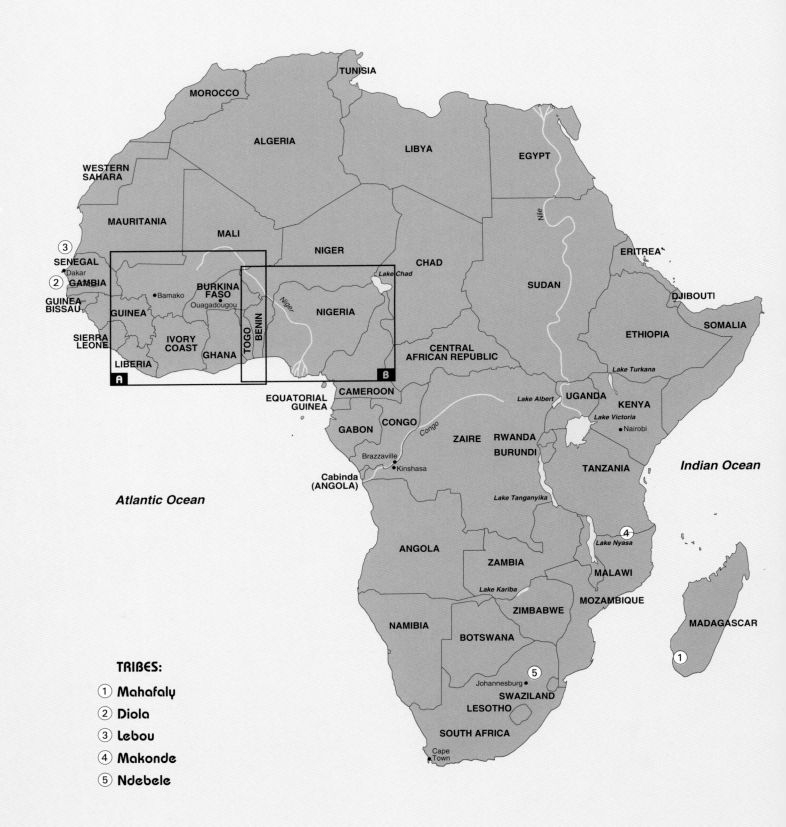

TUNISIA

MOROCCO

ALGERIA

LIBYA

EGYPT

WESTERN
SAHARA

MAURITANIA

MALI

NIGER

CHAD

Nile

ERITREA

③ SENEGAL
•Dakar

② GAMBIA

GUINEA-
BISSAU

GUINEA

BURKINA
FASO
Ouagadougou °

•Bamako

Niger

Lake Chad

SUDAN

DJIBOUTI

NIGERIA

TOGO
BENIN

SOMALIA

ETHIOPIA

SIERRA
LEONE

IVORY
COAST

GHANA

LIBERIA

Ⓐ

Ⓑ

EQUATORIAL
GUINEA

CAMEROON

Lake Turkana

CENTRAL
AFRICAN REPUBLIC

Lake Albert

UGANDA

KENYA

Lake Victoria

•Nairobi

GABON

CONGO

Congo

ZAIRE

RWANDA
BURUNDI

Brazzaville•
•Kinshasa

TANZANIA

Indian Ocean

Cabinda
(ANGOLA)

Lake Tanganyika

Atlantic Ocean

ANGOLA

ZAMBIA

④

Lake Nyasa

MALAWI

Lake Kariba

ZIMBABWE

MOZAMBIQUE

NAMIBIA

BOTSWANA

MADAGASCAR

①

⑤

Johannesburg•

SWAZILAND

LESOTHO

SOUTH AFRICA

Cape
Town•

TRIBES:

① Mahafaly

② Diola

③ Lebou

④ Makonde

⑤ Ndebele

West Africa

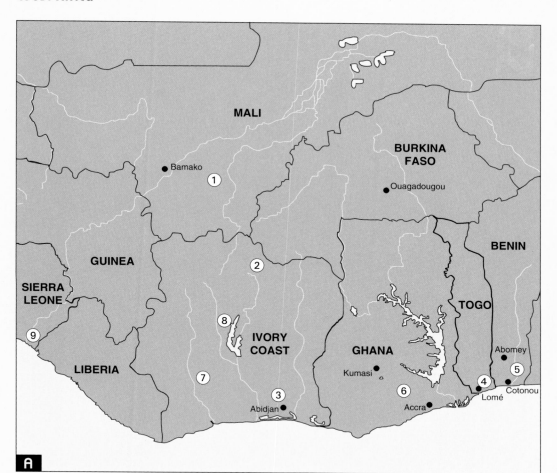

TRIBES:
1. Bambara
2. Senufo
3. Ebrie
4. Ewe
5. Fon
6. Akan
7. Bete
8. Baoule
9. Mende

Nigeria and Neighboring Countries

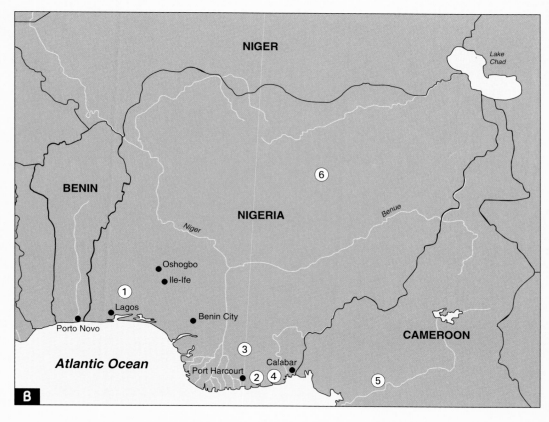

TRIBES:
1. Yoruba
2. Ibibio
3. Ibo
4. Efik
5. Bamileke
6. Tiv

TERRITORY

Sekon Sekongo

Born 1945 in Fakaha, Senufo Land, Ivory Coast
Lives in Korhogo, Ivory Coast

Sekon Sekongo in Korhogo,
Ivory Coast. 1993

Master Sekongo, as he is called by the artists who work under his guidance, was introduced by his parents to painting on cloth in his childhood. The practice of painting on fabric is in fact known throughout his village, which jealously guards this heritage. The textile is cotton, made up of narrow bands that form a piece of variable dimensions. The dye comes from a decoction of leaves and the bark of a shrub known locally as *N'gamenan*. To this is added pulverized corn. Seated on a plank set on the ground, the artist sketches motifs using a knife with a curved blade, which he dips into the color. The artist later adds a second coat.

According to oral tradition, the making of cloth paintings was initially bound by certain rules. Their execution was always supposed to result from the bidding of divinities, for specific purposes.

The costumes associated with the rite of initiation called *poro** have geometric motifs that bring to mind animals. They are linked to a vision of the world in which animals figure among the principal creatures, whence their constant presence in the works of the Senufu artists. The five family names of this agricultural society—Sekongo, Silué, Soro, Tuo, and Yeo—correspond to totems represented by animals who are venerated and considered protectors by members of that family.

Today, the production of Senufu cloth paintings has become a commercial operation governed primarily by the client's wishes.

Sekon Sekongo is one of the last representatives of a tradition on its way to total transformation.

Yaya Savané

Poro. 1992. Natural pigments on woven cotton, 35 × 57⅝″ (89 × 146.5 cm). Collection Jean Pigozzi

This painting refers to the initiation rite of poro. The crescent of the moon and the stars are the basic motifs. Cloth such as this would be produced for the chief's costume.*

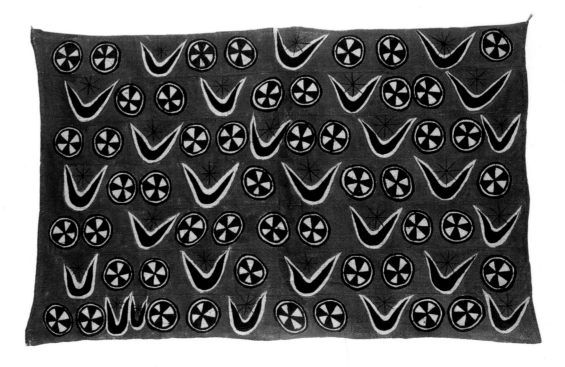

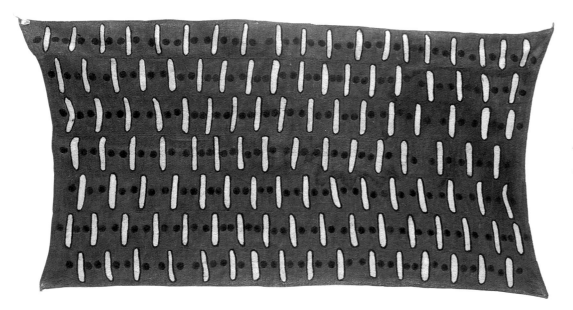

MBie Kangne. 1992. Natural pigments on woven cotton, 33¾ × 59⅝" (85.5 × 151.5 cm). Collection Jean Pigozzi

This painting represents heaps of yams (in local language "MBie kangne," shown by the white lines) and their buds (black lines). It expresses the peasant's astonishment on seeing the abundance of tubers his field has produced. The varieties of yam in the mounds of dirt in the foreground thus become his totem.

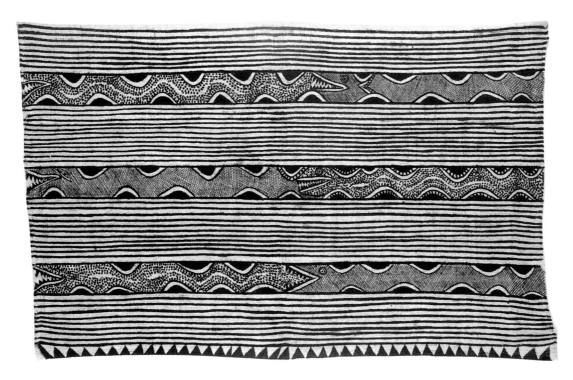

Fonaka-On. 1992. Natural pigments on woven cotton, 34¼ × 52" (87 × 132 cm). Collection Jean Pigozzi

Fonaka-on designates a type of unidentified snake. Following the bidding of the diviner, these snake motifs must be placed on the interior walls of a house and on the textiles used for loincloths or women's clothing. Tradition tells us that one can lose consciousness after coming upon a snake previously unknown. The cure is for the victim to live in a house decorated in this way or to wear clothes painted with its motifs. The inhabitant of that house becomes a diviner who receives his power from the snake.

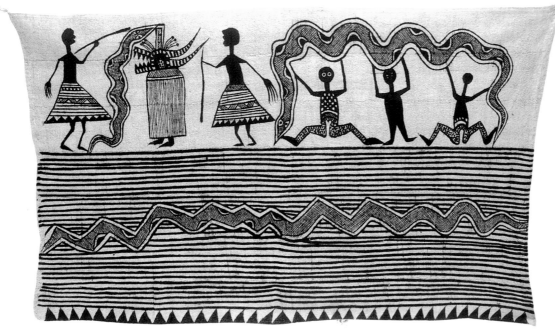

Kpogo. 1993. Natural pigments on woven cotton, 34½ × 53½" (87.5 × 136 cm). Collection Jean Pigozzi

This fabric represents the kpogo mask, along with large snakes and spirits. The spirits, who are incarnated in the form of large snakes (which facilitates their encounters with humans), reveal the masks to humans. The wearer of this fabric, using the motifs of the snake he has encountered, in his turn becomes a diviner who invokes the snake for his revelations.*

Efiaimbelo

Born c. 1925 in Androka, Mahafaly Land, southwestern Madagascar

Lives in Androka

Jacques-Jean Efiaimbelo

Born 1951 in Androka

Lives in Androka

Efiaimbelo in Androka, Madagascar. 1992

Jacques-Jean Efiaimbelo in Androka, Madagascar. 1987

The *aloalo* is a funerary post, which was developed to a high degree of significance among the Mahafaly, who live in the southern part of Madagascar (see map 1). It is a symbol of prestige, along with other tomb ornaments such as *bucranes* (buffalo horns), found on many monuments to important deceased Mahafaly.

The Mahafaly traditionally left the *aloalos* to the tomb and to the forest, the domain of ancestors and spirits. The funerary posts were to remain permanent guests of this place, far from the gaze of men. In 1896, however, a messenger from another culture—the French colonial regime—arrived in Madagascar. As part of their development program, the French began to construct roads that crisscrossed the island. In 1904, the Mahafaly region was opened up to the outside world. Many of the roads went right by important tombs and their *aloalos*. No longer were they contemplated in solitude.

At first sight, the *aloalo* appears to be a decorative object. This is especially evident when offered by the *anakampela* (the female child) as an ornament on the grave of a deceased parent who was rich or occupied a respected social position such as that of *mpisoro*,* the spiritual leader of a clan, or head of a dynasty.

In earlier times, only the Maroserana (nobles) of the Mahafaly royal dynasty could use the *aloalo* on their tombs. At this point, the *aloalo* symbolizes the woman (single or married) in everyday life, a simple housewife concerned with embellishing her home for the pleasure of those around her. Because of the woman's role as decorator, giving the *aloalo* the name of a woman makes it clear that it is an element of decoration. That is why the wood from which the *aloalo* is carved is chosen from the most beautiful and the most hardy, which in this case is the *Mendorave* (the *Albizia greveana* of the Mimosaceae family). Once erected on the grave, the *aloalo* incarnates the grace of the woman perpetuated in time by this special wood that resists decay.

Nevertheless, if the *aloalo* is regarded solely as an object of decoration, its funerary and sacred aspects would be missed. In order to ensure that it is imbued with the sacred spirit, nothing is left to chance: The Mahafaly turn to the *mpisoro*, in his role as spiritual leader, rather than going directly to the sculptor to negotiate the making of the *aloalo*; they mobilize the men of the village to choose the wood, and before it is cut, an animal (a bull or a ram) is sacrificed, which renders the wood sacred; and last, the sculptor's workshop is located outside the village—all these actions peculiar to the Mahafaly indicate quite clearly what careful attention surrounds the making of this funerary post.

The ban on creating the sculpture within the inhabited space of the village stresses the sacred dimension in which the world of the living and that of the dead are radically separated.

When the *aloalo* has been handed over to the *anakampela*, it must be transported directly to the tomb, to await the day the tomb will actually be finished and the funeral organized. During the course of the funeral another bull is slaughtered in order to affirm the sacredness of the tomb one last time.

The Mahafaly artist Efiaimbelo has made the *aloalo* the center of his art. Besides contributing to this form the endless inventiveness of his carvings, he has also played a decisive role in the introduction of color and in the revitalizing of themes. Among the elements on Efiaimbelo's *aloalos* are: a brightly colored or black and white ox known as a

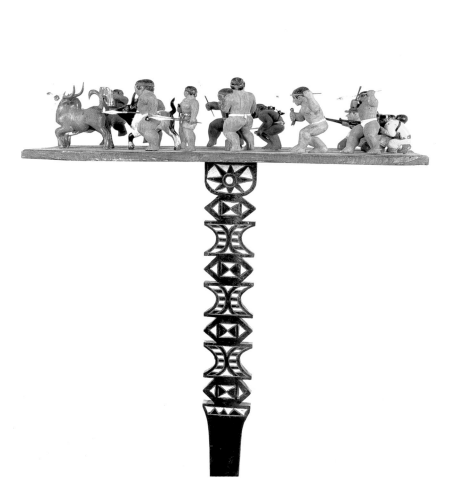

Left:

Pangalatra Omby (Stealing Zebus). 1989–90. Painted wood, 78¾ × 39⅜ × 13" (199 × 100 × 33 cm). Collection Jean Pigozzi

Right:

Mpisoro (Ancestor). 1989–90. Painted wood, 79½ × 5⅞ × 4 5/16" (202 × 15 × 11 cm). Collection Jean Pigozzi

Below:

Mahafaly tomb with **aloalos,** Betioky region, Mahafaly Land, Madagascar. 1989

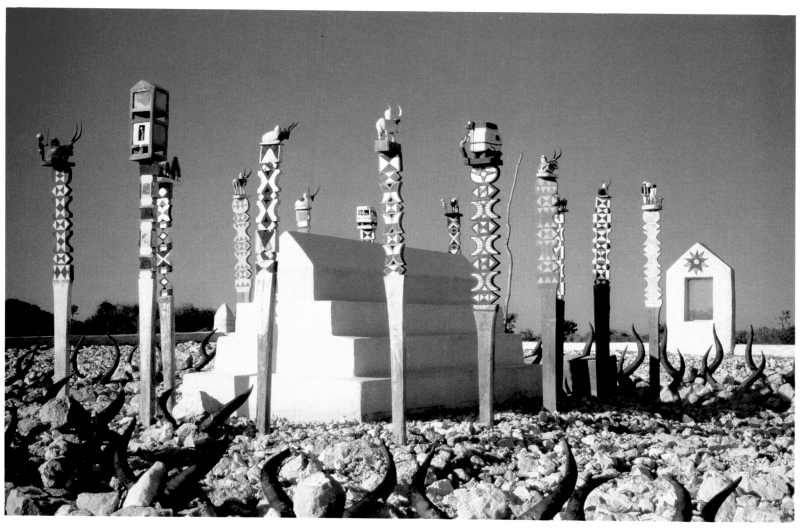

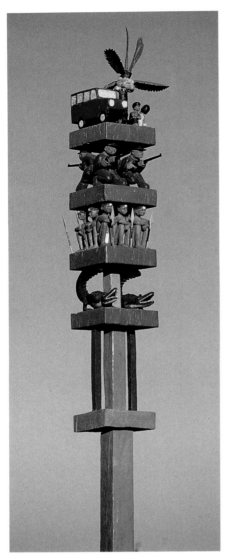

zebu, which expresses passion and prestige; a warrior, who covets sovereignty; a pair of birds, which symbolize love and faithfulness; a policeman, who incarnates the law and the strength of the new regime; and finally, a bush taxi, a motorcycle, and an airplane, which denote travel, the city, progress, and technology. His son, Jacques-Jean, now works alongside his father, perpetuating the art.

The Mahafaly know how to interpret these representations and to learn what kind of man is buried in this sort of grave. Each time they find themselves before such a monument, they contemplate it freshly, and they dream of one day being able to erect one similar or even more beautiful. This explains the presence of *aloalo*-style tombs everywhere in the Mahafaly territory, particularly on the road along the coast (see map 2).

In recent times, this art has become detached from the grave, and has come to be treated as a purely decorative object in a luxurious setting that only the affluent can afford. Thus the *aloalo* has moved outside of its region to conquer the cities. The once fearsome taboo against its introduction into the world of the living is nothing but a distant memory, which only the Mahafaly retain out of respect for their origin.

Paul Rabibisoa Ravoay

Milamina ny tany (This Is Peace). 1993.
Painted wood, 81⅝ × 15 × 15″ (208 × 38 × 38 cm).
Collection Jean Pigozzi

Detail of Mahafaly tomb
with *aloalos*, Betioky region,
Mahafaly Land, Madagascar.
1992

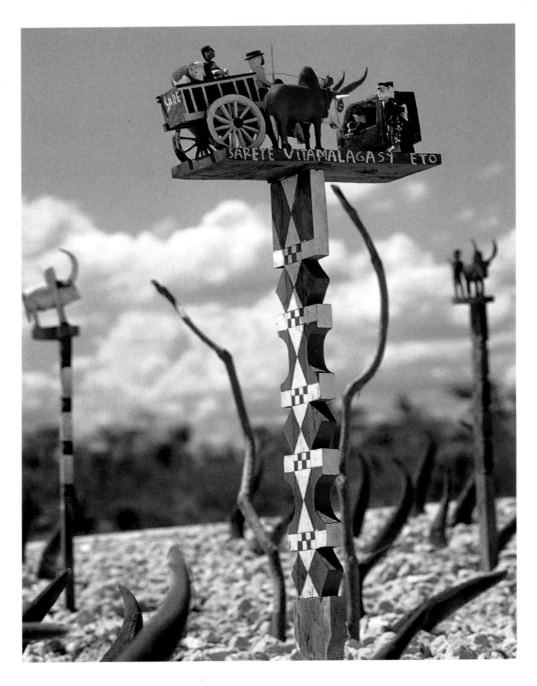

Emile Guebehi

Born 1937 in Anono, Ivory Coast
(born Nekedi, Kru Country)

Lives in Abidjan, Ivory Coast

Nicolas Damas

Born 1947 in Abidjan, Ivory Coast
Lives in Abidjan

Emile Guebehi. **Untitled.** 1990–91. Installation, painted wood, overall approx.
63 × 118⅛ × 55⅛" (160 × 300 × 140 cm). Private collection, Abidjan

Originally from the Kru region, bordering Liberia, Emile Guebehi returned to his native village, Nekedi, at the age of thirty. He did his first graphic work with a piece of charcoal, on the walls of local houses—in something akin to graffiti, which was not to everyone's liking. Later, his discovery of clay led him to modeling figurines, with which he had great success. A healer in the village even recognized his special talents by commissioning a wooden statuette for use in his consultations. That encouraged Guebehi to present his next two statuettes to the prefect, the leading official in the region.

Following these first, very promising attempts, Guebehi was invited by an Ebrie community to Songon Dagbé, a village in the Abidjan area. His significant works (exclusively in wood) can be understood only in relation to this society.

Emile Guebehi in Abidjan, Ivory
Coast. 1992

The Ebrie occupy the entire lagoon complex formed by the Ebrie, Ouladine, Aby, Tano, and Ehy lagoons, east of Abidjan. The Ebrie people, who belong to the Akan ethnic group, are characterized by a system that divides the generations into groups that each, in turn, submit to the same rites of passage. Every fifteen years, the lagoon village males born within that period move from one age classification to another: from the Niando (children), to the Blesue (warriors), to the Tiagba (mature men), and finally, to the Dugbo (the wise). At this time, each generation is initiated into the appropriate portions of the group's traditions. The lagoon villages thus have an important artistic and historic heritage at their disposal, which constitutes a true link between the artist Guebehi and the Ebrié community.

Essentially, Guebehi views the sociopolitical organization of the "lagoon" people of the southern Ivory Coast as his microcosm. With wood and paint, he creates tableaux that depict dramatic scenes in their daily lives and record the history of the Ebrié and other village scenes.

Nicolas Damas in Abidjan,
Ivory Coast. 1991

Toward the end of the sixties, Guebehi, now known as the "Master of Nekedi," initiated his brother, Nicolas Damas, into his own métier of polychrome wood sculpture. Damas has managed to create a personal style that reveals a more marked interest in urban life: dancers, the "free woman," and so on. Between the two of them, Emile Guebehi and Nicolas Damas thus cover the entire thematic spectrum of Ebrié life, both traditional and modern.

Yaya Savane

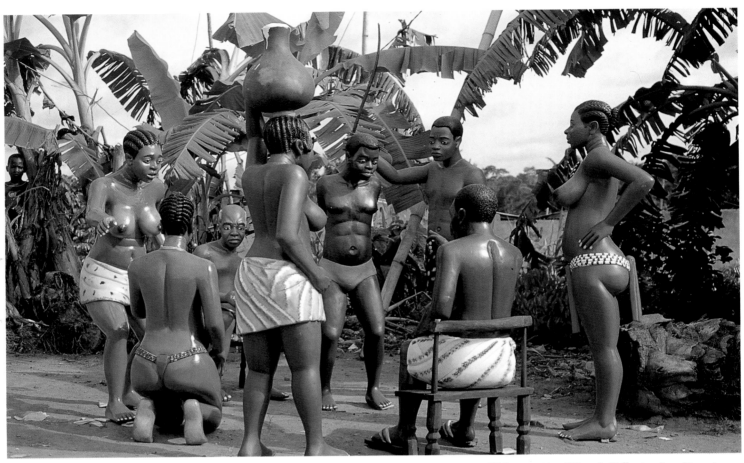

Emile Guebehi. **The Adultery.** 1992. Installation, painted wood, overall approx. 78¾ × 196¾ × 196¾″ (200 × 500 × 500 cm). Collection Jean Pigozzi

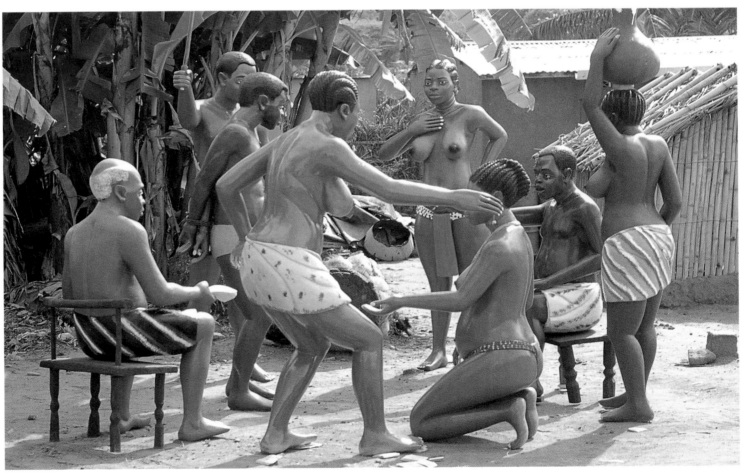

Emile Guebehi. **The Adultery.** 1992. Installation, painted wood, overall approx. 78¾ × 196¾ × 196¾″ (200 × 500 × 500 cm). Collection Jean Pigozzi

Emile Guebehi. **The Adultery** (detail). 1992. Installation, painted wood.
Collection Jean Pigozzi

*The woman, kneeling as a sign of respect, is about to be struck in the face
by her older sister for having committed adultery. The man with arms bound
behind his back is going to receive punishment from the cuckolded husband.
Seated, with money in hand, an old man is pleading the case of his son, who
has committed adultery. The money is meant for the village chief. A young girl
brings* bandji *(palm wine) to be offered to the chief by the old man.*

Y. S.

Nicolas Damas. **Bar Scene.** 1990–91. Installation, painted wood, overall approx.
70⅞ × 196¾ × 196¾″ (180 × 500 × 500 cm). Collection Jean Pigozzi

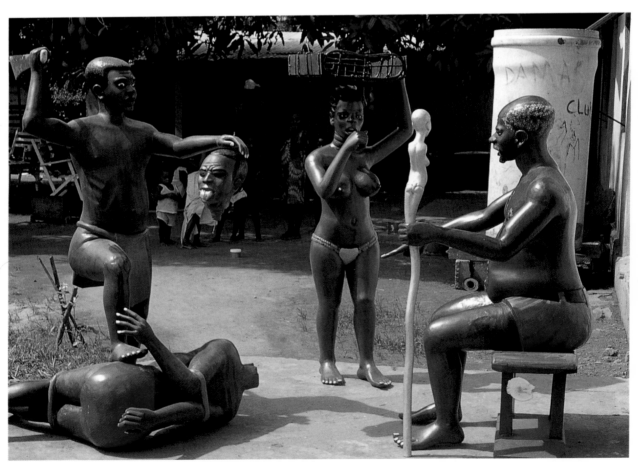

Nicolas Damas. **The Execution.** 1987–88. Installation, painted wood, overall approx.
66⅞ × 118⅛ × 157½″ (170 × 300 × 400 cm). Private collection

*As the executioner stands, his foot on the body of the lover whom he has decapitated, the adulteress,
bearing a basket on her head, has a look of horror. The elderly chief, with his carved staff, looks on.*

John Fundi

Born 1939 in Mueda, Mozambique
Died 1991 in Chanika, Tanzania

John Fundi in Chanika,
Tanzania. 1990

The Makonde are a Bantu people who inhabit the dry high plateaus in the north of Mozambique and the south of Tanzania, on both sides of the Ruvuma River. They are a restless people, haunted by a way of thinking that ascribes the mysteries of life to magic. They practice ancestor worship, particularly of the mother. Their sculptural tradition, tied to religion and the continuity of their society, reaches far back.

The struggles for colonial power brought about the first break in this traditional link; after colonization, sculpture was treated as art. The Makonde of Mozambique played a major role in this evolution, setting sculpture free from the bonds of ancestor worship and exploring materials and skills learned from infancy in a creative and personal way.

In the 1950s and 1960s, the Makonde developed a group of artisans who catered to the tourist trade. However, a few exceptional artists, attracted by the more favorable economy, moved to Tanzania. There they began to work with a hardwood called *mpingo* in Swahili—better known in the West as African ebony—and drastically changed the traditional forms. First, Samaki and Jacobo, then, Madanguo, Dastani, Kashimir, Matei, Anagangola, John Fundi, and others generated and refined the styles called *shetani** and *ujama.**

The sculpture in the *ujama* style, which serves communal goals, takes the form of a tree of life—a kind of column made up of realistic or fantastic beings, all mingled together—that evinces a high consciousness of the collective existence. *Rikangopa* is one of these. From the front it represents the leading farmer; from the rear, a field of maize.

While John Fundi originally came from Mueda in the high plateaus of Mozambique, the heart of Makonde culture, where its images were conceived, it was in Tanzania that he created a body of work and gained a reputation, working in the *shetani* style.

Shetani sculpture deals with cults of possession, with good or evil spirits: forces that give access to the realm of the supernatural. In *Sindamama*, Fundi depicts a witch doctor. He sees his evil and tries to remedy it with the serpent and with the bottle of medicines he pours into his ears.

It is not easy to define the work of "Johnny Walker"—a favorite nickname of John Fundi's that plays on the ambiguity between the sky traveler and the Scotch drinker. Asked the source of his inspiration, he liked to answer, "I suspect my spirit of sneaking out at night to take part in secret assemblies," humorously sustaining the mysteries of his unique art. Strongly marked by his restless and fantasmagoric personality, his work depicts both good and evil spirits, which invariably are sent forth into the world with some kind of deformity that seems to involve sexuality in symbolic and poetic form.

The supernatural world of these demons appears to govern Fundi, and his art brings us face to face with the archetypes of his unconscious and his sense of the sacred.

A. M.

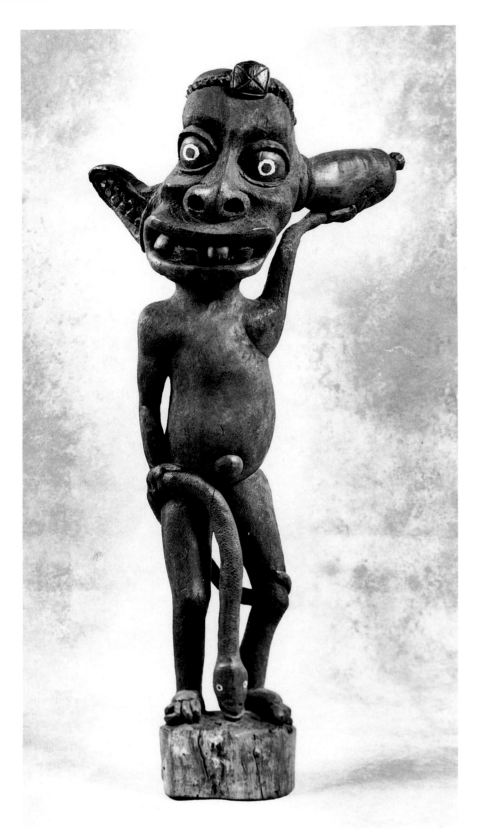

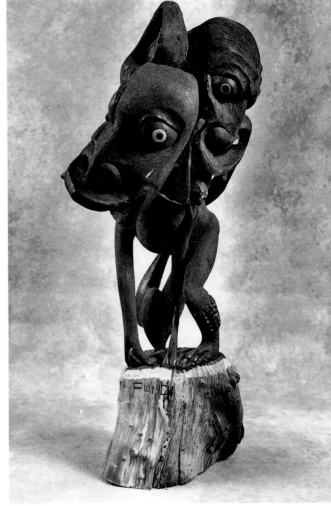

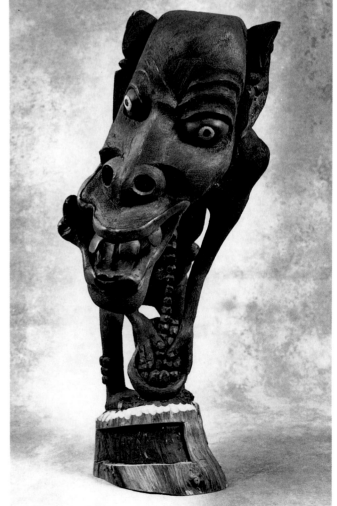

Left:
Sindamama. 1990. Ebony,
34⅞ × 8⅝ × 16½″ (88.5 × 22 × 42 cm).
Collection Jean Pigozzi

Above right:
Rikangopa. 1990. Ebony,
32¼ × 13 × 13″ (82 × 33 × 33 cm).
Collection Jean Pigozzi

Below right:
Untitled. 1990. Ebony,
29⅛ × 11¹³⁄₁₆ × 14⅛″ (74 × 30 × 36 cm).
Collection Jean Pigozzi

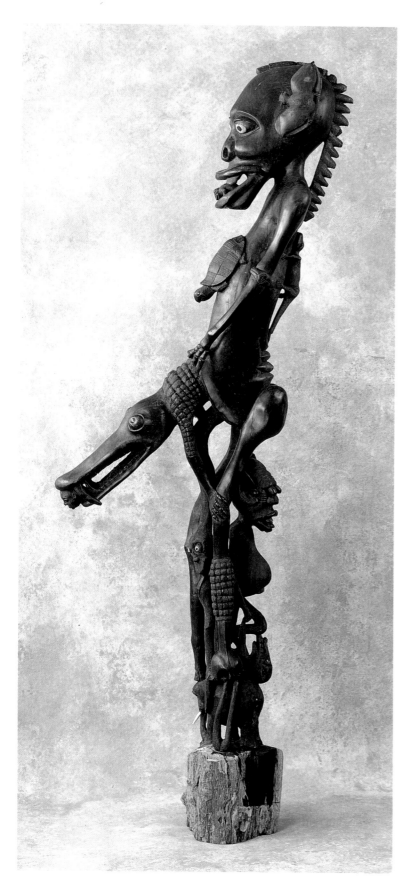

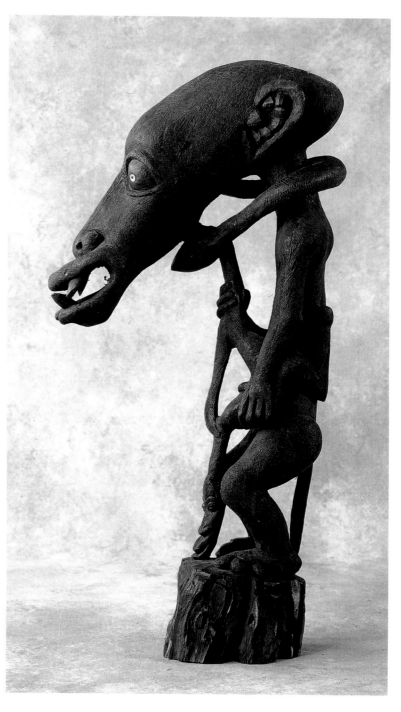

Left:
Untitled. 1990. Ebony,
63⅜ × 9¹/₁₆ × 19½″ (161 × 23 × 50 cm).
Collection Jean Pigozzi

Right:
Untitled. 1990. Ebony,
27⅛ × 7⅛ × 12⅝″ (69 × 18 × 32 cm).
Collection Jean Pigozzi

Zinsou

Born 1958 in Cotonou, Benin
Lives in Cotonou

Zinsou in Cotonou, Benin. 1995

Untitled. 1995. Acrylic on canvas,
50⅜ × 78¾" (128 × 200 cm).
Collection Jean Pigozzi

At first sight, the forms and the colors look so spontaneous and so simple that one might take them for childish caricatures from which strange humanoid creatures emerge. A giant with a squashed torso that could be taken for a neck running down into two enormous legs set far apart. Two disproportionate armlike things fuse with the shoulders. In the trunk-neck axis, the head is set between the shoulders of this apelike creature, whose great size is emphasized by the tuberous excrescences that hang from his armpits and between his legs. One dares not imagine what would issue from the giant tuber that hangs between the thighs if it turned out to be an organ of reproduction!

The predominant colors are the red of the hair and the close-fitting garment, as well as black, which dots the extremities and forms the feet and the hands.

At the opposite extreme from this gigantism are a pair of humanoids so tiny that they seem to be victims of dwarfism, although they show no signs of suffering. They look very dignified in their formal dress: wide green tunic, shoes as yellow as the man's eyes and red as the woman's hair and eyes. Both join their hands at the breast, as if in prayer. They have yellow skin.

On the same dwarflike scale, the triplets in the red chechis give the impression of having staked everything on their heads and arms, at the expense of everything else! Their elongated right arms are crossed by pointed stumps, which take the place of left arms. Three nearly identical creatures with red eyes that emerge from three faces as yellow as their shoes.

Whether from the height of their gigantism or from the distance of their dwarfism, these freakish creatures face us with proud, almost arrogant attitudes. They fix on us, and through us the world, their white, yellow, and red eyes.

Looking at these forms and colors whose composition seems so elementary, one might feel justified in talking about *art brut*. As for their creator, he could as easily pass for a genius as for a madman. It seems that in his own country, Zinsou is taken for a madman, although it is unclear if this is due to his art or his way of life. In either case, Zinsou pays for his convenient alibi of craziness by being marginalized and excluded.

The crazy are not subject to the pressures of normality. They are free to invent these abnormal creatures who look at us with yellow and red eyes. And that makes us uneasy.

Zinsou is a genius, or *aziza*,* in the fittingly legendary sense of the word. In the tradition of the Fon Porto Novo area, *zinsou* is the name reserved for male twins. Their birth and entire existence are placed under the sign of myth. The collective imagination tends to perceive them as exceptional beings, gifts of the gods, recompense for virtue and patience. As "gifts of the gods," twins are believed to be inhabited by the spirits (or genii) of creativity, gifted with the innate ability to perceive a dimension inaccessible to ordinary common sense. Twins are of another essence that makes them capable of communicating with the extrasensory universe.

This is undoubtedly one of the reasons why the Fon and the neighboring Yoruba accord them a form of respect that approaches veneration. The woman who brought them into the world earns the right to the reverence due a queen. A woman who gives birth to twins three times need bow to no one—not even the most powerful of kings!

Madman or *aziza*, Zinsou appears in two photographs. In one, he assumes the pose of an artist seated before a wall covered with painted forms; in the other, he stands behind the bars of a window—as in an insane asylum? Which of these two images is the stronger: that of liberty or that of exclusion?

Simon Agbe-Capko

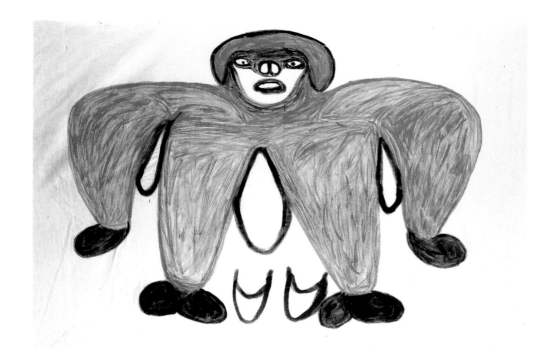

Untitled. 1994. Acrylic on cloth,
60⅝ × 100″ (154 × 254 cm).
Collection Jean Pigozzi

Untitled. 1994. Acrylic on cloth,
60⅝ × 100″ (154 × 254 cm).
Collection Jean Pigozzi

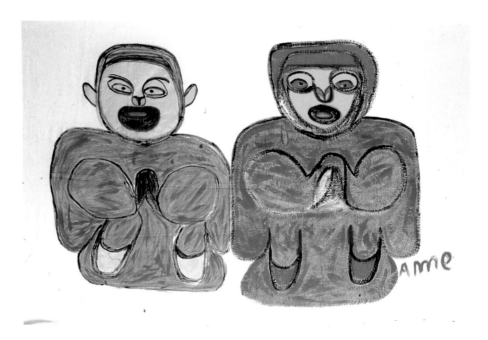

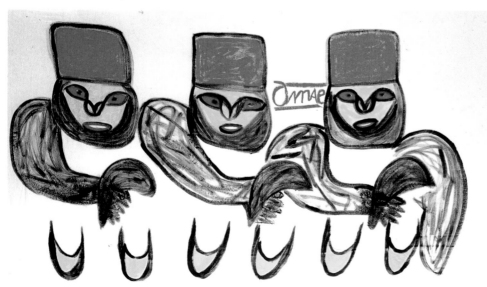

Untitled. 1994. Acrylic on cloth,
60⅝ × 100″ (154 × 254 cm).
Collection Jean Pigozzi

Georges Lilanga
Di Nyama

Born 1944 in Masasi, Tanzania
Lives in Dar es Salaam, Tanzania

Georges Lilanga Di Nyama in Dar es Salaam,
Tanzania. 1993

Lilanga is Makonde and comes from the high, arid plateaus of the
same name, on the Mozambique-Tanzania border, marked by the Ruvuma River. This is
the great center of Makonde culture, noted especially for its mapico* dance (with its ges-
tures and movements in space) and its sculpture, both of which communicate a deep sense
of social criticism and of caricature. The sculpture, produced by the whole ethnic group,
expresses a wide span of feelings: humor, fears, dreams, anguish. Lilanga has been familiar
with this art form since his earliest years, when he learned its technique from his family.

His sculpting career really began in 1961 in Lindi, in his native region. In 1972, he
settled in Dar es Salaam, the capital of Tanzania. The following year he was one of the
founders of the cooperative society Nyumba ya Sanaa (House of Arts), through which he
learned various other artistic techniques (drawing, engraving, lithography). In 1980, his
style changed radically after his encounter with the Tingatinga* School (under whose
influence he began to make vividly colored paintings, primarily of animals). He adapted
that style to make it his own, thanks to his knowledge and practice of sculpture, which he
reinterprets in his painting. He conveys every power—myth, sexuality, symbol, magic—he
acquired through his birth within the context of the Makonde culture.

Indeed, his painting is saturated with the spiritual universe of his community. His
work centers on and brings together the collective aspect of the Mapico dances, as well as
the universe of the *shetanis** (spirits, both good and bad, which may represent human
qualities or faults, celebrations or social conflicts) and the *ujamaa** symbolism (reflecting
human cohesion and solidarity). (See Fundi, pages 31–33.) Every painting is populated
with highly expressive characters, intermingled visionary figures that are always shown in
motion. As his titles indicate, everything he shows partakes of Makonde, the rhythm of
existence, the totality of the community's experience: *They Are Celebrating the Election of
Their Chairman for a Second Term* or *Maintain Good Relations with Your Neighbors and
They Will Help You When You Are in Trouble*.

Lilanga's art illustrates the continuity of artistic vision among the Makonde and its
renewal in the context of the present day. Lilanga is one of the important figures of a revo-
lution that makes it possible for an artist to function as an individual sensitive to plastic
creation among the Makonde and in Africa in general.

A. M.

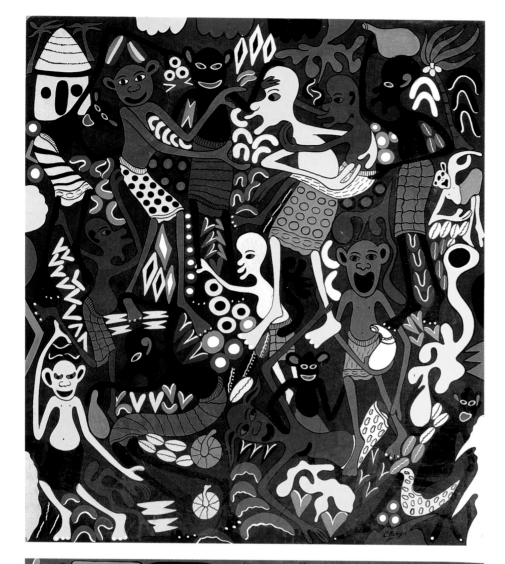

Kuishi Mjini Isiwe Sababu Ya Kusahau
Ulikotoka (Living in Town Is No Excuse
to Forget Your Roots). 1992. Acrylic on
plywood, 55⅛ × 47⅜ " (140 × 120.2 cm).
Collection Jean Pigozzi

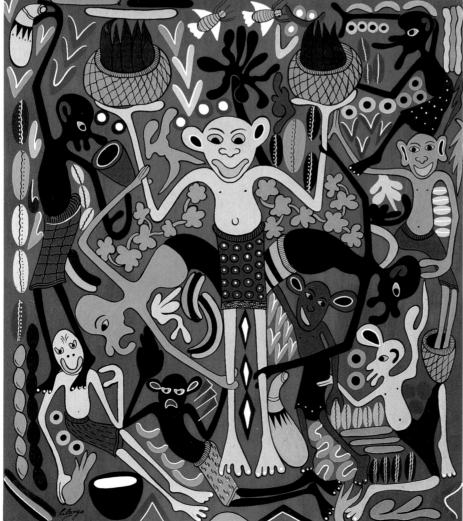

Uishi Na Jirani Zako Vizuri Ili Ukipatwa
Na Shida Watakusaidia (Maintain Good
Relations with Your Neighbors and They
Will Help You When You Are in Trouble).
1992. Acrylic on plywood, 55⅛ × 47⅜ "
(140 × 120.2 cm). Collection Jean Pigozzi

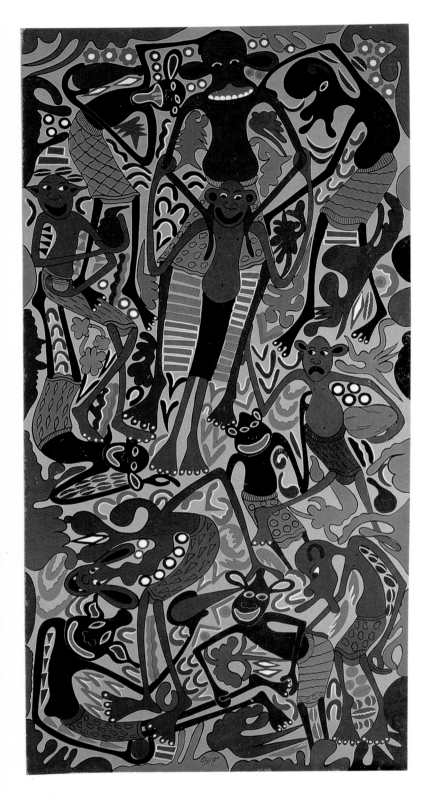

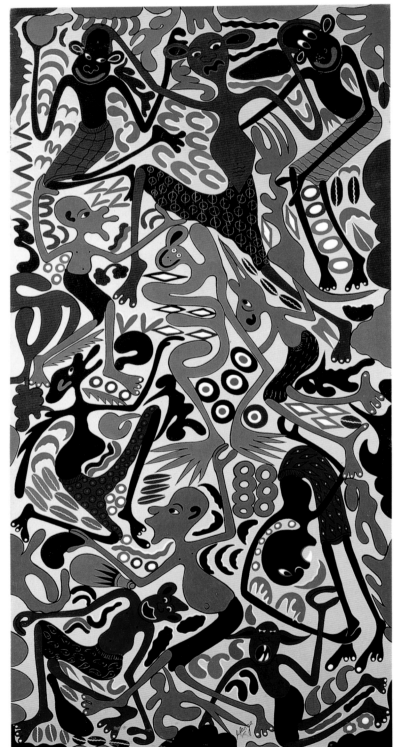

Aliyebebwa Ni Mganga Wa Jadi Na Anapelekwa
Kijiji Fulani Cha Jilani Kuna Matatizo Ya Mgon Jwa
Ana Hali Mbaya Sana (A Traditional Healer Being
Carried to a Neighboring Village to Attend a Sick
Patient). 1992. Acrylic on plywood, 96⅛ × 48″
(244 × 122 cm). Collection Jean Pigozzi

Mji Ni Watu Bila Watu Si Mji Na Sisi Hapa Tulipo
Ni Watu Kama Wewe (A Town Is Composed of
People. Without People It Is No Longer a Town.
We Are Here As People Just Like You). 1992.
Acrylic on plywood, 96⅛ × 48″ (244 × 122 cm).
Collection Jean Pigozzi

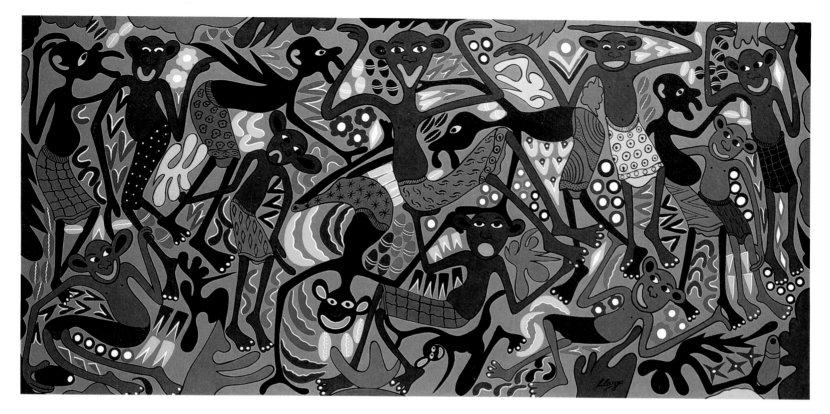

Manafurahia Kuchaguliwa Tena Mwenyekiti Wao
Kwa Mara Ya Pili (They Are Celebrating the
Election of Their Chairman for His Second Term).
1992. Enamel paint on plywood, 96⅛ × 48″
(244 × 122 cm). Collection Jean Pigozzi

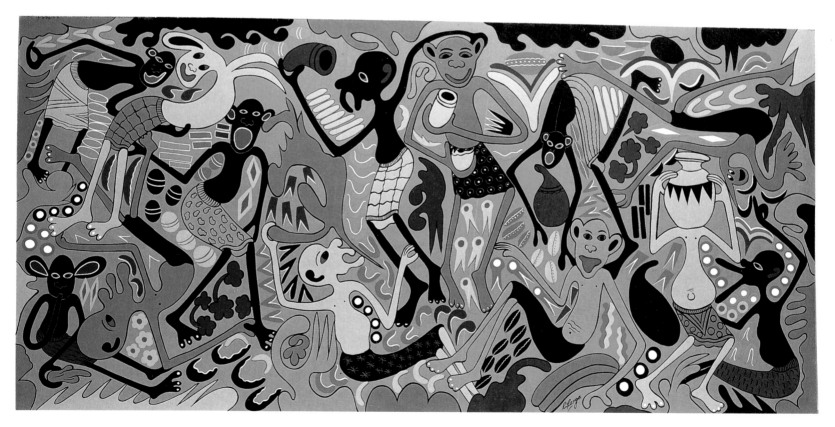

Akiwa Nyumbani Mganga Wa Jadi Na Wateja Wake
(Traditional Healer at Home with His Patients). 1992.
Acrylic on plywood, 96⅛ × 48″ (244 × 122 cm).
Collection Jean Pigozzi

Cyprien Tokoudagba

Born 1939 in Abomey, Benin
Lives in Abomey

Cyprien Tokoudagba in Abomey,
Benin. 1992

One of a family of modest means which did not allow him to pursue his studies beyond primary school, Cyprien Tokoudagba came to painting almost by accident, in response to a challenge from one of his friends regarding the decorating of a *Vodun** temple. From this awkward attempt, in 1966, other commissions followed, which allowed Tokoudagba to perfect and confirm the originality of his style within a context that actually left the artist little freedom.

Tokoudagba's art is closely associated with the social and religious history of the city of Abomey, the former capital of the kingdom of the Fon, who, in the seventeenth and eighteenth centuries, controlled the entire southern part of what is today the nation of Benin, all the way to the ocean, and eastward to the land of the Yoruba. Like many other powerful royal courts, the Fon kings had attracted numerous craftsmen, who were organized into two large guilds: the Huntunji, who worked in copper, and the Yemaje, who created the famous appliqué cloth made by sewing cutout figures onto a solid background fabric. Moreover, other craftsmen must have made the bas-reliefs that decorated the adobe walls of the royal palace, representing characters or animals emblematic of royal power. Tokoudagba is participating in the current restoration work on the royal palace of Abomey.

Tokoudagba's characteristic themes are most certainly derived from the *Vodun* of the Fon pantheon and mythology. Among the latter, the *Tohossu* (kings of the waters), royal *Vodun* with dangerous powers, occupy an important place, but so does the serpent Da Ayido Hwedo Legba* (labeled the "devil" by the missionaries because of his priapism), as well as historical subjects, such as the decapitation of Yaheze, ordered by King Akaba (1680–1708), to eliminate him as a rival.

Until very recently, Tokoudagba created only when commissioned by an urban or village community that wanted either to have a temple decorated in order to honor the *Vodun* or to have a group of statues erected in order to protect themselves from evil spirits.

The preeminence of his commissioned work is evident especially in the subjects the artist treats, and to a lesser extent in their rendering (a less generous commission will give rise to a less polished work).

Despite his dependence upon those who give him commissions, who for the most part want traditional forms observed, Tokoudagba has managed to bring a certain number of innovations to his work, especially to his painting, which remains his dominant means of expression: one such work represented not only the *Vodun* but also the *Vodunsi*, the one who serves and for that occasion wears a special white wrap.

In order to attain as much accuracy as possible in the rendering of these *Vodunsi* portraits, Tokoudagba took the unusual step of calling on live models from time to time. The other innovation has greater bearing on form: Tokoudagba has softened the absence of perspective in his pictures by introducing a surface relief obtained by a kind of shadow.

This concern with realism is also noticeable in the manner in which Tokoudagba has treated the Legba *Vodun* in his statuary, which one encounters around every corner of Abomey, particularly at the entrance of houses in the form of a hillock of earth in which a phallus has been planted: the *Zangbeto Legba* (from the name of a secret Fon society) sculpted by Tokoudagba (formerly in earth and now in cement) is shown in the form of a person seated on a throne, wearing two large horns (emblem of the secret society) and with an erect phallus.

With the exception of his wife, who helps him especially by making small earthen figures for temples such as one can see throughout the Fon region, Cyprien Tokoudagba works alone. In a recent development of his work, he has painted his *Vodun* and his *Vodunsi* on large canvases on which these figures are separated on a solid background, thus linking up with the aesthetics of the appliqués.

J. S.

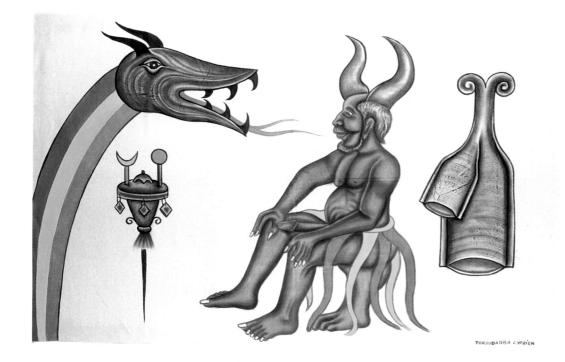

Zangbéto-legba. 1990. Acrylic on canvas, 56¼ × 88⅜" (143 × 224.5 cm). Collection Jean Pigozzi

This is an intermediary between a god and humans.

TOKOUDAGBA CYPRIEN

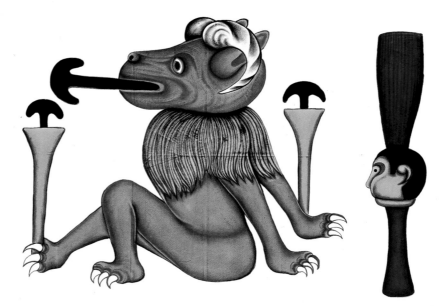

Agbolinssou (Regalia or Symbols of the God of Thunder). 1992. Acrylic on canvas, 52¾ × 88⅜" (134 × 224.5 cm). Collection Jean Pigozzi

TOKOUDAGBA CYPRIEN

VODOUN GOU

Kpe (Powers). 1992. Acrylic on canvas, 57⅞ × 69¼" (147 × 176 cm). Collection Jean Pigozzi

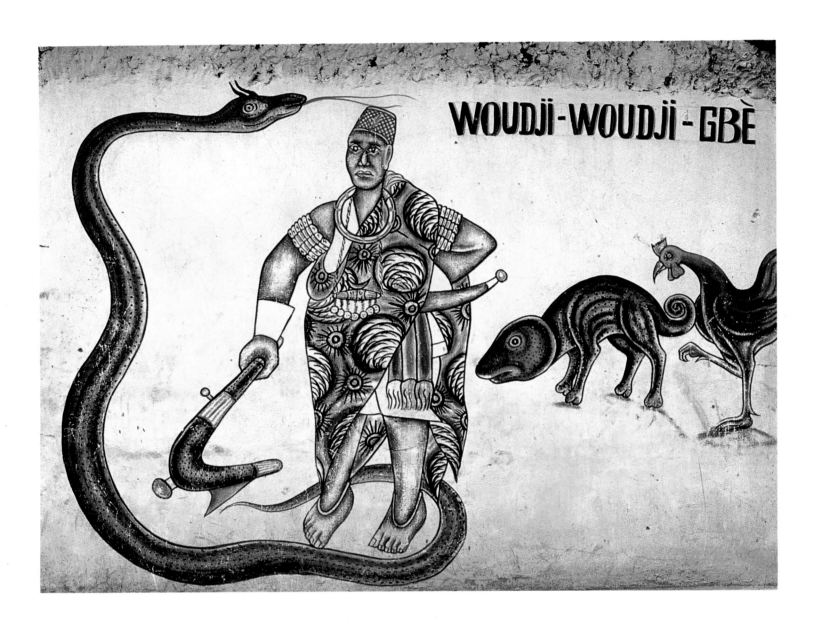

Woudji-Woudji-GBè. Mural in Abomey, Benin. 1991.

The title is a common expression in the Fon region, referring to the traditional song that tells the story of the cock and the chameleon. The cock wants to peck at the chameleon. The chameleon draws back and puffs out his throat, which frightens the cock, who says, "If you come near me, I'm going to peck at you." The chameleon replies, "You can't come near, you'd be afraid of me if I only looked you in the eye. If I made one little move, you'd be afraid. I am very powerful and you are very tiny."

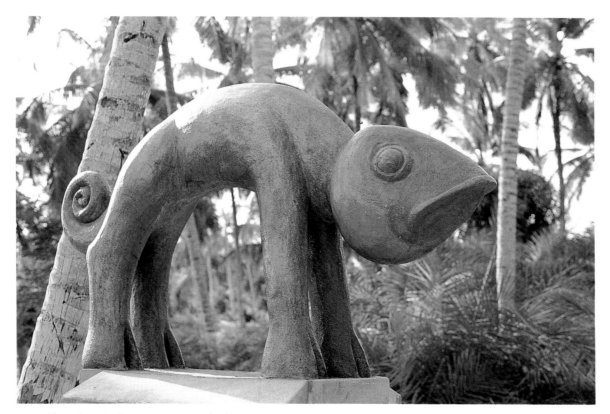

Chameleon Sculpture. 1992. Varnished cement, approx. $51\frac{1}{8} \times 27\frac{1}{3} \times 66\frac{7}{8}''$ ($130 \times 70 \times 170$ cm). Ouidah, Benin

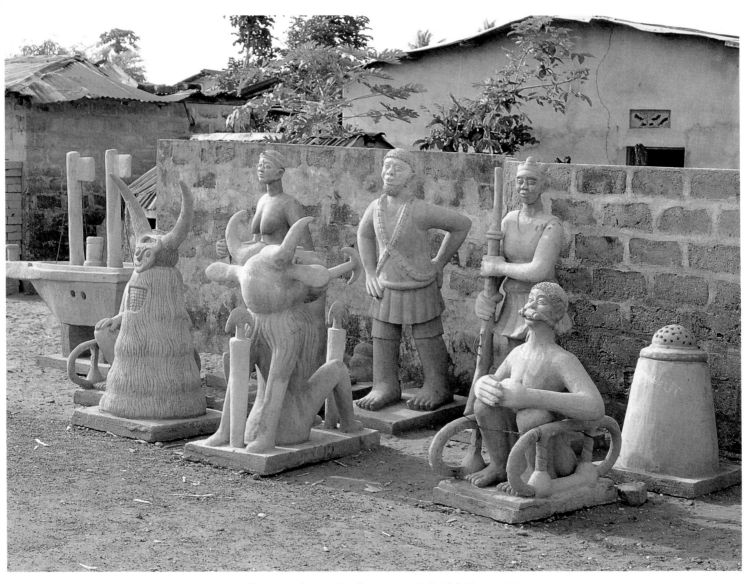

Cement sculptures (work in progress). Ouidah, Benin. 1993

Kivuthi MBuno

Born 1947 in Mwangini, Kenya
Lives in Langata, Kenya

Kivuthi MBuno in Nairobi,
Kenya. 1993

In his early days, Kivuthi MBuno worked as a chef on safaris, which led him to travel, primarily into the interior of Kenya and Tanzania. This is how he came to know nature and its wild fauna and to maintain the close relationship with them that was to mark him deeply. In 1976, his ties with the family of Baroness Karen Blixen (better known under her nom de plume, Isak Dinesen) led him to settle in Langata, where from then on he devoted himself exclusively to drawing. These lengthy treks inland, as well as the traditional life of the Wakamba tribe, from which he comes, have inspired him. MBuno gives himself to nature and shows us the extraordinary in what is commonplace. In a precise drawing style—using ink, color pencils, and pastels—he combines animals, humans, objects of traditional life, and huge spaces. This is his vocabulary, and it has not changed in almost twenty years.

Here the vast territories of Africa have none of that hostile aspect usually ascribed to them. MBuno transports us into a peaceable and luminous world that yields itself up to any activity. For Kivuthi MBuno the sparkle of this world is perceptible in places where we do not ordinarily notice it. Animals (gazelles, giraffes, hyenas, elephants, snakes, birds) ceaselessly play with their morphological characteristics (the giraffe's long neck, the powerful elephant's trunk, and so forth) in this nature in which they appropriate their respective territory in perfect harmony with the other animals. Only mankind might appear as the disturbing element. But there, too, MBuno decks them out with characteristics that are at one and the same time grotesque and elegant: they move about with the same ease as the animals they are hunting. Shining through their very singular faces are the spiritual characteristics of shrewd, pleasure-seeking, and joyful people.

The model in the artist's mind comes closer to the supernatural than to the natural. We would be wrong to believe in one ancestral vision or to see in this work the mark of primitive naïveté. The artist himself explains that what he wants to paint is less the reality than the idea he has of nature in a sort of Eden-like era. For him, beauty merges with the lovely harmony of people with their natural environment, and he feels that this way of being in the world might be called "being inside beauty."

A. M.

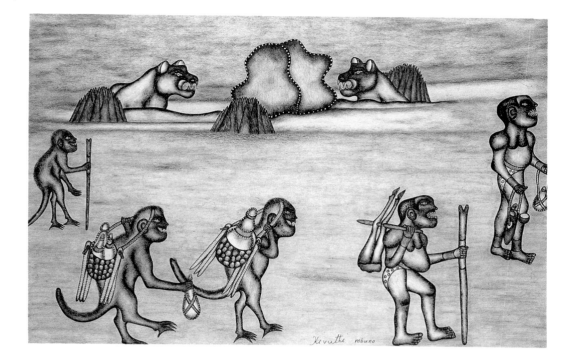

Mutinda. (Person's name, meaning "born beyond term"). 1992. Crayon on paper, 20 × 29⅞" (51 × 76 cm). Collection Jean Pigozzi

Wanywaji (Drunkards). 1992. Crayon on paper, 20 × 29⅞" (51 × 76 cm). Collection Jean Pigozzi

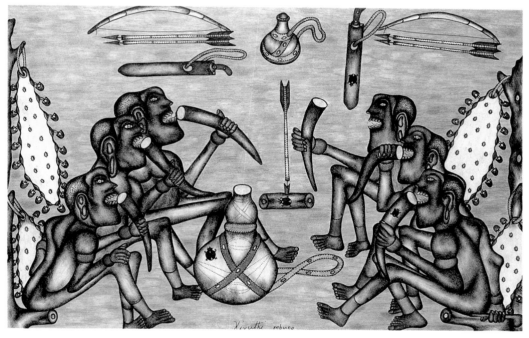

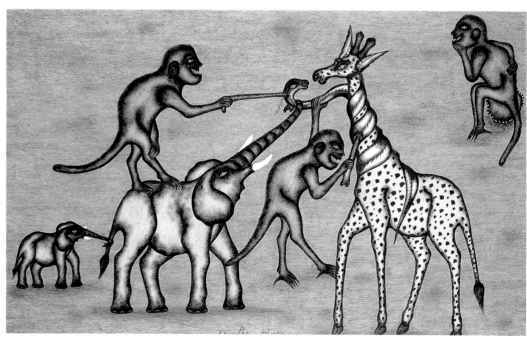

Taabu (Trouble). 1992. Crayon on paper, 20 × 29⅞" (51 × 76 cm). Collection Jean Pigozzi

Esther Mahlangu

Born 1935 in Middelburg, South Africa
Lives in Mabhoko, Kwandebele, South Africa

Francina Ndimande

Born 1940 in Weltevreden, South Africa
Lives in Mabhoko, Kwandebele, South Africa

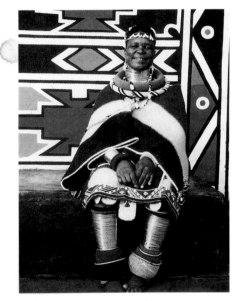

Esther Mahlangu in front of her house,
Mabhoko, South Africa. 1993

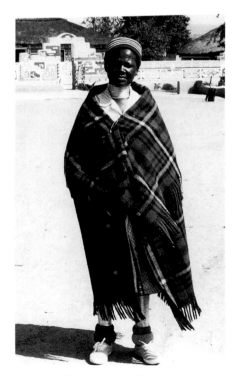

Francina Ndimande in Mabhoko,
South Africa. 1987

According to the Ndebele ritual, pubescent girls are isolated for three months. During this period, they deepen their knowledge of the techniques of mural painting and of beadwork. This artistic indoctrination has allowed the Ndebele to maintain their cultural identity and exceptional cohesion despite a turbulent history, to reinforce the traditions within the group, and to confirm the social status of women in the society. Esther Mahlangu and Francina Ndimande have both undergone this exposure and absorbed the Ndebele heritage.

Ndebele society used to be polygamous, and each co-wife had her own house. This situation fostered competition among the women, who were rivals both in the motifs and the colors used and in the techniques. Since the forties, they have had progressively greater access to the color palette offered by industrial paints, while in earlier days they relied on natural colorings: ochers, browns, blacks, or ingredients that were necessary to insure the longevity of the paintings. The lifespan of their paintings was one of their major concerns, and there, too, each woman would jealously guard her secrets.

To this day, each artist still creates work that remains very personal, aside from the obvious stylistic unity of the group. Thus, Francina Ndimande favors forms different from those of which Esther Mahlangu is fond. Her color choice carries her toward more acid tones.

The dwellings of the Ndebele, the *umuzi*, are composed of several independent structures: a parlor, a kitchen, an entryway. Each of these elements is treated in a specific manner, with particular care and decorative richness devoted to the front of the entryway and the parlor, which are the first to catch the eye. The back walls and the kitchen are frequently painted in monochromes.

If the interior of the dwelling is painted, it then has the advantage of being treated with great respect: as the paintings are not exposed to the elements, pigments that are more rare, more precious, are used here.

For a few years now, highly stylized figurative elements have appeared on the walls (staircases, [see page 48], airplanes, television antennas, electric light bulbs [see page 47, upper left]), transcribing images brought back from infrequent visits to the city or conveyed by the tales of the men around Mahlangu and Ndimande.

These representations of the details of a universe only glimpsed constitute a symbolic appropriation, but are above all the fruits of a quest for new forms. Thus, the *tshefama*

Esther Mahlangu. **Untitled.** 1990.
Industrial paint on canvas, 47½ × 74″
(120.5 × 188 cm).
Collection Jean Pigozzi

Esther Mahlangu. **Untitled.** 1990.
Industrial paint on canvas, 74¾ × 48⅝″
(190 × 123.5 cm). Collection Jean Pigozzi

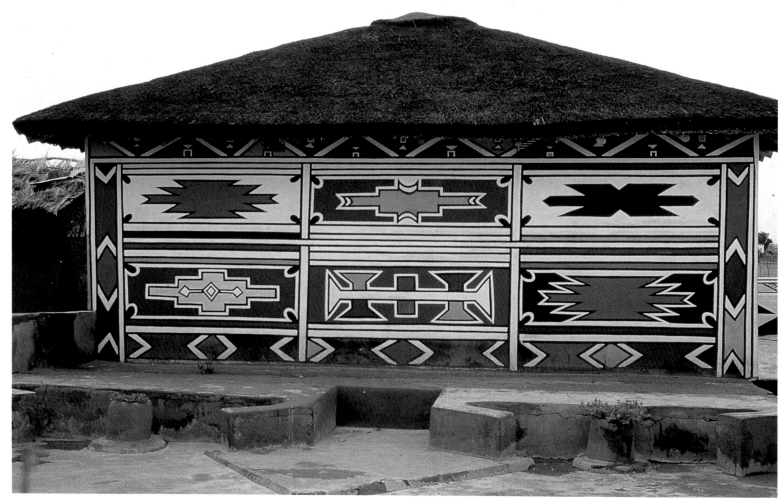

North facade of Esther Mahlangu's house, Mabhoko, South Africa. 1987

Francina Ndimande. **Untitled.**
1992. Acrylic on canvas,
49⅝ × 36¼" (126 × 92 cm).
Collection Jean Pigozzi

("razorblade" in Ndebele) motif is highly valued by Esther Mahlangu: the empty space in
the center of the blade demarcates a form that has held her interest because its plastic,
geometric aspect is well suited to be integrated into her style. The murals benefit from
annual plastering and traditionally are renewed every four years, on the occasion of the
wela ritual, the initiation of boys.

Esther Mahlangu decided of her own accord to transpose onto canvas paintings that
until then were exclusively reserved for the walls of houses. Some might see something
profane, even sacrilegious in that gesture. Esther Mahlangu always recalls that Ndebele
painting has historically been one of the primary elements of cohesion and social recogni-
tion among her people. Aware of contemporary mutations, she sees in her work on canvas,
so easily transportable, only a more efficient way in which to perpetuate and widen the
role and the impact of Ndebele painting on other peoples and other civilizations.

Esther Mahlangu is prompted by the will to keep the art of her people alive and to
develop it. She still teaches it to the young girls of her region, and paints stores, the houses
of chiefs, and the walls of public buildings. Francina Ndimande, who travels much the same
road as Esther Mahlangu, has also created her mural paintings on public buildings. It is
because they pursue this common goal that Esther Mahlangu and Francina Ndimande have
been chosen for this book. Certainly there are several other Ndebele women of equal
talent working now.

Jean-Michel Rousset

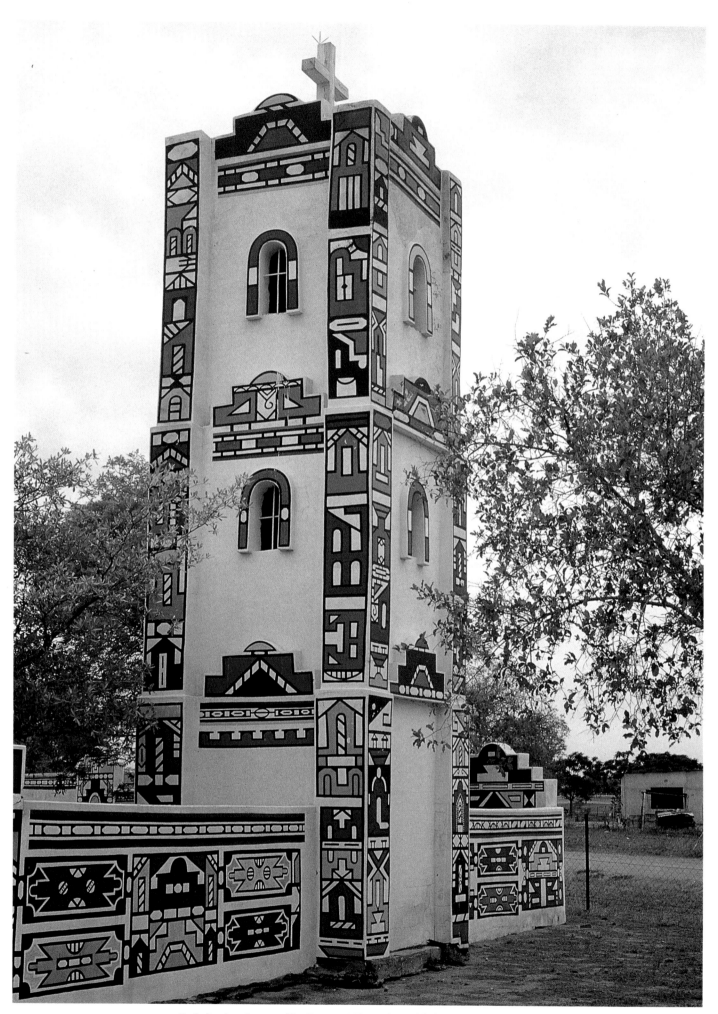

Catholic church painted by Francina Ndimande, Mabhoko, South Africa. 1987

Emmanuel Ekong Ekefrey

Born 1952 in Ndiya, Nigeria
Lives in Lagos, Nigeria

Emmanuel Ekong Ekefrey in Lagos,
Nigeria. 1992

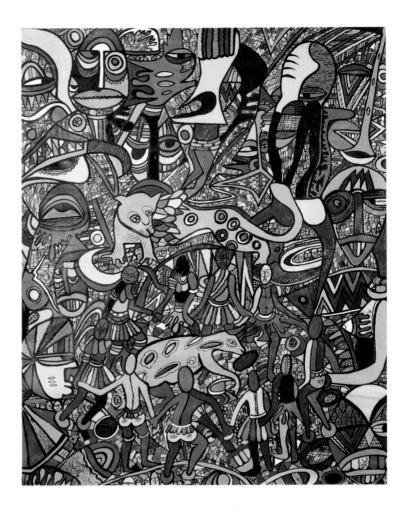

Above right:
Determination. 1990. Acrylic on
canvas, 69½ × 54⅞" (176.5 × 139.5 cm).
Collection Jean Pigozzi

Even though he lives in Lagos, one of the largest metropolitan
areas of Africa, Emmanuel Ekefrey bears witness through his painting to powerful attachment to his own Ibibio culture, akin to the Ibo group which occupies the southeastern
part of Nigeria. The Ibibio and Ibo societies, like the majority of those occupying the delta
region of the Cross River, do not have a strong central power, in contrast to the neighboring
Edo (in Benin City) or the Yoruba farther west.

Secret societies play an essential role in Ibibio social dynamics. One of the most
important of these is the *ekpe*, named from an Efik word that means leopard, an animal
that occupies a central place in the mythology of the peoples of southeastern Nigeria and
western Cameroon. Obviously, it is not by accident that we find the leopard repeatedly in
several canvases by Emmanuel Ekefrey, who uses it as the central figure of the masquerade
(see *Determination*).

The most striking formal characteristic of Ekefrey's painting is the use of large-sized
canvases left unstretched, which reminds us, in this respect, of François Thango's.

First of all, the artist draws his figures on the canvas; then he paints them, using industrial pigments, or recently, using oil paints. The total effect produced by his "allover"
technique is that of a cutting up and interpenetration of each figure with the next one,
which evokes the movement of a dance.

Ekefrey's themes strike a balance between the affirmation of an ethnic identity (Ibibio
legends, ritual ceremonies such as the masquerade linked to the secret *ekpe* society, the
first meeting of the Ibibio societies with the "white man," as in the vast fresco entitled
August Visitor) and the affirmation of what might be termed a national identity through
the treatment of themes that deal with the multiplicity of cultures within the Nigerian
Federation.

J. S.

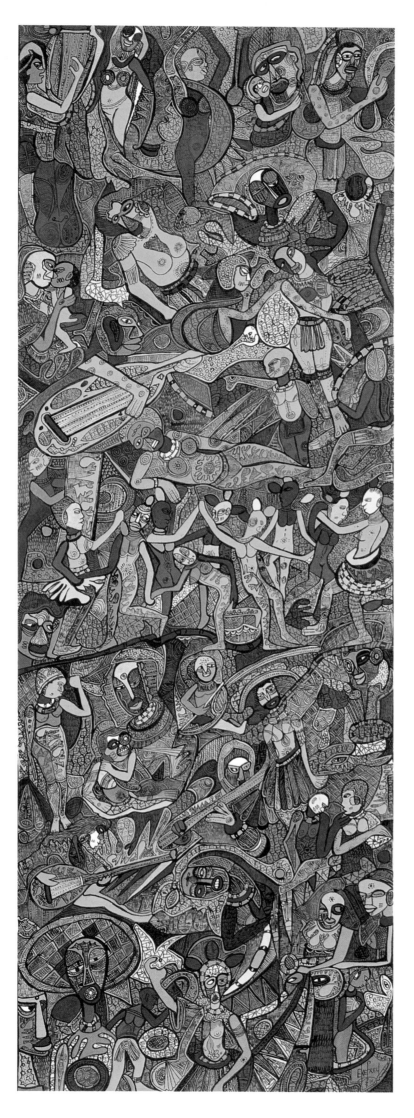

Motherhood. 1991. Acrylic on canvas, 98⅜ × 36⅝″ (250 × 93 cm). Collection Jean Pigozzi

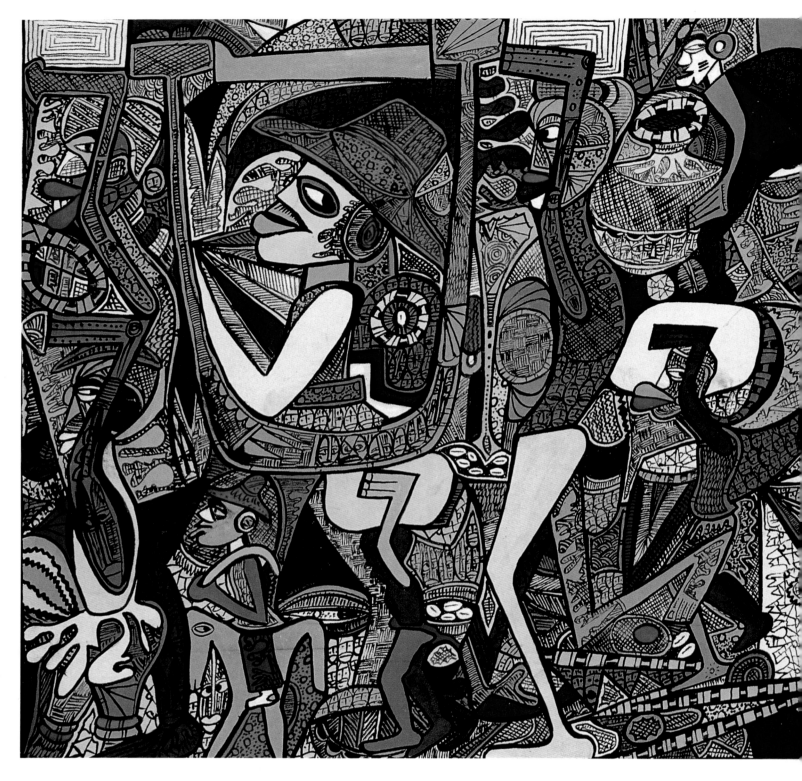

**August Visitor (Arrival of White Men
in an Ibibio Village).** 1991. Acrylic on
canvas, 36¼ × 72½″ (92 × 184 cm).
Collection Jean Pigozzi

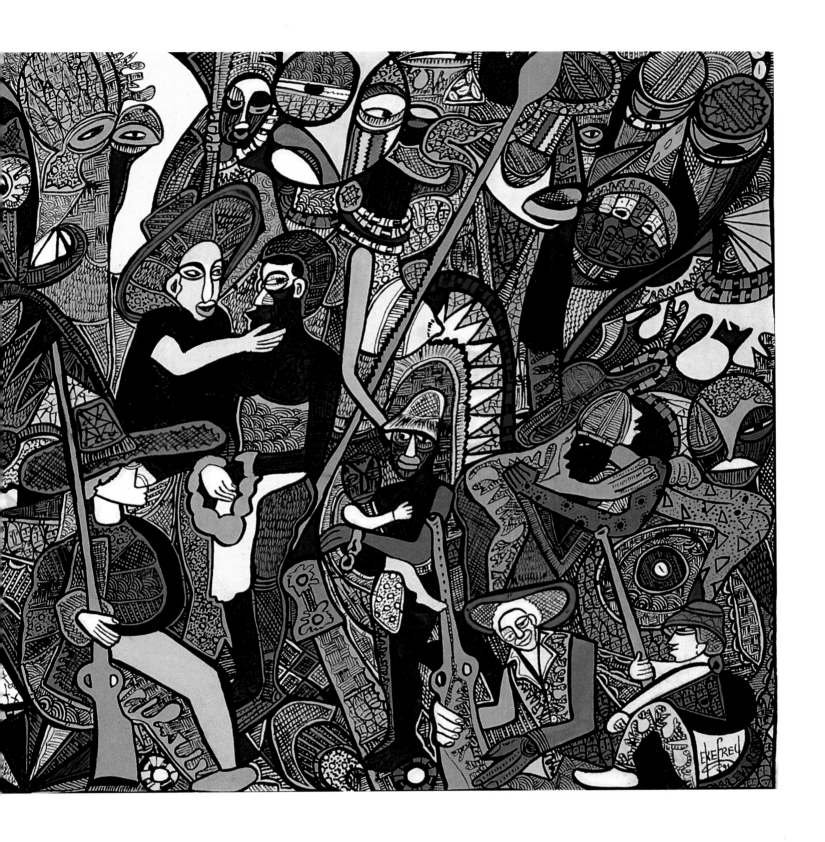

Seni Awa Camara

Born 1945 in Bignona, Senegal
Lives in Bignona

Seni Awa Camara in Bignona,
Senegal. 1992

Opposite:
Untitled. 1980–90. Terra-cotta,
28 × 10⅝ × 11⅜" (71 × 27 × 29 cm).
Collection Jean Pigozzi

Sitting in the noonday sun and inhaling smoke from a long, thin pipe, Seni Awa Camara has a quiet naturalness, like a flower that blossoms only for those who dream. For a long time, perhaps longer than she can remember, the Senegalese sculptor has smoked in the sun and worked in the sun, making thousands of clay images that have revealed themselves to her, images that merge with her observation of the world as she experiences it, and images of those closest to her—parents, partners, friends, children. "I reflect, I have an idea," she says simply.

Camara displays her fantasies and eccentricities at the marketplace in Bignona. Her work, well known in the region, is presented for milling throngs to see and examine in the vast outdoors, next to fresh potatoes and ripe tomatoes and cucumbers. Though I have never been to the marketplace, I find it strangely exhilarating that curious tourists and locals can find sculpture for sale among fleshy, smooth-skinned fruit and raw vegetables.

Do you want something to eat, drink, smoke, or admire? You must choose. The amazing bazaar allows everything, except pretense. Camara gets immense satisfaction from communication with her customers who have the courage to bet on her gifts out in the open, putting down cash. When money is exchanged, there is an assortment of thrills.

Camara shows and sells far away from the mainstream of any art world, as most of us know it. She enjoyed or missed the privilege of going to art school (a blessing in disguise). But there need be no apologies for naïveté or technical shortcomings. Her genuinely expressive figures have a coherence of style.

According to the Camara legend, she started modeling figures thirty years ago. The question people ask is, how old is she today. It is a boring question, because age does not matter. And to ask the question instantly raises the issue of credibility, always a sticky subject. In the marketplace, her husband will say anything to please a customer or to please her. The only important element is her vision. Camara is a woman in the prime of life.

Her figures are kneaded with her fingers from very fine, fresh clay that is sifted and resifted. After the clay has hardened, the works are arranged by size in her open kiln— really a big hole in the courtyard of her house—which looks like a sizzling barbecue. They bake on a burning wood fire at a low temperature. When fully fired, they are exhibited unglazed and without paint. The marble coloring comes from exposure to the flame. Some of the pieces are four feet high; most are no larger than a porcelain doll, and just as fragile.

Though she believes the omnipresent Devil is lurking nearby, she ignores him with friendly fantasies of smiling, laughing individuals and formal groupings of people who are pleased with themselves and each other. Her sculpture is not erotic. Sexuality is discreet, sometimes missing entirely. One intriguing work, for example, is of a mother and father, each clasping an infant. The mother has breasts—indeed, the baby she holds is greedily consuming her milk. Yet Camara's view of the family is primal and seen from a child's eye: the parents are joined above the hip and have no sexual organs. Mother, father, babies—all the bodies blend amid a confusion of limbs. Each touches the other playfully. There's hugging, embracing, nestling together.

The players in her theater of everyday life, whether in groups or perched singly on a tractor or motorbike, exude warmth and affection. They also accept twentieth-century civilization. Her protagonists, despite the shadow of demons, have no problem with modern transportation. In fact, it captures their imagination, along with a fussing and braiding of hair until it becomes a mask or a kind of hat.

Faces and shapes may be exaggerated, but happily, no one is on the attack. Camara's predominating theme is that of friendly affection. Like everyone else on earth, she seeks an intimacy—a need to relate to someone in a gratifying fashion. However interesting, the imagery is repetitious. But it is also personal. I recognize her originality and a certain beauty. Now, beauty is a dangerous word because notions of "beauty" are relative. So let me be very clear: the work gives me pleasure to look at. As one artist to the other, I respect, like, and enjoy Camara.

Louise Bourgeois

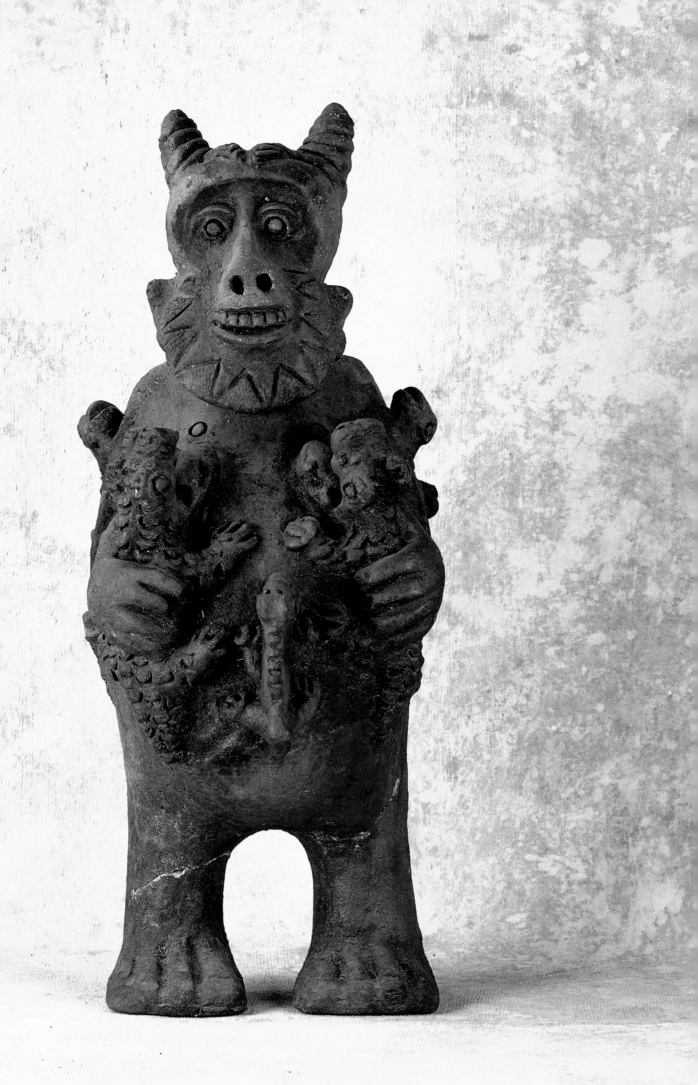

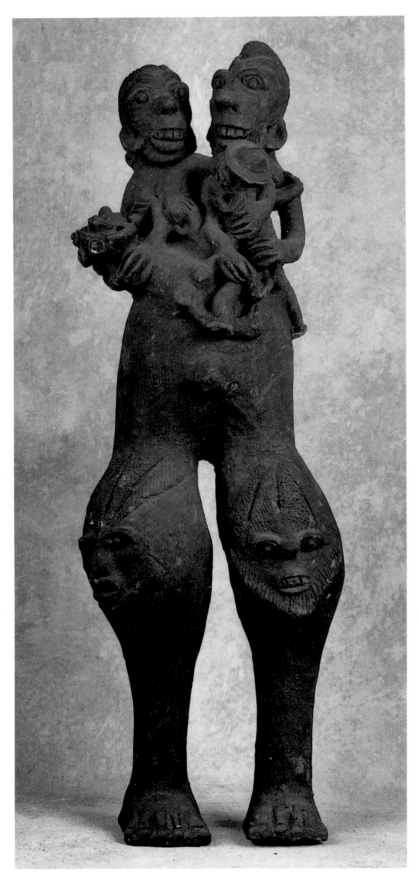

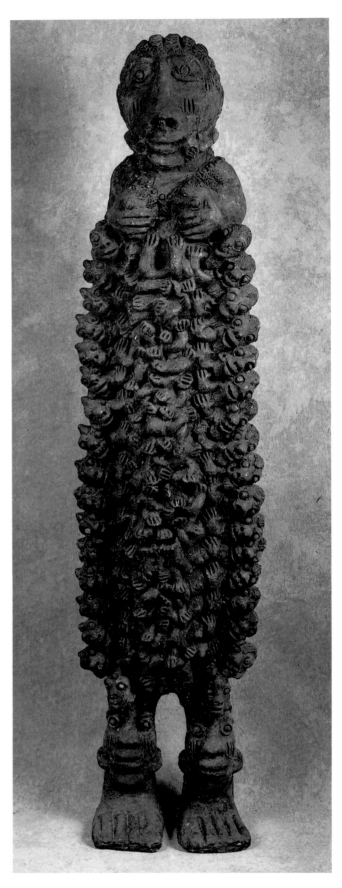

Untitled. 1980–90. Terra-cotta, 31⅞ × 11 × 7⅞"
(81 × 28 × 20 cm). Collection Jean Pigozzi

Untitled. 1992. Terra-cotta, 57⅛ × 13 × 9¹⁄₁₆"
(145 × 33 × 23 cm). Collection Jean Pigozzi

Untitled. 1980–90. Terra-cotta, 15¾ × 13¾ × 12⅝″
(40 × 35 × 32 cm). Collection Jean Pigozzi

Gedewon

Born 1939 in the province of
Bagemdir, Ethiopia

Lives in Addis Ababa

Gedewon in Paris. 1992

Talisman Diagram. 1991–92. Ink on paper,
39⅜ × 27½" (100 × 70 cm).
Private collection, Paris

*This talisman can be looked at from any of the
four sides. It reveals the spirits hidden in the
four directions.*

Gedewon calls his works "talismans of research and study,"
qualifying an old word with two others that also denote a university institute recently
established in Addis Ababa. Does this hybrid name indicate the inscription of a thousand-
year-old art into modernity? Is it a way around the prohibition that today, as much as in
ages past, attaches to forbidden knowledge? Is the artist admitting that he has produced
only a simulacrum? All these are probably true, for Ethiopian talismanic art has always
simultaneously copied models revealed to a few celebrated sages, such as King Solomon,
and created images in response to particular situations.

Far from being an artist seeking his roots, Gedewon is one of the most skilled practi-
tioners of poetry and rhetoric in the Orthodox Ethiopian Church. He was initiated secretly
into talismanic art along with his religious studies. Reaching back as far as the origins of
Christianity in Ethiopia (i.e., to the fourth century), talismanic art draws on the same
Hellenic sources as Arab alchemy and the Jewish Kabbala. But while this art remained
embryonic in the Mediterranean world, the Ethiopians developed it considerably, perhaps
because they cleverly used it to cure patients whose ills they understood in terms of
possession by a spirit. Gedewon's drawings, like those of his masters, are meant to be seen
by spirits through the eyes of the human beings they inhabit.

According to Gedewon, talismans are a writing from before writing; they are at once
and equally figure and writing. Their prototype is the Seal of the Father, which is typologi-
cally the equivalent of the Cross of the Son. This art is one of the secrets that were stolen
from Heaven and revealed to humanity before the Flood. By a very long time it predates
figurative painting, which began with the New Testament and was intended to serve didac-
tic and mnemonic purposes. The talisman, on the other hand, is an image that operates
effectively on the visual level, as the names of God do on the auditory.

Gedewon uses combinations of revealed models, but also considers it necessary to
question the patient about the places he or she has been and about the visions he or she
had upon falling ill, in order to include these images in the talisman. Thus, red paint refers
to red earth; green, to papyruses, and so on: the talisman is a landscape that is both real
and oneiric. Upon seeing it, the spirit that attacked in the colors and places represented
flees—to return in another guise. This is why the one who draws must confront the
unforeseeable, thus creating a work that is all tensions. Such an aim is the opposite of
Western art's ideal of harmony.

In his "talismans of research and study," Gedewon is both the healer and—because of
his empathy—the patient, as well as artist and hallucinator in another's stead. The violence
his theory requires also informs his visions, including his visions on his own account, as if
he had adopted a theory that corresponded to his temperament, as if he were the man of
this knowledge. This strange body of work is entirely traditional and newly created, as
fluid as the spirit of its creator.

Jacques Mercier

Cherchebbi. 1977. Ink on paper, 12⅝ × 9½"
(32 × 24 cm). Paris, Musée National des Arts
d'Afrique et d'Océanie

Gedewon occasionally borrows images from comic
strips: the dog who appears in this drawing may be
copied from the work of the popular French cartoonist
Chaval and the person may be derived from those of
Altan, another comics artist. Gedewon incorporates
them into various disguises assumed by devils when
they come to attack humans in their dreams. Their
mention in prayers testifies to their potency as talismans.

The inscriptions around the edges indicate that

this talisman is the last of a series of seven. It must be
used "Saturday, Tuesday, and the seven days" of the
week. It is associated with prayers entitled
"Cherchebbi, Prayer to Swallow Up the Demons." For
Cherchebbi, red ink must go over the outline of a
drawing already made in black ink. This talisman is
also called "qatsabi," that is, "twitching, which is a
sign of a simulacrum."

In this drawing are inscribed fragments of
prayers written in a careless guèze (the liturgical lan-
guage of Ethiopia). This drawing of prayers is essen-
tially fragmentary. It consists of invocations and lists of
evils and of the names of God. They can be lengthened

or shortened at will depending on the space available.

At the bottom, to the right of the head in profile:
"I take refuge in the power of your Names, in your
Art, and in your Wisdom, in what you have created
and pronounced so that I am not approached by all
those who cast spells, the devils, the impure spirits to
the North, to the South. . . ."

In the middle, at the left, under the two opposed
faces: "The Word of God, by the power of the Word of
God, by great Praise, the Word of God makes the cedar
tremble, the Word of God puts out the flame. . . ."

J. M.

Datraemir. 1975. Ink on paper, 39⅜ × 27½"
(100 × 70 cm). Private collection, Paris

*Datraemir (in the center), an aerial devil
inhabiting the mountains, receives the baleful
word (depicted in folded wings) and transmits
it to the spirits living in the water, the deserts,
and the ravines. These spirits, taking on vari-
ous appearances—as birds, flowers, snakes—
spread their poison among humans.*

The Earth: The Four Parts. 1992. Ink on paper,
20⅜ × 29⅝" (52.5 × 75 cm). Private collection, Paris

*The four sections correspond to the four periods of
human existence: before the Flood (colored section),
in the Flood with Noah (top right), the reign of King
Solomon (plants), and (bottom right) finally, the era
of Christ (cross).*

Twins Seven-Seven

Born 1944 in Ogidi, Nigeria

Lives in Oshogbo, Ogun
State, Nigeria

Twins Seven-Seven in Oshogbo,
Ogun State, Nigeria. 1990

Though his given name is Taiwo Olaniyi Salau, Twins Seven-Seven has chosen this pseudonym as a reference to his birth: he is the sole survivor of a line of seven sets of twins. (As was mentioned in connection with Zinsou [see page 34], twins in Fon and Yoruba cultures have special abilities denied to ordinary people.) First attracted to music and dance, Twins Seven-Seven has cut numerous records, gone on several tours abroad with his group, and today continues to practice his music (along with other activities such as politics and business).

His encounter with the graphic arts and painting came about somewhat by chance: it occurred in 1964, in Oshogbo, a town in the southwest of Nigeria, where Twins Seven-Seven had gone to dance. On the occasion of a celebration, he met a group of artists known as the Mbari Mbayo Club, founded by Ulli and Georgina Beier. This is where the Oshogbo School had its origins.

Twins Seven-Seven began by drawing on paper. Drawing and engraving have remained a constant and central reference in his work. The originality of his line comes from the fact that it appears to unfold blindly, with no plan, through a progressive invasion of the entire surface. Undoubtedly, this technique plays a role in giving his canvases their extraordinary wealth of detail. In some aspects, among them this total saturation, his art evokes that of certain practitioners of *art brut* (Augustin Lepage, a French naïve painter of the nineteenth century, used a very similar technique, which led him to fill every inch of the canvas).

A major change in the work of Twins Seven-Seven came when he began to transpose his drawings onto large sheets of plywood. In this way he combined the techniques of cutouts and collage, achieving the latter by stacking up sheets of plywood (as many as three) and including objects (newspaper clippings, bottle caps, and so forth).

With the exception of a few paintings which represent "profane" themes (for example, a satirical painting that portrays politicians as animals), the universe of Twins Seven-Seven is thoroughly rooted in Yoruba visionary imagery, both religious and folkloric. In this regard, the very rich pantheon of the Yoruba religion constitutes a powerful stimulus to creation, verbal as much as pictorial or sculptural. Jean Kennedy has quite properly warned against the frequent assertion that the novels of the Yoruba writer Amos Tutuola (also a self-taught man) have influenced the work of Twins Seven-Seven. Rather than speaking of an influence, it would be more suitable to speak of a convergence between two bodies of work that draw from the same source, characterized by its high spiritual content. Between the world of spirits and that of the living, between the natural and the supernatural, the real and the mythic, the exchanges are constant, both in the work of the writer and that of the painter.

J. S.

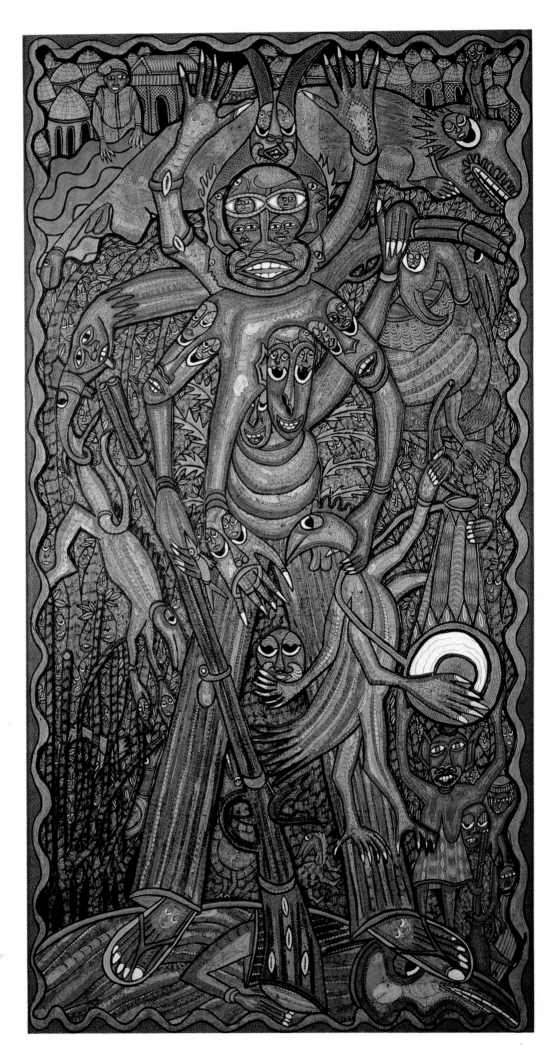

Untitled. 1990. Ink on plywood with plywood collage, 96⅛ × 48″ (244 × 122 cm). Collection Jean Pigozzi

Hunters and the Father of Beasts.
1991. Ink on plywood with
plywood collage, 45 ¼ × 45 ¼"
(115 × 115 cm). Collection
Mr. and Mrs. Tsuk, Paris

Assembly's Headache. 1985. Ink
on plywood with plywood collage,
50 × 98 ⅜" (127 × 250 cm). Private
collection, Paris

Tattoos/Body Rituals. 1990. Ink on plywood with plywood collage, 48 × 96⅛″ (122 × 244 cm). Collection of the artist

Three Wise Ocean Gods: Air, Sea, Nature Controller. 1990. Ink on plywood with plywood collage, 48 × 96⅛″ (122 × 244 cm). Collection of the artist

Johannes Maswanganyi

Born 1937 in Msengi, South Africa

Lives in Blinkwater, Giyani district, the Gazankulu, South Africa

Johannes Maswanganyi collects Peugeots, not necessarily out of brand loyalty, but more out of appreciation for their engineering, which appears to cope with the dirt roads of Msengi—his birthplace and a chieftainship (administrative area) straddling Blinkwater, where he now lives, in the Giyani district of the Northern Transvaal. As one engine wears out, it is replaced with one from another wreck.

The same process of renewal functions in terms of his profession. His father (and uncle) were woodcarvers supplying villagers with carved spoons, bowls, and *jsuri* (hollowed-out tree stumps in which corn is ground). So too his son, Colin, is undergoing an art apprenticeship under his father's guidance.

However, it was the change in his clientele, from local villagers to distant gallery-goers, that wrought the changes that helped Maswanganyi buy his first Peugeot. Not only were art patrons prepared to pay more, but the market for wooden household objects had dried up as a result of the availability of cheap plastic goods. Following his exposure in the *Tributaries* exhibition in 1985 and the *Out of Africa* exhibition at the University of Cape Town Irma Stern Museum in 1986, Johannes Maswanganyi suddenly found that he was being sought out as an "artist" rather than a "woodcarver."

Not everyone is happy about this development. The intrusion of deeply urban themes—*Jewish Wedding* (1985), *Peter Tosh* (1989)—and his signature writ large on the bases of his sculptures leave owners of his so-called *sangoma nyamisoro* (healer dolls) feeling that their authenticity as "tribal" pieces has been compromised. As S. L. Kasfir has observed in respect of dealers in African art, "'authentic' frequently means 'anonymous.'" Maswanganyi's dolls are, however, unique. Whereas healers in the area keep medicines in small gourds or bottles, Maswanganyi is adamant that Soweto-based healers prefer his naturalistically carved dolls.

An explanation of the term *sangoma nyamisoro* is needed here. Among the Shangaan people and the Sotho of South Africa, throughout the Bantu area, a *sangoma* is what used to be called a "witch doctor." A more appropriate term would be "traditional healer"—someone who heals by divination and herbalism, using traditional medicines found in plants, roots, etc. *Sangoma* dolls are carved effigies of people that sometimes have cavities for storage of medicine, or "power." Maswanganyi's *nyamisoro* always have a place for storing medicine.

The beaded cloth wand the figures hold, called a *chovo*, is said to be used for anointing patients with oil from the *nlampfurha* tree. The pits from the fruit of the tree from which the figure is carved (often the marula, *Sclerocarya birrea*) are used by *sangoma* as divining dice.

Maswanganyi's figures are carved from a single piece of wood—in addition to marula, kudu berry (*pseudolachnostylis maprouneifolia*). Most often, the base is also part of the same piece of wood as the rest of the sculpture. After a perfunctory curing period, the pieces are painted with enamel. Since works are prepared in batches, the painting process takes place at one time. In this way, a particular shade of, say, yellow would be used until the paintpot is empty.

Prior to its being bought or removed to a gallery, Maswanganyi's work is available to members of the community. Teachers at the nearby Haacke High School, as well as other residents of Blinkwater, see his work as a kind of social page in what could be called the local "newspaper." People are able to recognize themselves through Maswanganyi's stereotypical parody of their foibles and mannerisms.

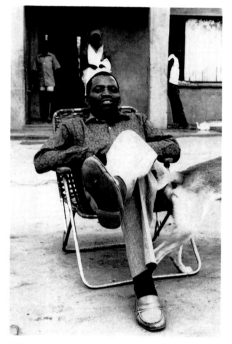

Johannes Maswanganyi in Blinkwater, South Africa. 1990

Although carved and painted at the same time in 1989, the four figures *Rich Man*, *Woman at Home*, *Man with Closed Eyes*, and *Soccerman* were not intended to be viewed as a group. It is, however, as a group that the figures gain their power. *Rich Man* contains none of the vanities of fame attendant on an attempted self-portrait. For one thing, Maswanganyi is much older, and second, for all his success, he remains a poor man. In its observation of the proper attitude of a successful black businessman in South Africa, his sculpture captures the right degree of deference toward his benefactors.

Maswanganyi's smaller pieces (of which the figures in the group are an example) display a greater degree of detail than do the larger, more recent works, in which he is content to indicate ties, belt loops, and the like by painting them. Inexplicably, the goalie depicted in *Soccerman* is holding not one, but two footballs. The geometry of their construction appears to have defeated the artist.

Maswanganyi is religious and attends the Assemblies of God Church near Giyani. This accounts for his interest in biblical stories and the astonishing work in the South African National Gallery collection entitled *Moses and the Burning Bush*. Here the artist has overcome the limitations imposed by the size and girth of available timber by using two logs: Moses is pictured as being both erect (ready to receive the covenant) and supine, as the afterimage of an already burned bush.

In a curious inversion of the way flames seem to lick at the surface of burning logs, Maswanganyi has driven branches into the trunk of the spirit figure. This gives the impression that the flames come from within the soul of the supine figure. In another reading the flames are indicated solely by the pink glow which bathes the entire piece.

A mixture of defiance and appeasement is apparent in the series of works depicting political leaders from the heyday of Nationalist rule: Magnus Malan (Minister of Defense) and Pieter Willem Botha (Prime Minister, State President) among them. Maswanganyi's carving of ex-President Botha, *PW and His Chief's Blanket*, is symptomatic of this ambivalence. On one level the sculpture is a piece of sly flattery. On another level, the subversive elements of parody are evident. His pink features and sightless, all-white lenses carry more than a trace of satire. The green painted "blanket" carried over his left arm is his badge of office as a chief of the white tribe. This transference of cultural signifiers from Maswanganyi's Tsonga background to that of the Afrikaner lends the piece its special defining power.

Gavin Younge

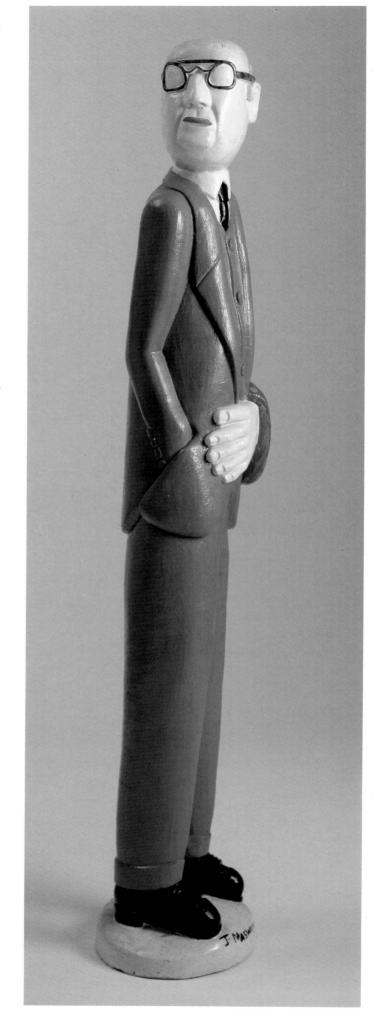

PW and His Chief's Blanket. 1988.
Enamel paint on wood, 52 × 8⅝ × 8⅝″
(132 × 22 × 22 cm). Private collection

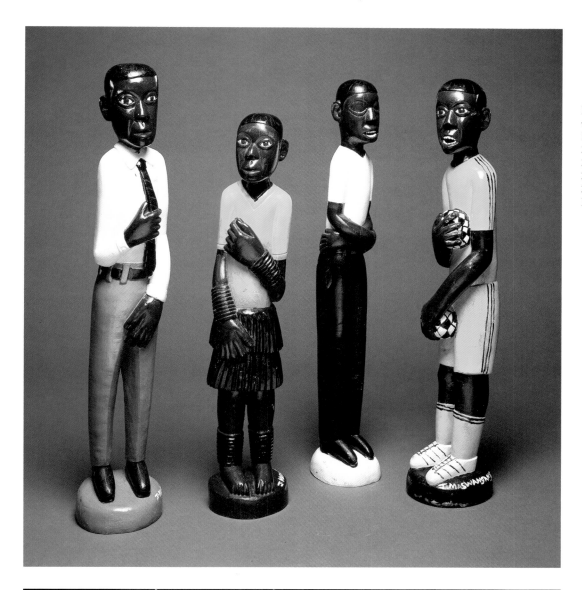

Rich Man, Woman at Home, Man
with Closed Eyes, Soccerman. 1988.
Enamel paint on wood, respectively
36¼ × 5⅞ × 5⅞" (92 × 15 × 15 cm),
32¼ × 6⁵⁄₁₆ × 5⅞" (82 × 16 × 15 cm),
34¼ × 5⅛ × 5⅞" (87 × 13 × 15 cm),
34¼ × 7⅛ × 5⅞" (87 × 18 × 15 cm).
Private collection

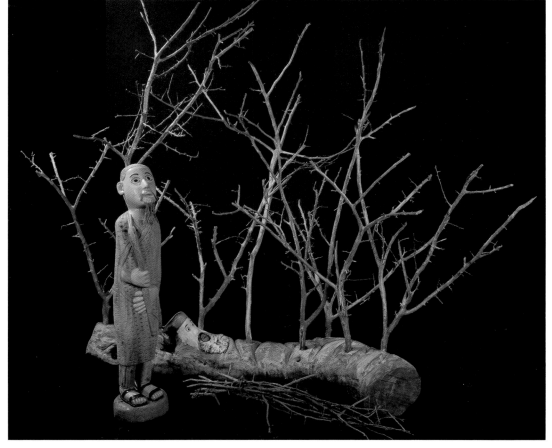

Moses and the Burning Bush. 1989.
Enamel paint on wood and mixed medi-
ums, 84¼ × 82⅝ × 66⅞" (214 × 210 ×
170 cm). Collection South African
National Gallery, Cape Town

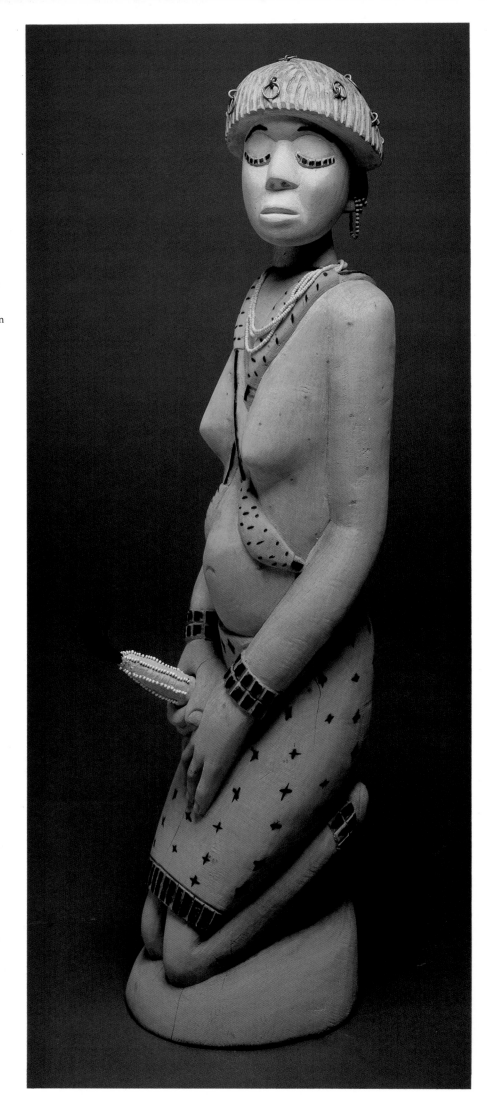

Nyamisoro Figure. 1988. Wood, scorched wood, and glass beads, 334¾ × 74¾ × 102⅜″ (850 × 190 × 260 cm). Private collection

FRONTIER

Sunday Jack Akpan

Born 1940 in Ekot Ide Etukudo, Nigeria
Lives in Ibesikpo-Uyo, Akwa Ibom State, Nigeria

Sunday Jack Akpan in Ibesikpo-Uyo,
Nigeria. 1993

Originally trained as a mason, Sunday Jack Akpan continued to use a mason's material—cement—when he turned to creating large funerary sculptures. It was in a dream that Akpan first felt his calling as an artist—a common experience among African artists, especially those who are self-taught. This need to find the origin of his vocation within himself is surprising since Akpan's art is connected to a tradition of funerary sculpture that is both very ancient and very extensive across the African territory. Although funerary sculpture in cement goes back only to the period between the two World Wars in West Africa, it has its roots in the age-old religious practice of representing the deceased in a more or less realistic effigy made of wood or earth. Such sculptures are found in the area extending from the Ivory Coast to Zaire, passing through Ghana, Togo, Benin, and Nigeria. In the southeastern region of Nigeria, between Uyo and Calabar, where Sunday Jack Akpan lives today, many other sculptors also practice this commemorative statuary art.

Several characteristics, however, differentiate Akpan's art from that of his "rivals," Aniet Okon Akpan and Akan Edet Anamukot, for example. Unlike them, Sunday Jack Akpan strives toward naturalism, a concern clearly reflected in the wording of his business card, which reads: "Natural Authentic Sculptor." In order to attain this naturalism or realism, Akpan often refers to a photograph of the deceased when sculpting. Not only the face, but also the adornments and the dress and finery worn, are rendered in luxuriant detail, which makes these sculptures authentic anthropological documents on the Ibibio and Ibo cultures in particular.

A kind of "living catalogue" of Akpan's sculptures is found in his studio. Piled up by the hundreds on the ground floor of his house, they form a sort of museum that evolves through time (by accumulation or destruction) and permits potential clients to make their choice. A panoply of portraits molded in cement reside in the studio, as well as several examples of sculptures, either rejected by their clients or else produced solely to show off the sculptor's talent. The presence of several apprentices (not to speak of the occasional help his wife extends) allows the artist to have this vast and costly display. Sunday Jack Akpan has always confirmed his independence with regard to commissions in this way, even though they constitute the main source of his income.

The funerary theme, heavily dominated by the figure of the traditional chief, forms only one part of Akpan's production. Another important part deals with "profane" sculpture (an eagle, a nursing woman, a woman carrying a water jug, a soccer player, a military man, and so forth), meant to decorate private or official buildings and gardens of notable people's villas or to enrich contemporary art collections in Europe and the United States.

On the technical side, Akpan begins his sculpture right on the sand, forming the cement in pieces, which he later assembles. While the figure's limbs are solid, the abdomen is hollow. For very large sculptures Akpan uses iron armatures. Today, in dividing up the work in his studio, Sunday Jack Akpan tends to concentrate his efforts on the face and the painting of the subject—in a way, the noble part of the work.

J. S.

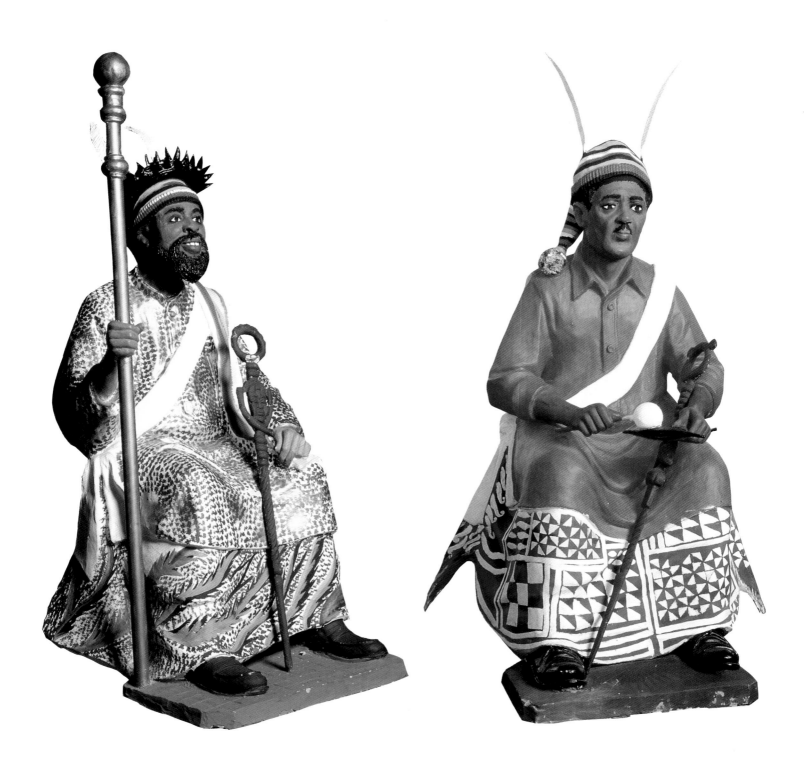

Portrait of a Seated Chief. 1989. Reinforced concrete and industrial paint, approx. 68¼ × 27½ × 27½″ (173.5 × 70 × 70 cm). Musée d'Art Contemporain, Lyons, France

Portrait of a Seated Chief. 1989. Reinforced concrete and industrial paint, approx. 66⅞″ × 27½ × 35⅜″ (170 × 70 × 90 cm). Musée d'Art Contemporain, Lyons, France

Traditionally Dressed Figure, Soldiers, Businessman. Sculptures in front of Akpan's studio. Ibesikpo-Uyo, Nigeria. 1993

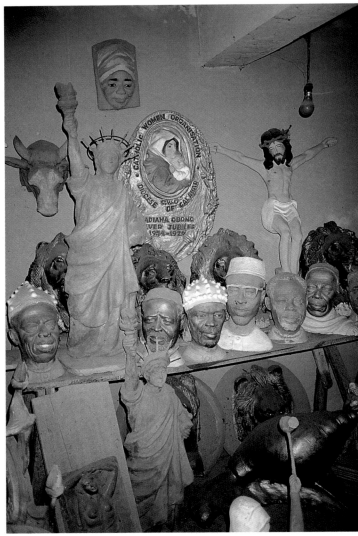

Interior of Akpan's studio, with commissioned portraits in the foreground. Ibesikpo-Uyo, Nigeria. 1993

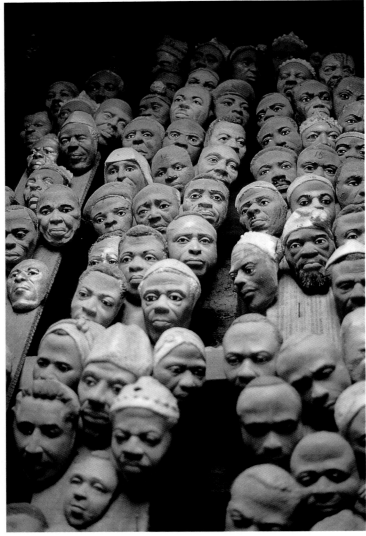

Sculptures of heads in Akpan's studio. Ibesikpo-Uyo, Nigeria. 1993

Agbagli Kossi

Born 1935 in Amoutivé, Togo
Lived in Lomé; died 1991

Agbagli Kossi in Lomé, Togo. 1990

Born in the house where he always lived, in the heart of a "district-village" long since joined with and absorbed by Lomé, Agbagli Kossi populated the courtyards, enclosures, sanctuaries, and altars of lower Togo and Ghana with innumerable creatures of faith, nostalgia, and dreams over a period of about thirty years.

An initiate of the Mamy Wata cult, Agbagli held an officiating role of modest rank as therapist, priest, and sacrificer in this syncretic religion, which today is deeply implanted on the shores of the Gulf of Benin, from Lomé to Ouidah, from Accra to Cotonou.

Agbagli was never attracted by the so-called modern school, and he lived frugally, creating only when commissioned by traditional patrons or foreigners.

Agbagli Kossi was already twenty-six when, as he liked to tell it, one day in the forest the *vodun* Agué revealed to him that henceforward he would guide his destiny, and his sculptor's hand in particular. Was Agué a family idol? No, but since Agbagli's father, a traditional diviner, had died without ever seeing his son, Agué became Agbagli's demanding and faithful inspirer until the end of the latter's life.

In his visible form, Agué is an astonishing little wooden character, hairy and dusty, decorated with strings and cowrie shells. Agbagli used to summon Agué by whistling, in order to confide his wishes and his worries, to divulge the names of his enemies, and to solicit his support, never neglecting to make the sacrifices required to renew the pact of allegiance that united them. Agué seems to remain in the service of Agbagli's sons, who, courageous and inspired with new ideas, have already picked up their father's torch.

This is not the place to introduce the prolific *vodun* pantheon. From among five or six hundred minor earth and water divinities, I shall limit myself to evoking the figures most representative of Agbagli Kossi's art.

Color plays an essential role in his art—whether revealed to him in a dream or chosen by his client. The three "primary" colors in his work are pink, white, and black; green or yellow seldom appear. Pink appears by far the most often in Agbagli's work. The most frequent subject is Mamy Wata,* a sea or river goddess, alluring in somewhat the manner of the sirens, sometimes on horseback, escorted by a whole group of aides, bodyguards, liaison officers, and scouts that are frequently three-headed (triads are legion in the *vodun* pantheon), wrapped in ribbons of green and red serpents fed on raw eggs.

What is mysterious is the affiliation, or simply the influence, that indisputably connects many of these figures to popular Hindu imagery, which is said to have brought forth an aesthetic renewal here a few decades ago, harmoniously assimilated through the universe of the traditional African forms. (One must recall, in this connection, that many Indians immigrated to the west coast of Africa.)

Many of Agbagli's sculptures are painted in black and very shiny, with a lovely chocolate-brown lacquer, depicting people of every walk of life and all ages: forest diviners; bare-breasted *vodunsi* servants; followers of the god of thunder, or iron, or smallpox, wearing a narrow G-string and a red tiara made of parrot feathers; drummers; cursed hunters in

The Messenger. 1991. Painted wood, 25¼ × 11⅜ × 14⅝" (64 × 29 × 37 cm). Collection Jean Pigozzi

Dressed and decorated in the Ewe/Akan style, almost as richly as the chief himself, he wears jewels on his cap and sandals. The stick and the key he is holding signify the direct summons from the person whom he is visiting.

P. D.

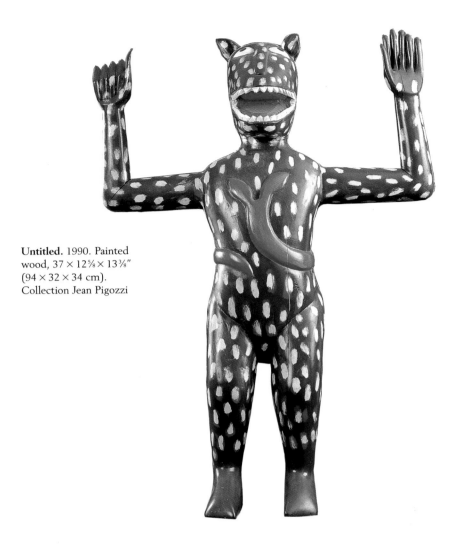

Untitled. 1990. Painted wood, 37 × 12⅝ × 13⅜" (94 × 32 × 34 cm). Collection Jean Pigozzi

Opposite page left:

Ayo. 1990. Painted wood, 42⅛ × 30¼ × 10¼" (107 × 77 × 26 cm). Collection Jean Pigozzi

Either male or female, the Ayo generally are three-headed, and their existence is closely bound to that of Densu and Yasu, two spirits of the vodou *in Togo. Densu takes the form of a serpent, a six-armed supernatural being associated with water. Yasu is a female and may have two or three heads. Followers of these cults claim that some beings exist with nine or even sixteen heads. Both are syncretic figures related to Hindu deities.*

The Ayo are helpers, servants, escorts, or pilots for Densu and Yasu, by virtue of a kind of alliance they have drawn together. The Ayo characteristically wears a coiled serpent on each of its three heads; the snakes watch out for possible dangers and warn Densu and Yasu promptly. This Ayo carries red male snakes on its body, which are fed with eggs.

P. D.

whom "evil mortals," killed by iron and steel, have been reincarnated; chief justices; jealous husbands and unfaithful wives, humbly prostrate as they await judgment; elegant princes or old, tired farmers; executioners with their threatening cutlasses or royal messengers, bearers of the key that is symbolic of an immediate convocation.

Agbagli also sculpted great numbers of the *venavi* statuettes of twins ("child-of-a-mother-of-two"), which are to be fondled, pampered, rocked, carefully dressed, and fed with beans. These are the wide-eyed, mute but demanding substitutes for a deceased twin, which the mourning mother will carry everywhere and as long as necessary in the knots of her belt in order to prevent the dead twin from tormenting his or her surviving sibling. The cunning and silent *venavi*, often also in groups of a dozen at the foot of *vodun* altars on the Togolese coast, soon invaded the verandas and living rooms of admiring foreigners.

A servant of a still vigorous traditional religion, Agbagli Kossi never gave in to the relatively easier alternative of the statues in *colon** style, which he left to others, more businesslike and more "modern"—besides, would Agué have permitted it? His creatures, even those destined for resident or traveling foreigners, were always endowed with a specific magic treatment that left no visible trace; it would have been necessary to cut his statues in two in order to discover the hiding place of what he had buried there.

Toward the end of his life, Agbagli clearly no longer had the health he enjoyed at thirty: his hand used to tremble terribly, but when he had company, even though he lay feverish on a dirty mat right on the ground, his wink lost nothing of its mischievousness, reassuring the impatient client or affirming that, more than ever, he sacrificed to Agué to perpetuate his good graces.

Today, without any doubt, the "vital spirit" of Agbagli, who died in 1991 and was buried in accord with the appropriate funerary rites, has been admitted into the venerable company of ancestors—eternal guarantors of the maintenance of the "relationships of man with his invisible foundation" (Albert de Surgy).

Philippe David

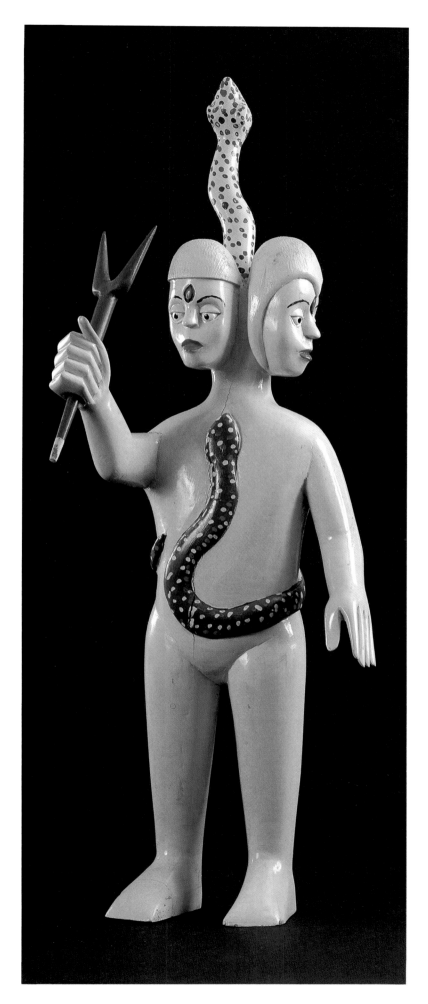

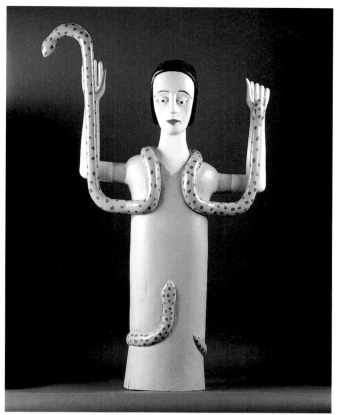

Mamy Wata.* 1990. Painted wood, 47¼ × 32⅝ × 11⅜"
(120 × 83 × 29 cm). Collection Jean Pigozzi

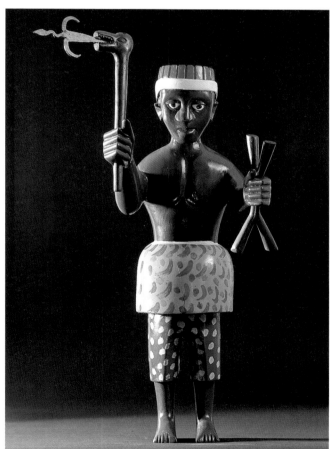

Heviessovi. 1990. Painted wood, 29⅛ × 15¾ × 14⅛"
(74 × 40 × 36 cm). Collection Jean Pigozzi

Female servant of Heviesso, vodun of thunder and lightning.*

Kane Kwei

Born 1924 in Teshie, Ghana
Died 1991 in Teshie

Samuel Kane Kwei

Born 1954 in Teshie, Ghana
Lives in Teshie

Kane Kwei in Teshie, Ghana. 1987

Samuel Kane Kwei in Teshie,
Ghana. 1993

The death of a close relative whom he wanted to honor was for Kane Kwei, a cabinetmaker, the occasion for making his first decorated coffin. The population of Teshie, an outlying district of Accra, was most impressed by the funeral procession dominated by the fishing boat in which the deceased rested. Several years passed, however, before a family came to order a coffin similarly decorated for a deceased person to whom it wished to give a last homage of a very special kind. Today the use of Kane Kwei's coffins has become so widespread that every well-to-do family in Teshie has its dead buried in a coffin that recalls the activity or an event marking the life of the deceased.

Subjects he fashioned into these memorials include boats, houses, eagles, fishes, elephants, crawfishes, onions, and mother hens and chicks. These coffins, made of light wood painted in bright colors, have in common the fact that they lengthen the shape of the object re-created. The most famous one among them—later reproduced on several occasions—is, without a doubt, the coffin in the shape of a white Mercedes, because it touches upon an object of desire and power common both to Africa and Europe: the automobile and its mythology. The original was supposedly made for the funeral of the owner of a cab company.

Although some may consider him a craftsman, Kane Kwei ranked himself among creative artists because of his inventiveness. He also designed furniture, mainly stools, an important object in Ashanti culture as a traditional symbol of political power. In the example here, the part underneath the seat represents interlaced and painted fruits or animals. Its structure evokes that of the royal Ashanti thrones and ingeniously renews the formal vocabulary.

Although Kane Kwei was led to create new images for his coffins in response to the demand, today one finds in the market stalls of his students, who came to him in droves, that the repertory has shrunk notably. Happily, the work of his son Samuel displays some of the fertility of mind and high spirits of his father.

Jean-Hubert Martin

Opposite:
Kane Kwei. Installation. 1993. Haute Chapelle,
Château de Oiron, Deux-Sèvres, France.
Collection Grande Halle de la Villette, Paris

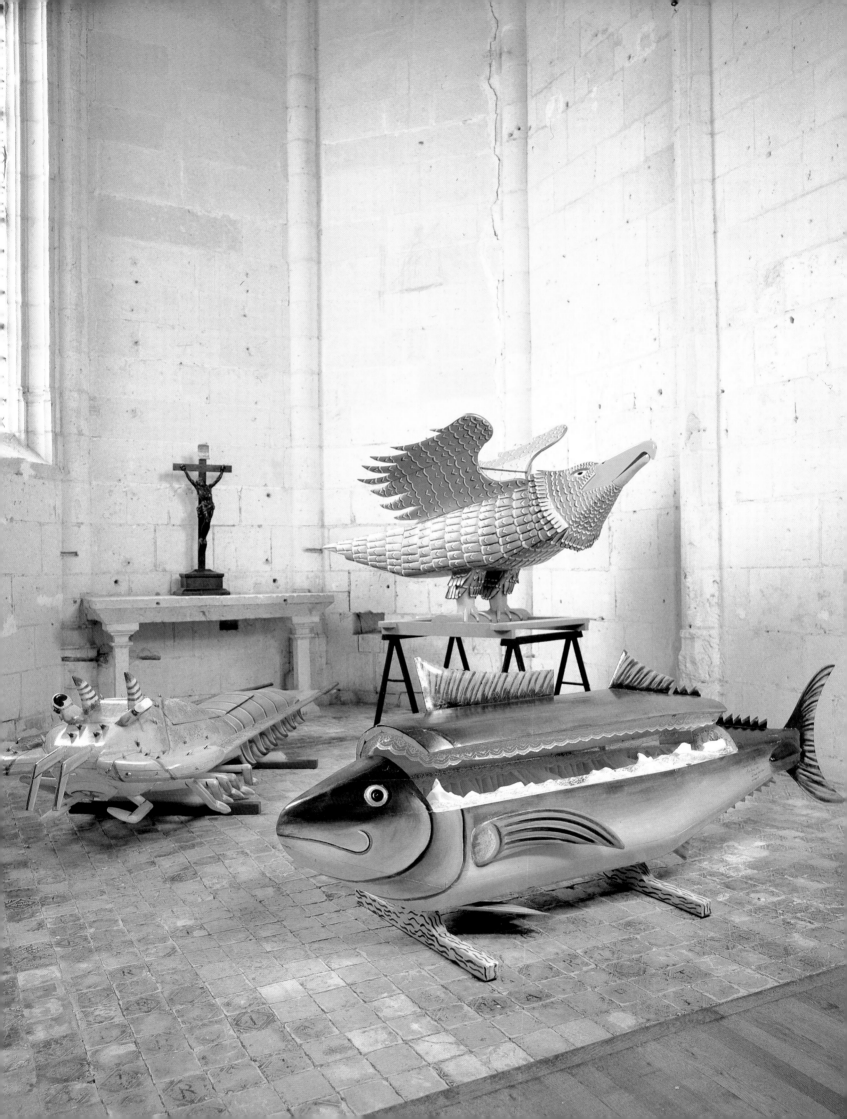

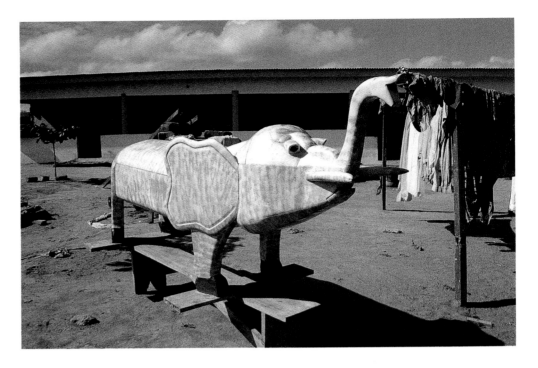

Kane Kwei. **Elephant-Shaped Coffin.** 1988.
Enamel paint on wood, 43¼ × 94½ × 31½"
(110 × 240 × 80 cm). Collection Grande
Halle de la Villette, Paris, France

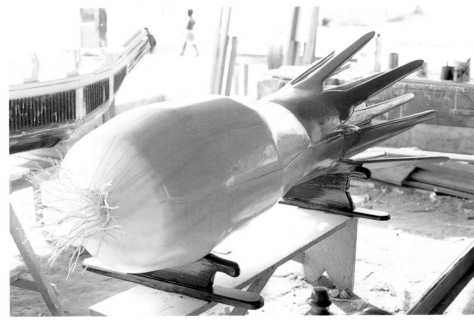

Samuel Kane Kwei. **Onion-Shaped Coffin.** 1993.
Enamel paint on wood, 27½ × 106¼ × 27½"
(70 × 270 × 70 cm). Collection Jean Pigozzi

Samuel Kane Kwei. **Mercedes Benz–Shaped
Coffin.** 1993. Enamel paint on wood,
27½ × 106¼ × 27½" (70 × 270 × 70 cm).
Collection Jean Pigozzi

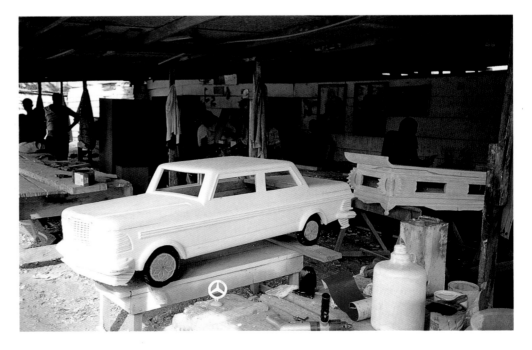

Zephania Tshuma

Born 1932 in Wanasi Mission, Filabusi District, Zimbabwe (Rhodesia)

Lives in Mberengwa, Zimbabwe

Zephania Tshuma in Mberengwa, Zimbabwe. 1990

Zephania Tshuma acquired his skills as an artisan and his knowledge of agriculture through seven years of schooling. After terminating his education to help support the family, Tshuma worked for four years as a postman and later began an apprenticeship in stonemasonry, which he never completed. Despite this, he worked for more than twenty-five years as a builder in southern Zimbabwe. About 1978 Tshuma began to carve sculptures in his free time as gifts for his neighbors and to sell in Bulawayo. Since then he has participated in exhibitions at the National Gallery in Harare, and his sculptures have been displayed in Botswana and in Denmark, Belgium, France, Italy, and Germany since 1988.

Tshuma's sculptures are scenes carved in wood that portray his reality, and his dreams, and his fears. He shows great humor as a storyteller, while also being a moralist able to look ironically at his own situation. His sculptures are a blend of humans and animals, as in fables or myths; his motifs are both biblical and profane, traditional and modern, political and commonplace. His characterizations of social behavior, human traits, and personal relationships express affectionate goodwill as well as a tinge of sarcasm. The members of his rural community see his works as parables, as lectures in good manners. For example, in *Danger Love* a young girl ignores the admonitions of her parents and is eaten by a man. The moral of the work is, "Girls, beware of unknown boys! . . . Listen to your fathers and mothers!"

Tshuma's work repeatedly addresses and reinterprets three issues: love, politics, and religion.

LOVE:

The series of works about AIDS began in 1988 with *Checking AIDS*, which depicts a large doctor examining the bottom of a significantly smaller patient. This subject is repeated until 1992, with the doctor becoming increasingly smaller while the patient grows larger. The patient becomes thinner, his facial expression more desperate. The AIDS worm, which is the cause of the illness, generally remains invisible to the people affected. A man bending to inspect his bottom does not see the worm, which is grinning as it looks out of his back.

Sometimes, however, the AIDS worm talks to people, as in the following story Tshuma wrote in 1991:

Man talking with AIDS worm

Yes, it is true that AIDS can talk because a lady can talk and a gentleman can talk. One night we were at the Bekezela bottle store. There came a well-dressed lady from Bulawayo. All of us were shocked trying to make love to her.

But the businessman won her because he had a lot of money.

She slept with him. In the morning he got his car to West Nicholson. The AIDS worm crossed the road. The man got out from his car. The AIDS worm called him and said: "I am inside your body, so you will die very soon."

The man said: "What do you mean? You are out of my body. Why do you say you are in my body?"

The AIDS worm answered, saying, "That lady you slept with is going to die. Also I am a killer, the bomb from heaven. The lady will die first, you are number two."

Snake Through Him. 1992. Painted wood, 30¼ × 6⅛ × 6½" (77 × 15.5 × 16.5 cm). Collection Jean Pigozzi

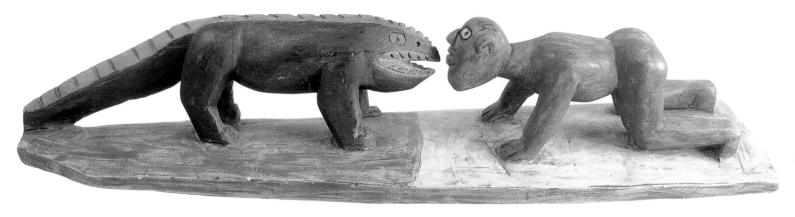

Do Not Be Friendly with AIDS Worm.
1992. Painted wood, 6⁵⁄₁₆ × 29⅞ × 6⅛"
(16 × 76 × 15.5 cm). Collection Jean Pigozzi

Please, please! AIDS talks and AIDS kills. Do not simply make love with everybody. AIDS kills.

"What can we do?" his lovers seem to ask in other sculptures. They embrace, but look unhappy about it. In *No, I Am Married*, a proud, somewhat uncertain-looking man demonstrates: *"I use condoms."*

POLITICS:

Reconciliation alludes to Zimbabwe's achieving independence, in 1980: A white man is sitting alone, but a black woman stretches out her arm in conciliation, and both are sheltered by a marriage canopy, the symbol of national unity. *Phoning West Germany* reflects on the situation of the poor in Zimbabwe. In this work Tshuma telephones to Germany and asks for help; for example, for a sewing machine for a women's group. The sculpture's coloration adopts Germany's national colors of black, red, and gold.

RELIGION:

Who Is God? and *Thinking About God* originated out of a discussion between a teacher from Tshuma's village and a European visitor: Is God a white man or is she black? Tshuma often depicts biblical scenes that also have a political meaning. For example, *Black Crucifixion* addresses the issue of the Christianized, colonialized African.

Jürgen Blenck

Playing on Her. 1991. Painted wood,
26⅜ × 6⅛ × 6½" (67 × 15.5 × 16.5 cm).
Collection Jean Pigozzi

Danger Love. 1990. Painted wood,
16½ × 5¹³⁄₁₆ × 6¹³⁄₁₆" (42 × 14.8 × 17.3 cm).
Collection Jean Pigozzi

Ngoy Mukulu Muntu (Mode Muntu)

Born 1940 in Lubumbashi, Zaire
Died 1982 in Lubumbashi

Mode Muntu in Lubumbashi,
Zaire. 1980

Mode Muntu spent his whole life in Lubumbashi, in southern Zaire, where he took courses at the Académie des Beaux-Arts. He exhibited his first work in 1958 at the Exposition Universelle in Brussels.

For a variety of reasons, Mode did not begin to paint with any regularity until 1972, when he attended the University of Lubumbashi, which employed teachers from around the world—especially Poland, Belguim, and France—whose instruction stimulated him. But it was another eight years before Muntu was able to paint steadily. In 1981 he became affiliated with the Museum of Lubumbashi, which provided him with a framework for working, materials, and a public. He created twelve paintings in 1982 on the traditional medicine of Luba-Shaba for the Zairian Surgery Association.

The Kenya district in Lubumbashi was the center of Muntu's life. He used to frequent the market every day and even sold cigarettes and canned goods there. It was there, too, that he found the source of his inspiration and a sense of security amid the crowds. The work of Mode Muntu comes out of this everyday life, but also from the Luba cultural tradition—a tradition rich in history, in art (which counts among the most prestigious of Africa), and in oral literature. The titles of Muntu's works attest to these two influences: *Using Mother's Milk to Cure Conjunctivitis in Newborns* was inspired by the practices of Luba culture; *Chatting Like the Birds Often Leads to Disorder* is a Luba proverb; *The Mountain Luba and the River Luba* and *The Mikalayi Spirits* also refers to the culture of his people.

Mode Muntu always followed the same process of creation for his works. He would first choose a solid background, whose color would vary according to the theme to be treated. Without concerning himself with symmetry, he would draw large straight or twisted silhouettes in pencil, turning the lips into a bird's beak for a cry or a word to be spoken. An elaborate overall pattern would repeat the central theme: canoe, tree, serpent, house. A snake's bite would twist the tree and its branches. Small motifs of recollection (house, ring, bird) are interspersed in every space, and the tiny surfaces themselves are full of little dots. He generally worked in gouache on cardboard, preferring its flat and rigid surface to that of canvas.

Guy de Plaen

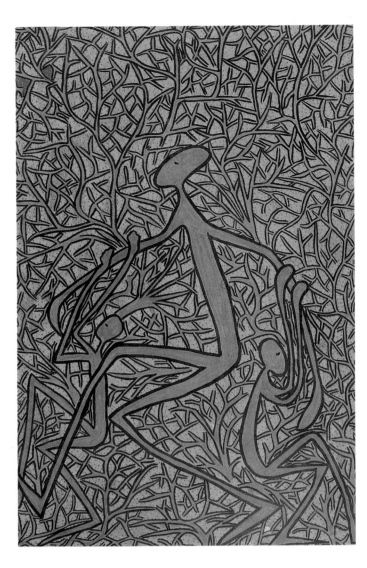

Using Medicinal Plants to Heal Circumcision Scars. 1980. Gouache on paper, 23⅝ × 18½″ (60 × 47 cm). Collection Guy de Plaen, Belgium

When There Is Work, the Village Expands. 1980–81. Gouache on paper, 23⅝ × 35⅜″ (60 × 90 cm). Collection Guy de Plaen, Belgium

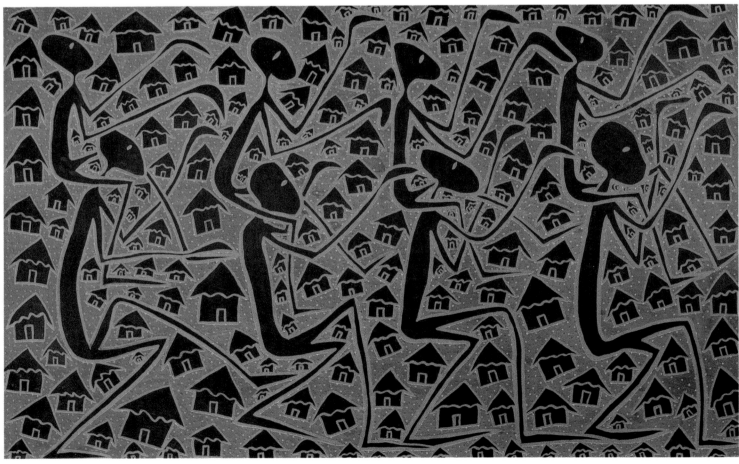

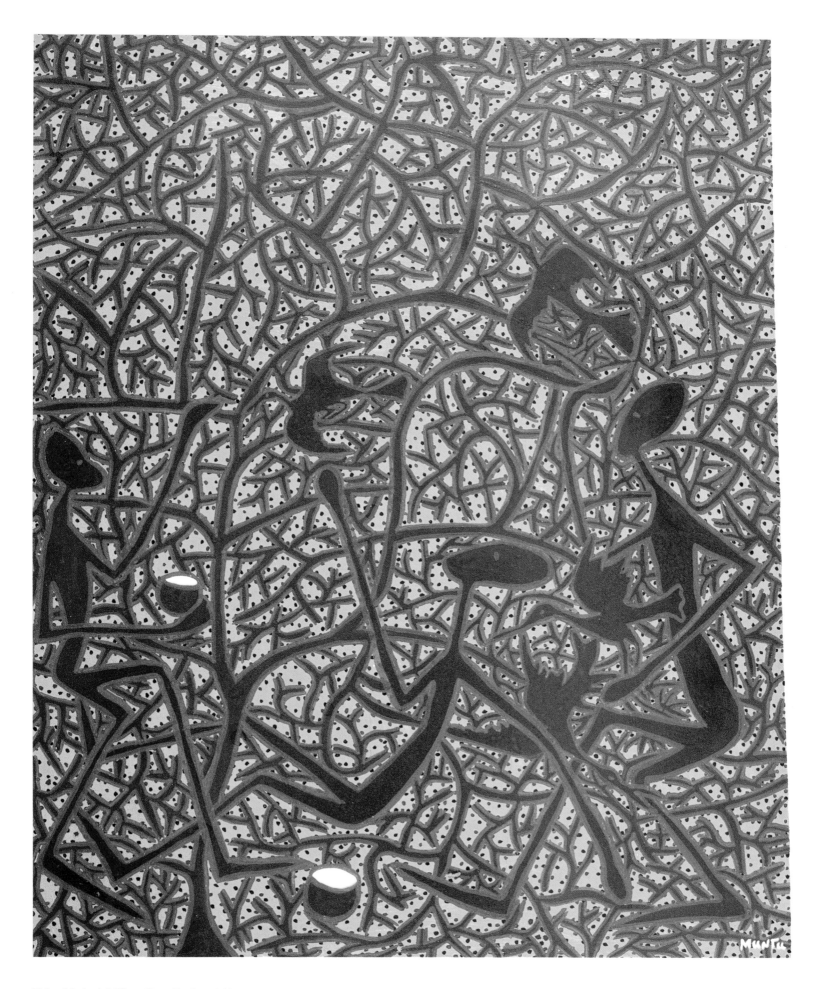

Using Mother's Milk to Cure Conjunctivitis in Newborns. 1980–81. Gouache on paper, 23⅜ × 20⅛″ (60 × 51 cm). Collection Guy de Plaen, Belgium

John Goba

Born 1944 in Marru Jong, Sierra Leone
Lives in Freetown, Sierra Leone

John Goba in Freetown, Sierra Leone. 1992

Opposite:
Untitled. 1993. Painted wood and porcu-
pine quills, approx. 55 × 39⅜ × 23⅝"
(140 × 100 × 60 cm). Collection Jean Pigozzi

Of Mende origin, John Goba grew up in an environment of
secret women's societies, such as the Bondo Society, in which his grandmother held an
important rank. As an adult John settled in Mountain Cut, a district in Freetown. This is
where, at the age of about thirty, he had a "revelation," as he explains it, that led him to
artistic creation, especially mask making. His first efforts quite naturally bear the mark of
a childhood and adolescence spent in the heart of a traditional society deeply attached to
its beliefs, meant to ensure its continuity and, at the same time, to protect it against
possible outside attacks. An essential role in this social regulation is played by the masks
and the ceremonies associated with their "coming out." The masks (the term includes the
full costume) are kept for most of the year in a sealed building. Yearly, at the time of the
initiation rite, the masks are put on and come out into the view of everyone. The experience
is usually frightening, occasionally friendly. This is the first step in the performance known
as a masquerade. In any event, it is not to be witnessed by women.

Even in his creations meant for such societies, which presumably favor traditional
renderings, John Goba gives proof of a tremendous power of plastic inventiveness that links
formal elements borrowed from totally foreign worlds. For example, one of Goba's masks,
created in 1979 for the hunters' society, combines the iconography of the robot, inspired
by a science fiction film, and that of an egba* Yoruba mask, brought over in the beginning
of the nineteenth century to Sierra Leone and assimilated into the local rituals (see John
Nunley's article cited in the bibliography).

Many of John Goba's masks are used in the contemporary social ritual of creation
performed by the Ode-lay Society. The masquerades performed by this society of young
city-dwellers of different ethnic origins aim to affirm group solidarity within a new social
environment and, at the same time, assert their emancipation. The Ode-lay masks and
dress are characterized by ornamental exuberance that often incorporates totally unex-
pected materials (such as Western Christmas tree decorations) in order to obtain the most
spectacular visual effect.

In Goba's most recent creations there are again certain traits that are characteristic of
the Ode-lay masks, but considerably expanded this time—protuberances that sprout from
the heads of human and animal figures forming the mask and ending in a bouquet of
antennae made of the spines of porcupines. Each sculpture, John Goba likes to say, has its
own history to which only the artist holds the secret.

J. S.

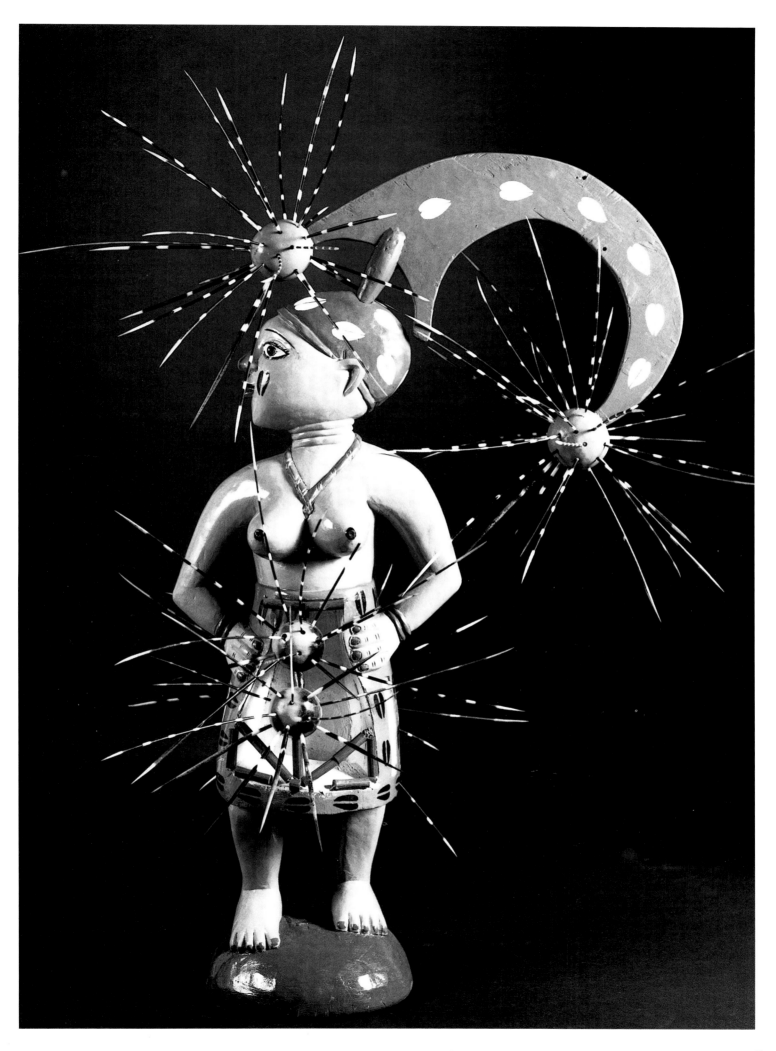

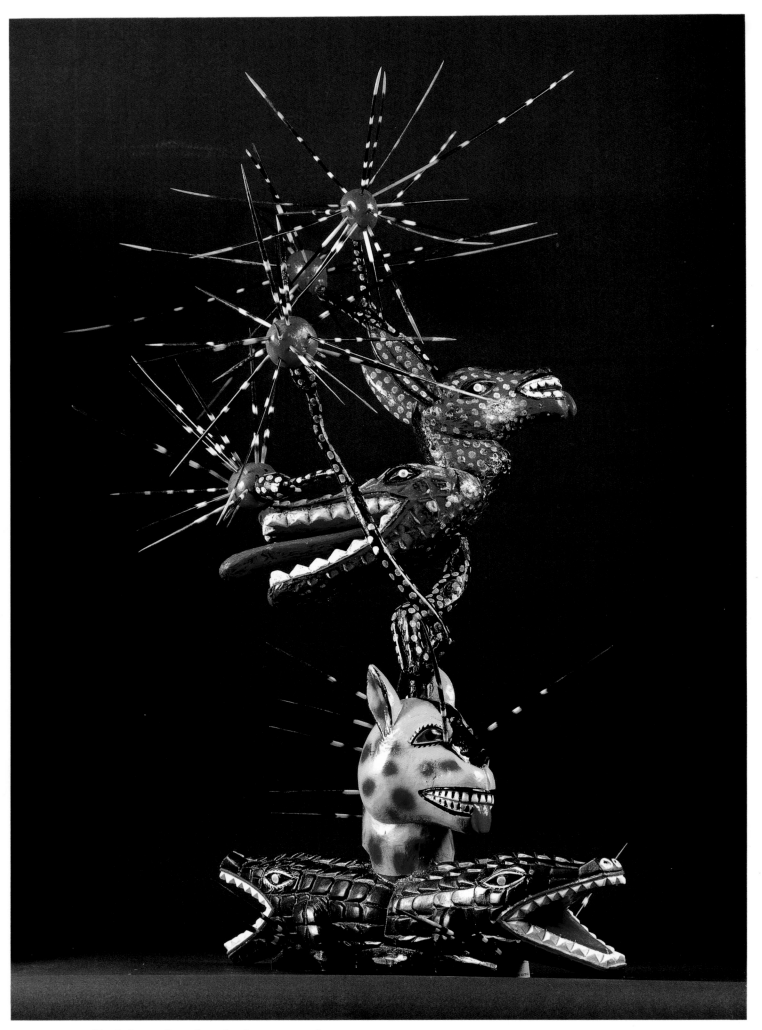

Untitled. 1992. Painted wood and porcupine quills, approx. 49½ × 27½ × 31½″ (125 × 70 × 80 cm). Collection Jean Pigozzi

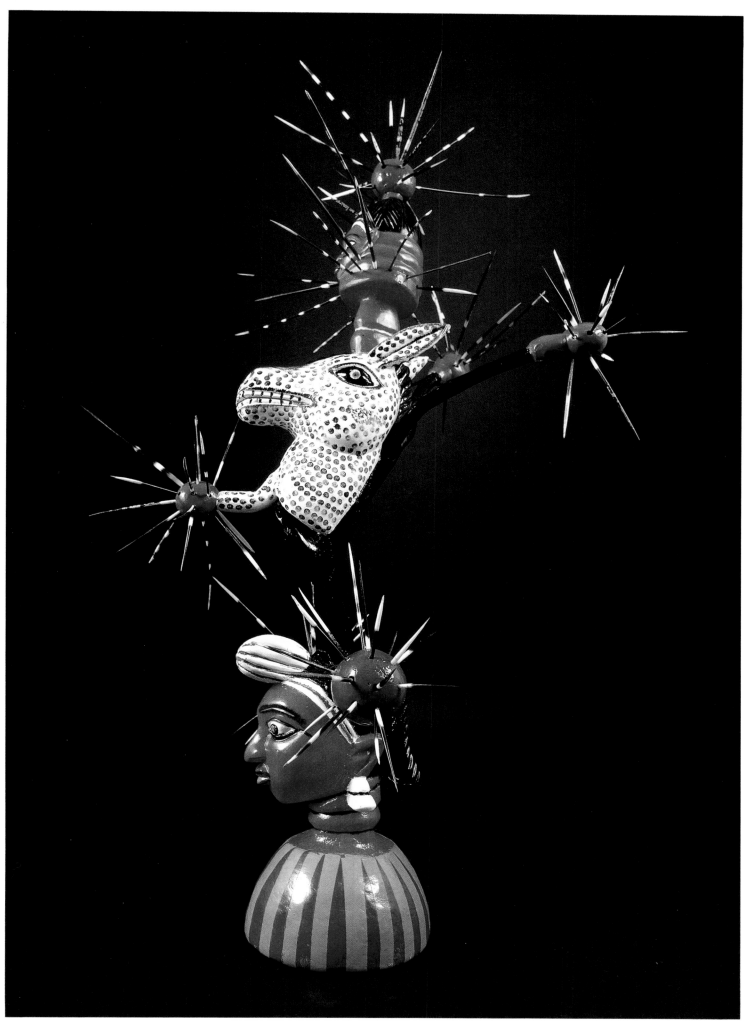

Kukujumuku. 1992. Painted wood and porcupine quills, approx. 51⅛ × 23⅝ × 25⅝" (130 × 60 × 65 cm). Collection Jean Pigozzi

Amadou Makhtar Mbaye

Born 1945 in Rufisque, Senegal
Lives in Dakar, Senegal

Amadou Makhtar Mbaye in Dakar,
Senegal. 1992

**Box No. 5: Xamb Mi (The Sorcerer's
Retreat).** 1993. Wood and mixed mediums,
20⅛ × 20⅞ × 20⅞" (51 × 53 × 53 cm).
Collection Jean Pigozzi

Xamb *literally means altar where Pangols**
rites are performed.

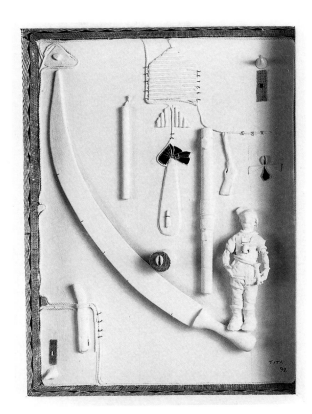

I have always had a passion for the theater, especially historical theater. These "theaters in boxes," as one might call them, put situations on the stage that belong to the history of Senegal [beginning in the twelfth or thirteenth century]: King Daaw Demba Faal, his brother Kocc Barma Faal, [two sages,] the philosopher Ndiadiane Ndiaye, the war chief Lat-Dior Diop, the Battle of Dexxële, El Hadj Omar Tall, Moussa Molo, and the sad Tuesday of Ndeer under the reign of Brack Amar Mbodj. Several signs appear during the course of reading these scenes which have a visual, philosophical, and religious meaning beyond the purely historical aspect. For example, fruits symbolize the everlastingness of beings; the geometric motifs, an integral part of African aesthetics, indicate either rhythm (broken lines) or melody (curves). The majority of the costumes of African royalty actually come from elements of these two signs: one rhythmical ∿∿∿, the other melodic ∿∿∿ or △ + ⌒ : ⌒, which refers to the shape of the dwellings of the Sahel.

These boxes can be contemplated from very different points of view: the initiate recognizes his roots in this sort of theater of the memory, and the layman can entertain himself by examining the way in which they have been put together, noting that the bodies are made from spray cans of shaving cream or insecticides, that the columns of the palaces are glass bottles, and that the totality of the stage set is, in fact, made up of ordinary objects—bits of string, cutout pieces of fabric, the inside of pockets, horns, fruits, and so forth.

Equipped with a bottom, two sides, and a lid, the boxes may be either black and rich in colors, or glassy white. The color of the boxes is linked to the tradition of sacrifices in the traditional religion. While the first one is made with blood (the slaughtering of an animal), the second one calls upon milk, a candle, the white cola nut that one offers in sacrifice to the spirits. Another theme is resurrection, here expressed by the new life given to recycled materials, iron or wood, thrust up from the soil or collected at random. Thus, they come to life again in a new, enchanting setting, which is perhaps the one to which we all aspire.

Amadou Makhtar Mbaye

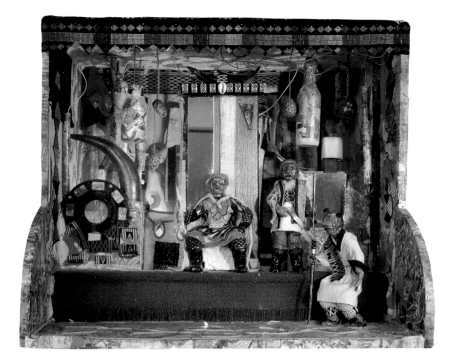

Box No. 1: Kajoor Demb Wala Etub Daaw Demba Faal
(Kajoor Yesterday or King Daaw Demba Faal's Court).
1992–93. Wood and mixed mediums, 23⅝ × 26⅜ × 20⅞"
(60 × 67 × 53 cm). Collection Jean Pigozzi

Box No. 2: Palum Musaa Moolo Ca Kaasamaas
(Coronation of Musaa Moolo in Casamance,
southern Senegal). 1990–93. Wood and mixed mediums,
19⅝ × 24¾ × 18½" (50 × 63 × 47 cm).
Collection Jean Pigozzi

History of Box Number 2:
The coronation.
Musaa Moolo was a great hero who reigned over the Upper
 Casamance.
His coronation is seen here by an artist
concerned with posing the problem of physical pollution
and providing solutions.

In the forefront is Musaa;
A Yotox aerosol can, a recycled object,
is covered with signs and symbols
of the royalty of Casamance.
The ndombu baat allows the Diola kings to be identified.*
The ndombu bopp is borne as a crown*
at the moment of the anointing.
Both these n'dobb are Islamic talismans,*
and their coexistence with the cowrie shells
symbolizes religious syncretism
(religions that mix Islam and Pangols).*

In the background, the sorcerer also wears a ndombu bopp.
He heads a procession of wise men
and appears only during coronation ceremonies
and ceremonies of prediction before departures for war.

In the middle, the group of anonymous wise men,
represented by shaving-cream spray cans,
and throughout all the multitudes of features, mirrors, columns,
we can read the discourse of the sorcerer (incantations without
 order)
the presence of the colonial (blue, white, red), prisoners of war,
and a group of ambushes to represent the "die that has been
 cast,"
which is a means of struggle in all African societies.

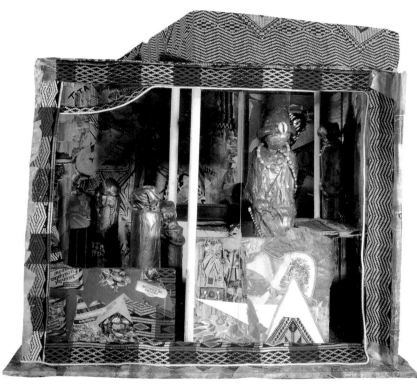

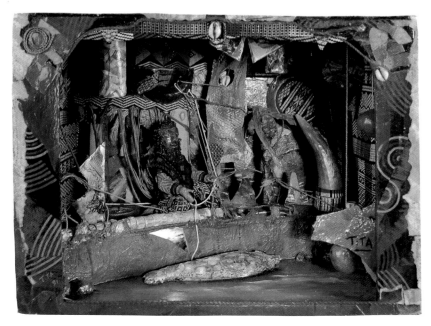

Box No. 3: Njaajaan Njaay Ca Waalo (Njaajaan Njaay in
the Kingdom of Waalo). 1991–93. Wood and mixed mediums,
17¾ × 23⅝ × 22" (45 × 60 × 56 cm). Collection Jean Pigozzi

Three Zimbabwean Sculptors

Henry Munyaradzi

Born 1931 in Guruve, Zimbabwe (Rhodesia)

Lives in Ruwa, Zimbabwe

Bernard Matemera

Born 1946 in Guruve, Zimbabwe (Rhodesia)

Lives in Guruve, Zimbabwe

Nicholas Mukomberanwa

Born 1940 in the Buhera District, Zimbabwe (Rhodesia)

Lives in the Buhera District, Zimbabwe (Rhodesia)

In 1957, Frank McEwen was named director of the National Gallery of Salisbury (present-day Harare), one of the first museums on the African continent. Passionate about African art, McEwen is also an expert in modern European art. In 1945, he organized the first exhibition of the sculptor Henry Moore's work in Paris and, in the same year, a Picasso-Matisse exhibit in London that caused a scandal.

Facing the problems of a lack of money and an absence of collections, McEwen had the idea of creating a sculpture studio right inside the museum. As he made tools, intended for work on very hard stone (serpentine, verdite, granite), available to apprentice sculptors, McEwen allowed them to find and express their own style and stayed far away from imposing a Western vision upon them. The artists learned to rid themselves of a certain aesthetic brought to them by the religious missions and to give a new form to the ancestral myths and beliefs of their culture.

The most famous among them, Henry Munyaradzi, confirms that his goal is to "bring into being the spirit or the particular essence of each animal and every plant." For him, "the form already exists in the stone and is only waiting to be revealed." From the sixties onward, having been shown in the Musée Rodin, in London, at The Museum of Modern Art in New York, Munyaradzi is a kind of magician who knows how to go to the heart of what is essential and how to immortalize the spirit of the moon, of an animal, or of the wind in steles that have a hypnotic gaze. His simple questioning faces have the purity of a signature, with straight, deep lines that seem only lightly to skim the stone in a sign of respect.

Munyaradzi is a self-taught artist who became aware of his talent at the age of thirty-seven, when he was an unemployed farm worker. One day he was drawn to the hammering on stone by the sculptors of the Tengenenge community, established in 1966 by Tom Blomefield, a white farmer whose tobacco farm was suffering from the economic sanctions then striking racist Rhodesia and who, following McEwen's example, encouraged his workers to try their hand at sculpture. In a few years' time, Tengenenge became a village of sculptors that witnessed a flourishing of talents such as Munyaradzi and Bernard Matemera. The most gifted among them were to leave Tengenenge in order to settle on their own farm in the surrounding area of Harare. Today, they form a core of about ten artists of international renown.

In his youth, when he was a herder, Bernard Matemera made sculpture using clay. Later, his school introduced him to sculpture in wood, for which he showed very marked talent. Unlike the sculpture of Henry Munyaradzi, with its stylistic purity and semantic economy, Bernard Matemera's sculpture presents a face of formal richness, with often very powerful features. In some degree it is reminiscent of the figurative statuary of the kingdom of Benin.

Nicholas Mukomberanwa struggles against the aspect, both seductive and evocative, of stone: thus he sometimes cuts the rock into polished cubes in order then to impose his own inspiration upon them. "In the final analysis," he says, "I must know which one of us is the artist: the stone or I." His style is in constant transformation, alternating round and soft forms with forms that are more angular and geometric in which the cutting angles become wedded to the organic forms. In his work, as in that of Munyaradzi, the simplification of the facial features, the intensity of their expression, evoke African masks and, to refer to something outside of Africa, certain drawings of Paul Klee.

Olivier Sultan

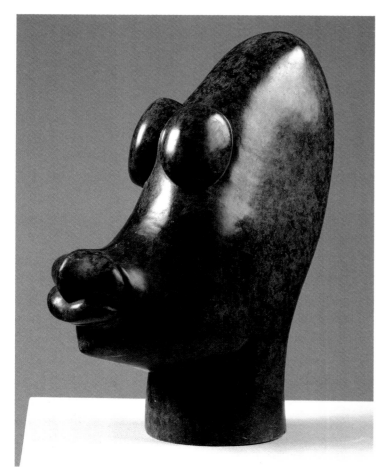

Bernard Matemera. **Big Eyes.** 1990. Black serpentine, 23⅝ × 11⅞ × 9⅞"
(60 × 30 × 25 cm). Collection Bernd Kleine-Gunk

Bernard Matemera in Guruve, Zimbabwe

Henry Munyaradzi in Guruve,
Zimbabwe. 1988

Nicholas Mukomberanwa in the Buhera
District, Zimbabwe

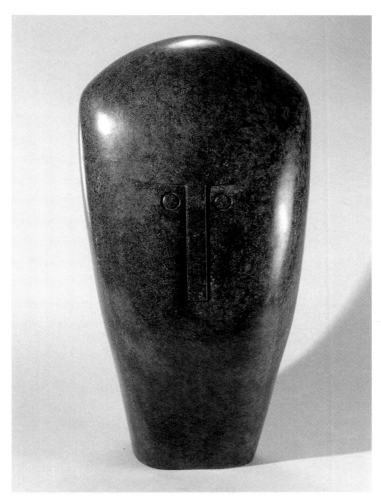

Henry Munyaradzi. **Master Man.** 1988. Green serpentine, 28¾ × 15¾ × 10¼"
(73 × 40 × 26 cm). Private collection, Paris, France

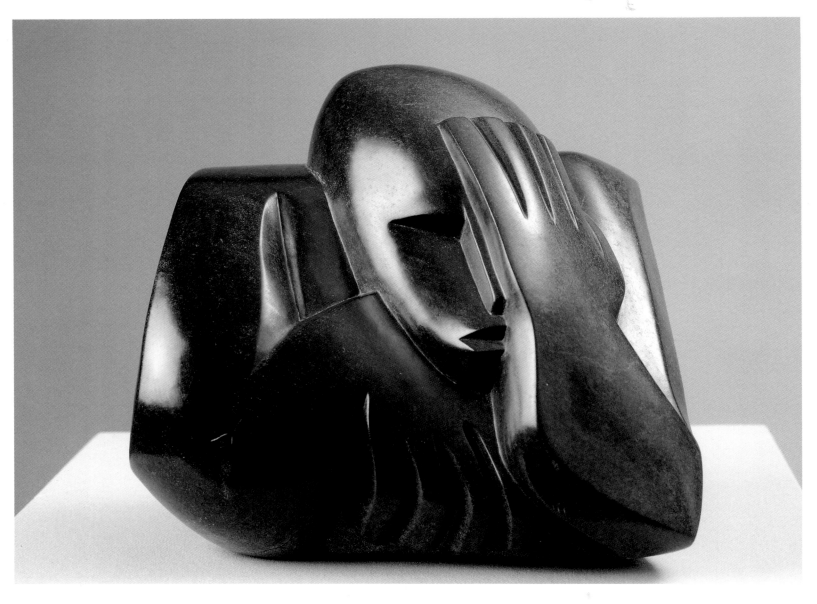

Nicholas Mukomberanwa. **Desperate Man.** 1988. Black serpentine, 11⅞ × 9⅞ × 11⅞" (30 × 25 × 30 cm). Collection Bernd Kleine-Gunk

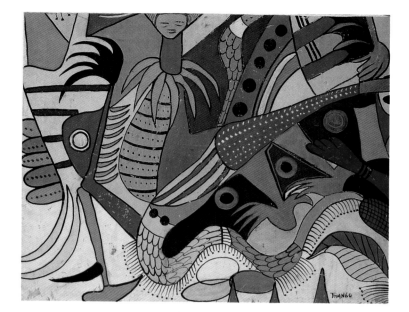

François Thango

Born 1936 in Angola

Lived in Brazzaville, Congo, and Kinshasa, Zaire

Died about 1981 in Brazzaville, Congo

François Thango in Brazzaville, Congo. c. 1979

Facing each other, Brazzaville and Kinshasa seem to continue the centuries-old conversation of their Bantu origins. The Zaire, the immense river that separates the two capital cities, is a road on which all kinds of goods and ideas are transported. In the early fifties, Pierre Lods brought together painters such as Gotène, Iloki, and Thango, who formed the beginnings of the Poto-Poto School, which took its name from an outlying district of Brazzaville. On the other side of the river, the Maecenas Maurice Alhadeff gathered the painters of the Pool-Malebo and Lubumbashi schools (whose names were also geographic in origin) such as Nkusu, Bela, Mwenze, and Mode Muntu (see page 8). Precursors of contemporary painting in Central Africa, these artists were able to develop freely and search for an original pictorial art, drawing upon the sources of the ornamental tradition of the villages. François Thango spent time in both studios and quickly became one of the central and mythical figures in each of them. He created his first narrative paintings in the Poto-Poto School and from 1959 until 1972 settled down as Alhadeff's protégé in Kinshasa, where his art flourished. For family reasons he then went back to the city of his birth, where he died prematurely under highly mysterious circumstances.

According to the painter Nkusu, Thango's work refers to sorcery—a tradition of the Woyo clan which he learned from his mother, who maintained ancestral customs and beliefs (magic, soothsaying, dreams, mysteries). Certain biographical details, such as the fact that Thango used to disappear into the forest for frequent stays, can help us to understand his pictorial language, through which he undoubtedly sought to exorcise the evil he thought he carried within him.

Thango was not an artist who painted on an easel. Instead, he used enormous narrow rolls of canvas, placed on a flat surface, on which he sketched in pencil forms, figures, and objects that appear on his canvas much as visions, stories, and questionings would undoubtedly come to him during his meanderings in the forest. His huge frescoes painted in flat, monochrome colors and encircled with thick, black outlines—similar to Gauguin's technique—lead us into a kind of imaginary and primitive forest where the worlds of animals, plants, monster figures, and two-dimensional stylized masks become tangled, as if he wanted to bring the depth of nature back to its surface. Thango's use of black outlines perhaps reveals a desire to divest the world of the irrational, this world of myths, mysteries, and fables—his attempt to bring this world into harmony in order to liberate himself from the combustion of Being.

Maybe François Thango was seeking to cut himself a path or perhaps to build himself a new world with which he might find the dialogue again through the miracle of a form of order.

A. M.

Above left:
Untitled. Late 1960s. Water-based paint on canvas, 32⅜ × 34⅝″ (83 × 88 cm). Collection Jean Pigozzi

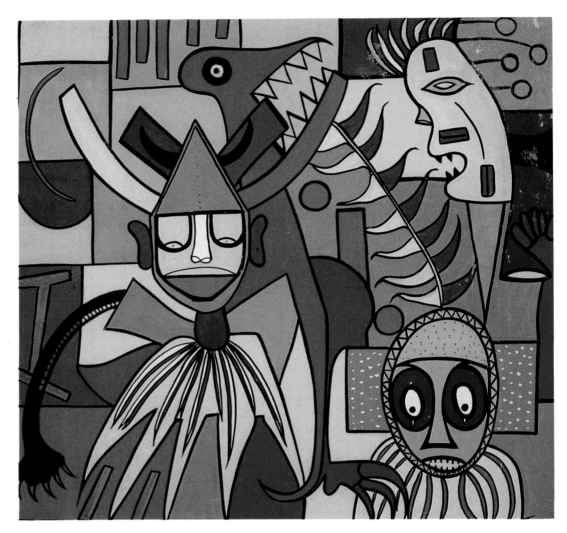

Untitled. 1957. Water-based paint on hardboard, 24⅛ × 30¼″ (61.3 × 77 cm). Collection Jean Pigozzi

Untitled. Late 1950s. Water-based paint on hardboard, 20⅞ × 32⅜″ (53 × 80.2 cm). Collection Jean Pigozzi

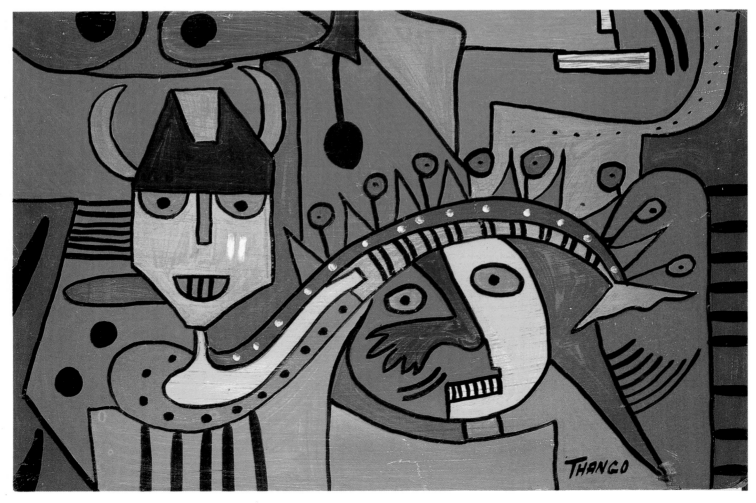

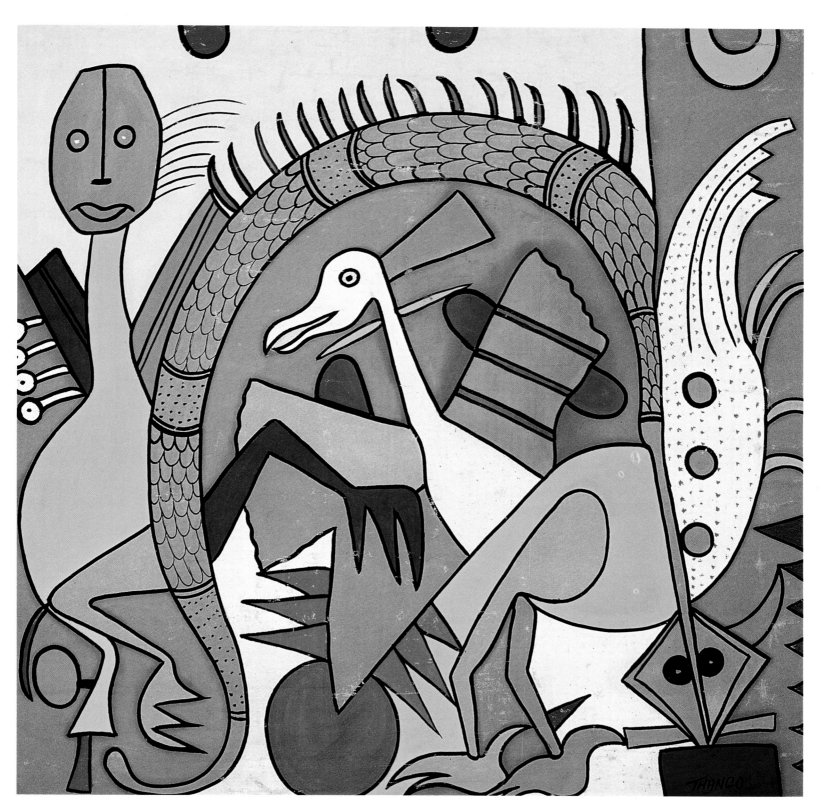

Untitled. Late 1960s. Water-based paint on canvas, 33⅛ × 36⅝″ (84 × 93 cm). Collection Meir-Levy, Belgium

Johannes Segogela

Born 1936 in Sekhukhuneland,
the Transvaal, South Africa

Lives in the Transvaal

Mashengo Johannes Segogela in
Johannesburg, South Africa. 1993

Mashengo Johannes Segogela belongs to a generation of artists whose work gained international recognition after the important 1985 *Tributaries* exhibition in Johannesburg alerted the art market to the work of rural African sculptors. After some formal primary education, Segogela went on to train as a boilermaker. He claims to have been sculpting wood for many years, but has only attempted to make a living from his art since the *Tributaries* show. Segogela's work, like that of other artists from the rural areas of the northern Transvaal, has its roots in local woodcarving traditions and does not rely very heavily on contemporary Western conventions.

Segogela's earliest sculptures consist mostly of single figures or groups of two or three figures of animals and humans, often with a biblical or saintly theme, such as *Samson and the Lion* (1986) or *Saint Francis of Assisi* (1988). Many of the figure groups appear to have a deliberate didactic wit aimed at an essentially urban audience. Subjects drawn from contemporary life often reflect a church background, with meetings and meals favorite themes. Figures in these scenes tend to be clothed in contemporary Western style, as opposed to the sculptures of religious themes, where the clothing shows a familiarity with Western biblical themes. This suggests that Segogela has some knowledge of Western art traditions, even if confined to biblical illustration or Christmas card graphics. Most of the early sculpture is small in scale; here Segogela, using both the texture and color of the indigenous woods in combination with brightly colored enamel paints, follows a pattern of simplified, almost naïve naturalism. Small figures were produced as independent entities which can be arranged at the whim of the buyer or gallery owner and are not set in a fixed relation to each other, or to a fixed base. Segogela himself moves the figures around and rearranges them to make different images.

In his more recent works, Segogela's concern with the notions of good and evil, the opposition of Satan to the church of Christ, is more overtly stated. In *Satan's Fresh Meat Market* (1993), the figure of Satan and two of his dark minions can be assembled in front of a shrinelike sculpture whose altar also reads as a butcher's block with a stylized meat saw behind. Dismembered human limbs are strewn about, and Satan holds a stiff human body, as if either to carve it up or to devour it. Satan is painted bright red, and he and his minions all have an animal-like monstrousness that contrasts with the essential simplicity and small scale of the human figure. The large scale of the dismembered limbs next to the full figure Satan holds suggests that the latter might represent a child, and thus an innocent victim of Satan's lust. Again, Segogela has not fixed the positions of the figures relative to one another, and their meanings could change with different arrangements.

The principle of fluidity of the pieces in the tableaus is also clear in another recent work, *Multidenominational Conference*, in which a number of figures representing members of several faiths surround the figure of the Devil. In this instance Satan, colored black, is caught by the tail by the largest priestlike figure, who waves a staff as if to beat him. Two figures hold aloft a crucifix and an orb, signaling the victory of the church over the forces of evil. The kneeling, prostrate figures are puzzling: Do they submit to the Devil or to his capturers? Once again, the arrangement of these figures can alter the meaning of the whole work, and the ambiguity and tinge of satire that run as leitmotivs through Segogela's works give one a sense of instability and impermanence and represent an acknowledgment that boundaries are not finite.

Anitra Nettleton

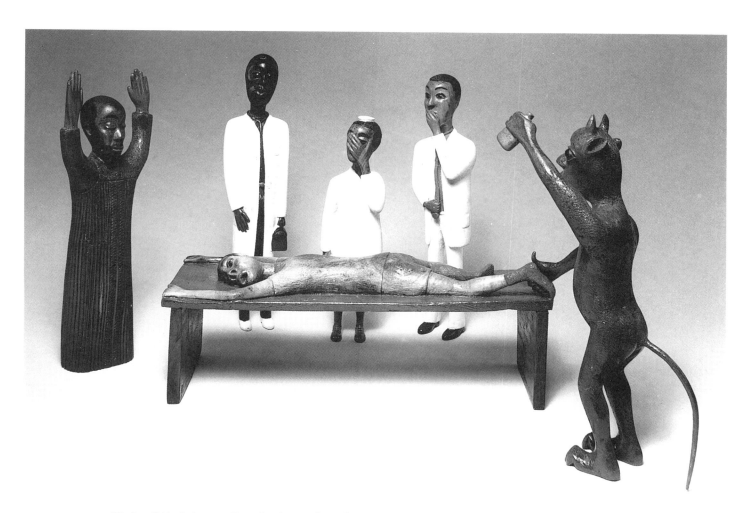

Victim of Alcohol. 1993. Carved and painted wood, 18⅞ × 31½ × 15¾″ (48 × 80 × 40 cm). Collection Jean Pigozzi

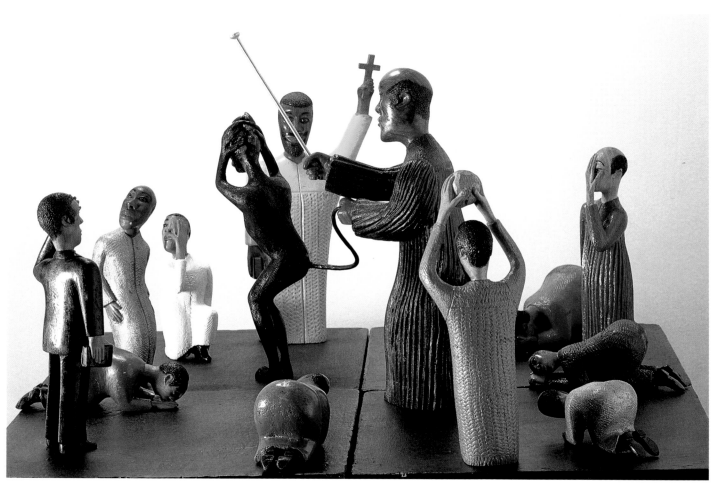

Multidenominational Conference. 1993. Carved and painted wood, 18½ × 31½ × 31½″ (47 × 80 × 80 cm). Collection Jean Pigozzi

Satan's Fresh Meat Market. 1993.
Carved and painted wood, mirror, and tin,
22⅞ × 31½ × 26¾" (58 × 80 × 68 cm).
Collection Jean Pigozzi

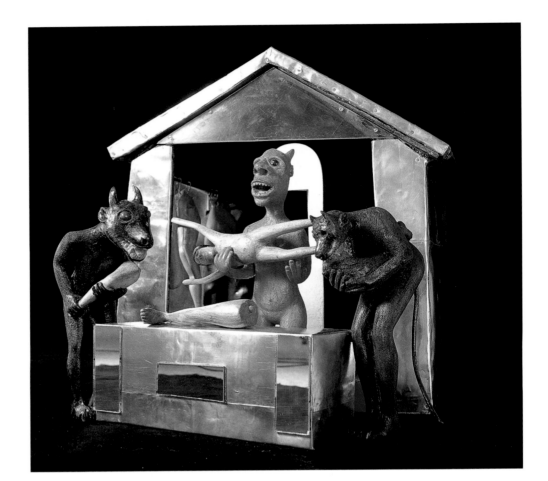

Burial of Apartheid. 1993. Carved
and painted wood, 72 × 41⅜ × 26"
(183 × 106 × 66 cm). Collection
Jean Pigozzi

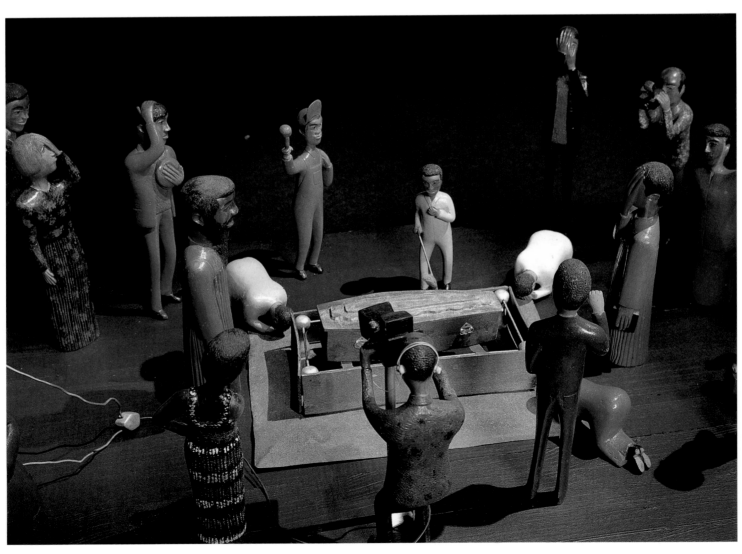

Jackson Hlungwani sets the date of the beginning of his artistic work in the early eighties, although he had been creating objects well before that time. His work is the fruit of an inborn artistic sensitivity, revealed to him through a divine vision in 1978. Indeed, according to Hlungwani, the origin of his works does not come from within himself, but from God, the Holy Spirit, and the Messiah. He has founded his own church, Yesu Geleliya One Apostle in Sayoni Alt and Omega, on a mountaintop sanctuary in his village in the rural northern Transvaal, the area where he spent his childhood. Hlungwani has renamed this location New Jerusalem, and it has become his place of work, residence, and exhibition. The work of Jackson Hlungwani is, before anything else, a means of sublimating poverty and oppression, and bears witness to a continuous coming and going between Judeo-Christian and African traditions.

Like any complex work of art, the *Altar for God* can be written about in any number of ways. This is only one. In Western terminology this *Altar* may be described as an installation, comprising as it does separate wooden pieces and numerous rocks with no set arrangement. Yet installation does not adequately convey what the work is about, and in any case it was created outside Western art historical concerns. It was originally made for a specific didactic purpose, providing a locus for Hlungwani's church, but was later moved to Johannesburg for his retrospective exhibition in 1989 and then bought by the University of the Witwatersrand Art Galleries.

The *Altar* is dramatic and impressive; the tallest figure is over six feet high and when assembled the whole work covers an area of 11½ by 16 feet. It is a richly conceived and elaborated idea, finding expression in a variety of forms, some of which are strongly carved, while others remain close to the trees from which they come. It is as if Hlungwani carves only what is necessary to reveal the essence of an image.

The *Altar for God* is unconventional in its treatment of a Christian scene. Not all the characters have a biblical or ecumenical origin, and their combination does not fulfill any established program. The characters depicted by Hlungwani play a role in a different enactment of a Christian drama. Dominating all is the figure of Christ with a disk-plow halo and a hollow eye. Nearby stands the tall figure of Cain holding a shield, while the small figure of Abel is tied to the silver and red Aerial to God structure at the back. In front is Gabriel the warrior with outstretched double right arm and in his left a shield.

Jackson Hlungwani

Born 1923 in Nkanyani, North Transvaal, South Africa

Lives in Mbokote, South Africa

Jackson Hlungwani in Mbokote, South Africa. 1993

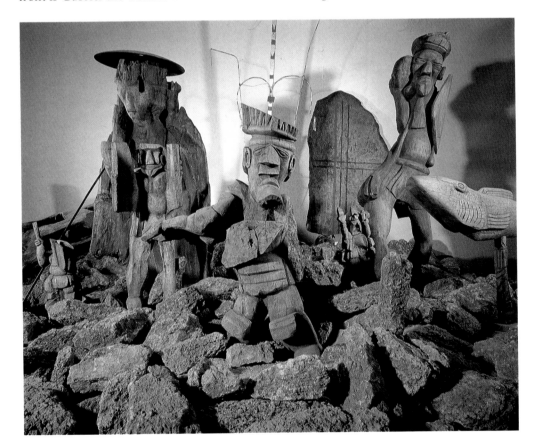

Altar for God. 1983–86. Wooden pieces, assembled and painted aerial, and rocks (detail). Collection University of the Witwatersrand Art Galleries, Johannesburg, South Africa

Behind him is Seth who holds two tablets, one in each hand. Two smaller figures represent Shangaan warriors (Shangaan is a designation for the group to which Hlungwani belongs), and the fish on a carved short pole is the Jonah Fish. On the left, the two carved panels are both titled *God and Christ*. Next to them lies the boatlike Christ's Aeroplane. The large panel, *"Map" for God and Christ*, and the reduced Aerial to God (the original was a telephone pole) are at the back.

An explanation for the unusual combination of figures on this altar may be sought in Hlungwani's belief system. His conversion to Christianity took place at a time when he was desperately ill and contemplating suicide. He was visited by Christ and two companions, and received three promises: he would be healed, he would see God (he saw the feet of God walking in a southerly direction), and he would be a healer and tell people about God. Hlungwani subsequently established an independent church in which improvisations of biblical events are combined with personal and local beliefs. A complex set of dualities lies at the center of his teachings: man/woman, good/evil, up/down, black/white, Christ/Satan, Cain/Abel, new world/old world.

Altar for God contains many oppositions such as Cain/Abel and the up/down divisions of earthly and spiritual realms in *"Map" for God and Christ*. Opposites battle, as indicated by the shields which Cain, the two Shangaan figures, and Gabriel hold. Yet, at the same time, *Altar* demonstrates the potential for victory—New World, New Jerusalem. In Hlungwani's exposition, Gabriel is Christ's oldest brother, providing not only protection, but also revealing the word of God. The inclusion of the fish is a further endorsement: fish are peaceful, "they don't fight." Hlungwani could use these images in his teaching to illustrate his ideas.

With *Altar for God*'s relocation (some might say, dislocation), the spiritual power and essence have obviously shifted, although for Hlungwani the new venue equals a new audience. Most visitors respond with enthusiasm to the sculptures, but whether they respond to the message, as Hlungwani hopes, is a moot point. Hlungwani has received a great deal of attention since he was first exposed to the art world in the 1985 *Tributaries* exhibition. He continues to work on developing a new site for women, making sculptures, and expanding and developing his theology.

Rayda Becker

Installation. 1989–93. Carved wood, 63 × 315 × 236¼" (160 × 800 × 600 cm). Mbokote region, South Africa

Calixte Dakpogan

Born 1958 in Ouidah, Benin
Lives in Porto Novo, Benin

Théodore Dakpogan

Born 1956 in Cotonou, Benin
Lives in Porto Novo, Benin

Calixte and Théodore Dakpogan in
Porto Novo, Benin. 1993

The creations of Calixte and Théodore Dakpogan are clearly reminiscent of the famous mid-nineteenth-century statue of the Fon *vodun** Gu (the equivalent of the Yoruba *orisha** Ogun), shown at The Museum of Modern Art in New York in the 1936 exhibition *African Negro Art*. This assemblage of scrap iron of European origin (see page 14) prefigured European twentieth-century sculpture and was hailed as an emblematic figure of modernity. The striking similarities between that work and the work of the Dakpogan brothers, some one hundred and fifty years later, extend not only to the technique used and the result obtained, but also to the process of creation—although the pieces by the Dakpogans do not have the sacred characteristics of the statue of Gu.

The abundance of wrecked automobiles near the megalopolis of Lagos (Porto Novo lies just a few miles from the Nigerian border) provides the brothers with an inexhaustible source of raw material. A symbol of power, the car is at once terrifying and seductive; it was placed very early on under the protection of Ogun, the most powerful of the *orisha* in the Yoruba pantheon. Ogun, associated with iron and warfare, is also the master of blacksmiths. Born into a lineage of blacksmiths, Calixte and Théodore Dakpogan have a privileged relationship with, and loyalty to, metal and mechanical elements.

Family ties link them with Romuald Hazoume (see pages 132–33) and brought them into frequent contact with him when he was beginning to work with salvaged objects to be recycled; this contributed further to inspire the artistic vocation of the brothers Dakpogan.

In 1990 they produced their first pieces composed of anthropomorphic mechanical parts. For them, the figure takes its form from the central mechanical part, while the limbs may often come from fragments of machine parts. Thus, a gas tank for a motorcycle or a piece of a moped frame will become the body of a person, while the head will be shaped from the shell of a motorcycle saddle or the headlight of a car.

In 1992, on the occasion of a large *vodou** festival, the government of the Republic of Benin commissioned them to create one hundred works that are now on permanent display in the city of Ouidah. They are indeed carrying on the family's craft tradition in the modern world.

Jean-Michel Rousset
1993

Above left:
Untitled. 1992–93. Found objects
and mixed mediums, approx. height,
70⅞" (180 cm). Collection the Republic
of Benin

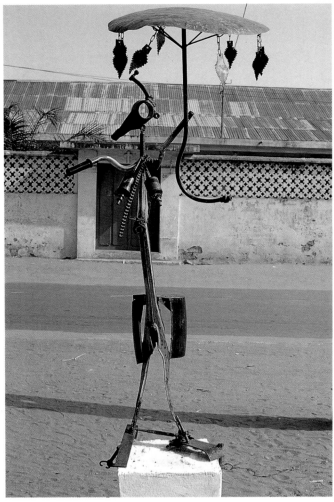

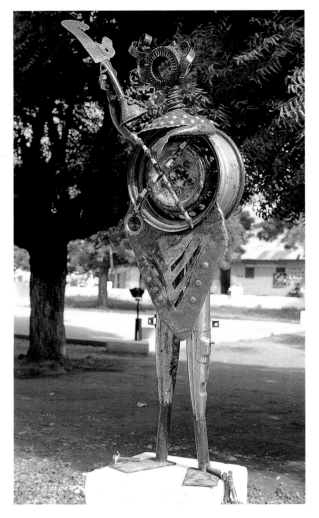

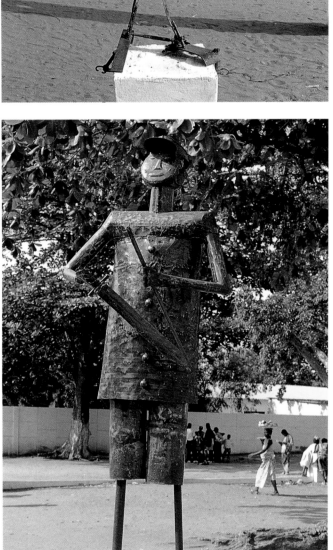

Top left:
Untitled. 1992–93. Found objects and mixed mediums, approx. height, 70⅞" (180 cm). Collection the Republic of Benin

Top right:
Detail of **Untitled.** 1992–93. Found objects and mixed mediums. Collection the Republic of Benin

Bottom left:
Untitled. 1992–93. Found objects and mixed mediums, approx. height, 70⅞" (180 cm). Collection the Republic of Benin

Untitled. 1992–93. Found objects and mixed mediums, approx. height 70⅞″ (180 cm). Collection the Republic of Benin

Christian Lattier

Born 1925 in Grand-Lahou, Ivory Coast
Died 1978 in Abidjan, Ivory Coast

Christian Lattier in Abidjan, Ivory Coast

Above right:
Mask. 1966–69. Rope and metal wire,
20⅛ × 12⅜ × 6⁵⁄₁₆" (51 × 31.5 × 16 cm).
Musée National d'Abidjan, Ivory Coast

Christian Lattier is the most original Ivory Coast artist of the first two decades after independence, which was achieved in 1960. His relationship with his country could be summarized by the phrase, "Too early in a world too young." He was trained in France, where his talent was quickly recognized, and was the recipient of numerous medals: first prize of French Cathedrals, 1953; first prize from Chenavard, 1954; first prize for sculpture in Asnières, 1960; gold medal of the city of Taverny, 1960.

At the time of independence, nostalgia and love for his country called Lattier back to the land of his ancestors, Abidjan. In 1962 he became a teacher, at a low level and meager salary. In 1966 he nevertheless received the supreme African award—the Grand Prize at the Festival des Arts Nègres in Dakar.

Despite all his awards, Lattier remained largely unrecognized by the government and never received the support necessary to expand his artistic production. Full of bitterness and despair, suffering from ill health, Lattier died April 25, 1978. In 1992 his country made him an officer of the Ordre du Mérite.

Engraver, architect, decorator, Lattier was above all else a sculptor. He set himself to remake sculpture by radically rejecting the sculptor's basic tool. No longer did he work with the adze but with his bare hands. Literally weaving his works, he shaped volumes, forms, characters, and stories out of string and cord from gunny sacks. He was able to transfigure this very simple and commonplace material into a pictorial expression that redefined sculpture.

The general tone of his works ranges from mockery to mystery, even to mysticism. Lattier's small characters, which he called "fine little men," are full of humor and playfulness. Yet he granted equal attention to spirituality—first Christian (during his lifetime he sculpted three Christ figures and one Pietà), then African—for Lattier knew how to produce the marvelous.

Lattier liked to work in solitude and would periodically dispose of certain works by burning or abandoning them at a crossroads, the symbol of sacrifice in Africa. He was a pioneer in the plastic arts of Africa, inspiring many young artists today.

Yacouba Konate

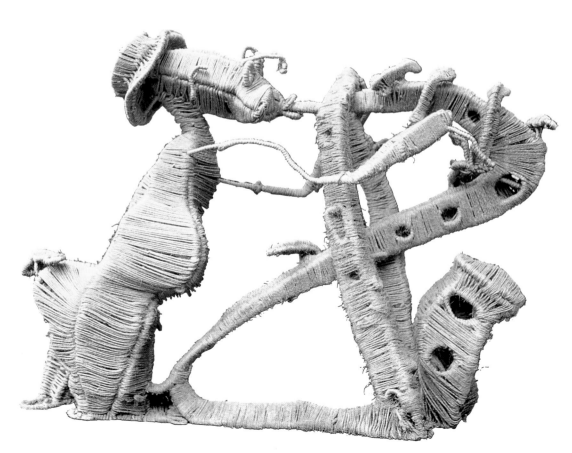

Top left:

Jules. 1962. Rope and metal wire, 38⅝ × 28¾ × 21⅝" (98 × 73 × 55 cm). Musée National d'Abidjan, Ivory Coast

Top right:

Etienne's First Days. 1963–64. Rope and metal wire, 49⅝ × 19⅝ × 14⅛" (126 × 50 × 36 cm). Musée National d'Abidjan, Ivory Coast

Bottom:

Fax (The Saxophonist). 1966. Rope and metal wire, 48 × 39¾ × 15¾" (122 × 101 × 40 cm). Musée National d'Abidjan, Ivory Coast

Zwelethu Mthethwa

Born 1961 in Umlazi, Durban,
South Africa

Lives in Cape Town, South Africa

Zwelethu Mthethwa in Cape Town,
South Africa. 1994

Zwelethu Harold Joseph Mthethwa was born on the east coast of South Africa. His upbringing in the town of Umlazi was in fact the most important "education" he was to receive—as it was his strong cultural roots that became the inspiration for his colorful and expressive pastel drawings. Cultural issues of marriage, alienation, growing old, initiation, and *lobola* (dowry practice) are all explored in his drawings.

After completing his schooling, he began premedical studies, only to discover that his true calling was the paintbrush, not the scalpel. According to Zwelethu, this was the best decision he ever made. His introduction to art came about at the Abangane Open School, where he subsequently enrolled. Two professors there, Joseph Ndlovu and Charles Sokhaya Nkosi, noticed his talent and suggested he apply to the Michaelis School of Fine Art at the University of Cape Town. He followed their advice and enrolled in 1981. That same year he won the coveted Simon Gerson Prize for the most promising student.

In 1983 Zwelethu received the City of Abidjan Prize at the Abidjan Biennale. In 1984 he was awarded the class medal for graduating with a Distinction in Fine Art and in 1985 earned an Advanced Diploma in Fine Art, winning the Irma Stern Scholarship. The following year he went to work for the Department of Education and Training. While working there, he was granted a Fulbright scholarship to study at the Rochester Institute of Technology in New York, where he was honored with the Certificate of Global Perspectives by the Rochester Institute Friendly Council and graduated with a Masters of Fine Art in Imaging Art in 1989.

Zwelethu's art has been exhibited in various countries around the world. He says that he has been lucky enough to travel and explore many other cultures through his art and has been "able to mature as an artist because of this." He could study at firsthand the work of Picasso, Gauguin, and Dalí—three artists who had a major influence on Zwelethu's work following his return to South Africa. Intrigued by Picasso's method of combining different cultures and themes in his painting, Zwelethu explores this idea by blending African and Western cultural aesthetics in his drawings. For example, in one of his pastel drawings, *It's No Dress Rehearsal* (1993), he shows an image of an African woman in a flowing, traditional Western-style wedding dress standing alone in an empty church. Through the arched windows decorated in traditional Ndebele patterning one sees the shanties of impoverished township life. The theme is potentially depressing in its stark reality, but Zwelethu makes it appealing through his Gauguin-inspired use of color.

After viewing his latest exhibition, Benita Munitz, a well-respected art critic, commented, "[Zwelethu] infuses his subjects with a spirit that is evident through their coats of many colours, and he recognises their uniqueness by rendering them as individuals—not in stylised shapes familiar to African-style art. Colour, too, is used in very un-African ways. These are not the bright colours of traditional African beads and wall decoration but exotic hues—the reds of molten lava, the blues of German expressionism and the throbbing contrasts of Gauguin." Zwelethu's aim is to bring his art to a point where it is understood by both schooled and unschooled audiences. Yet there is always an element of his work that strikes a personal chord in each individual.

After exhibiting at the Michaelis Gallery, in Cape Town, in 1985, Zwelethu has held exhibitions in several other cities in Africa; in Rochester and Buffalo in the U.S.; in France, as well as in Belgium; in the Slovak Republic; and in Singapore. He now holds the position of Lecturer in Drawing and Photography at the Michaelis School of Fine Art, of which he is a graduate. According to Zwelethu, "It's kind of a homecoming for me and an opportunity to give something back."

Grant A. Lyons

Married and Middle-aged in Mbumbulu. 1993. Pastel drawing on cotton paper, 28¼ × 40⅛" (72 × 102 cm). Courtesy Goodman Gallery, Johannesburg

Transcend. 1993. Pastel drawing on cotton paper, 28¼ × 40⅛" (72 × 102 cm). Courtesy Goodman Gallery, Johannesburg

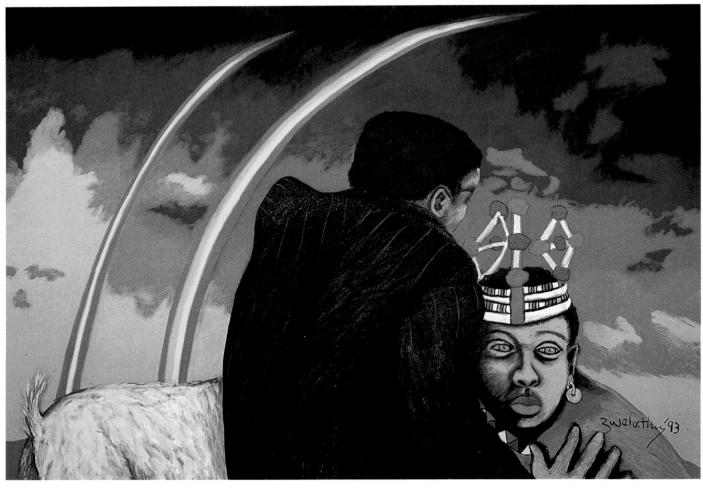

African Landscape I. 1993. Pastel drawing on cotton paper, 28¼ × 40⅛″ (72 × 102 cm). Courtesy Goodman Gallery, Johannesburg

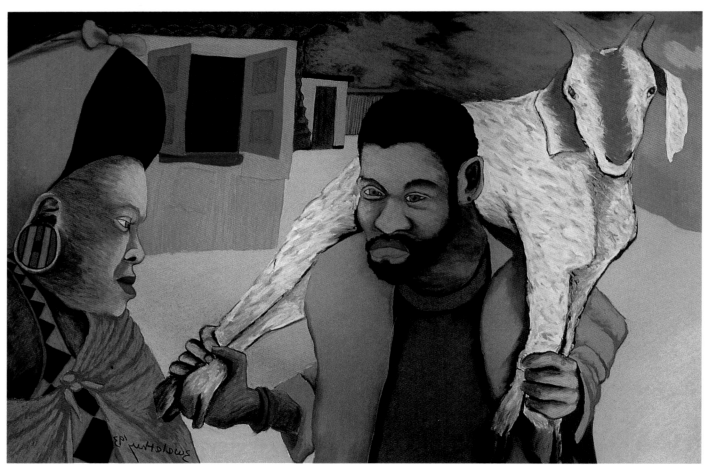

Sacrifice. 1993. Pastel drawing on cotton paper, 28¼ × 40⅛″ (72 × 102 cm). Courtesy Goodman Gallery, Johannesburg

Growing up with uncles who were *nyantussoro*, or healers, Malangatana considers his initiation into the rituals of their activities, in which he even served as their assistant, one of the main influences on the artist and his work. At an early age, he left the countryside for Mozambique, where he worked as a baby-sitter, a kitchen helper, and a ballboy at one of the elite colonial Portuguese clubs, never losing touch with the village of Malangatana, dwelling place of his Ngwenya forebears and his roots.

Self-taught, with only a modicum of secondary-level study, Malangatana appeared on the Mozambican art scene in 1959. In a highly racist society in which the black man was not viewed as a possible *maker* of culture, Malangatana's initial *naïf* approach, mixed with a natural Surrealism—or rather, a fantastic realism born from within—helped him to secure a place in the art world of contemporary Africa.

Identifying deeply with the problem of colonialism, Malangatana devoted himself to this situation in his canvases and drawings of the sixties and seventies. Monsters devour and are themselves devoured in an atmosphere of an African Bosch; the blood and the cries of his oppressed people are everywhere. However, his work is always charged with traditional symbols and meanings specific to his own culture—often mixing the monsters of colonialism with the monsters engendered by the magic dreams of African mysticism.

Of course, Malangatana did not confront the problem of the colonized only in his art; his political views led to a year and a half in prison and subjected him to pressures and threats from the Portuguese political police. Fortunately, his growing international prestige prevented further abuse. And Malangatana was able to travel to several European countries. This, and contact with other artists and with other visions, enabled him to try other approaches.

Malangatana's work, especially his painting, has always reflected a heightened sense of emotion. His early works focus on dramatic—even melodramatic—scenes of daily life, since his perception of the world was shaped by the influence of the colonialism around him. The tragedies of the war following independence in 1975 also had a profound influence on his art. Replete with tightly packed figures, Malangatana's compositions are full of tension. His palette is dominated by dark brownish-yellow and reddish-black tones and his quasi-baroque composition becomes intensely dramatic, clearly delineating two zones: that of the people and that of the *other*.

Valente Ngwenya Malangatana

Born 1936 in Marracuene, Mozambique

Lives in Maputo, Mozambique

Valente Malangatana in Maputo, Mozambique. 1992

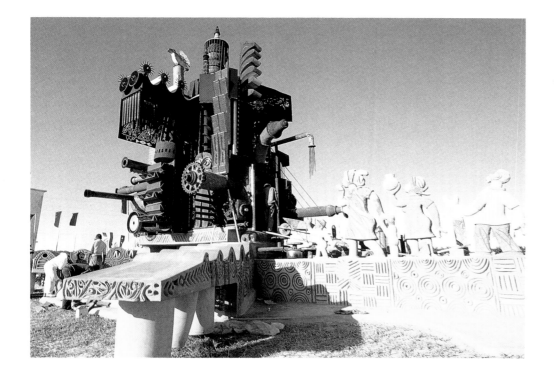

The Sacred House of the Mabyaya Family. 1988–89. Cement and iron, 39′4½″ × 19′7½″ × 14′ (1200 × 600 × 400 cm). Mabor Tire's Facture, Maputo, Mozambique

Left:
Untitled. 1982. Ink on paper, 27⅛ × 19⅝″ (69 × 50 cm). Collection the artist

Right:
My Flute Plays the Thousand Unending Songs of Liberty. 1975. Ink on paper, 27⅛ × 19⅝″ (69 × 50 cm). Collection the artist

Perhaps the most optimistic of Malangatana's works is *The Sacred House of the Mabyaya Family,* an immense sculpture in iron, a medium he has little utilized. It is an inhabitable sculpture, a cathedral for flying birds composed of painstakingly and meticulously crafted discards and machine parts. Rising nearly forty feet, the sculpture thrusts outward in an explosion, this time of joy.

For those who know him personally, Malangatana is himself an explosion of joy, capable of making a solemn international symposium rise to its feet to join him in singing and dancing. This is why today he is considered to be a kind of artistic ambassador for Mozambique. His international renown has brought him invitations from China, the United States, Austria, and Mali, and requests to serve on competition juries in Zimbabwe and for the UNESCO Prize for the Promotion of the Arts. If we add to this the fact that he is an elected deputy to the Mozambican Assembly of the Republic, that he can't stop on a street corner without countless people greeting him, that his residence (soon to be an art gallery as well) is a whirlwind of visitors despite its location on the outskirts of the city, it is clear that his prestige among his own people is also enormous.

Today, the lessening of political tensions and a reprieve in the war are starting to have an effect on Malangatana. Lively emerald greens are emerging, and his compositions are beginning to show a few open spaces. There is hope that Malangatana will be able to see another reality and more frequently portray a beautiful country, rich in culture and diversity. From his first works painted on sheets of fiberboard, sometimes with his fingers, in simple colors but already exhibiting great compositional balance, to his assured and careful painting of today, displaying great textural concern and consciously seeking balance and intensity of color, there is an unbroken progression in each new phase of his artistic life.

Julio Navarro

The Last Judgment. 1961. Oil on canvas, 36¼ × 48″ (92 × 122 cm). Private collection

Moke

Born 1950 in Ibe, Bandundu, Zaire
Lives in Kinshasa, Zaire

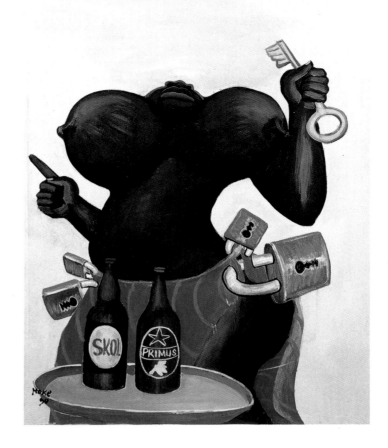

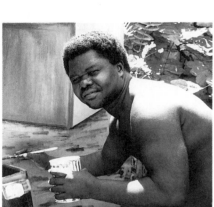

Moke in Kinshasa, Zaire. 1991

Above right:
Untitled. 1990. Oil on canvas, 43¼ × 34¼"
(110 × 87 cm). Collection Jean Pigozzi

Opposite:
Untitled. 1991. Oil on canvas, 69¼ × 51⅛"
(176 × 130 cm). Collection Jean Pigozzi

Along with Cheri Samba, Moke belongs to a generation of painters whose work is popular, not "high," art. Their success was linked to the consolidation of the economic and social situation of the urban lower-middle and middle class of Zaire in the sixties, twenty years before the republic's economy deteriorated badly. Moke's work gained attention from the public with the 1978 exhibition *Art partout* (Art Everywhere) in Kinshasa. Not, of course, from the general public, but through his roots in popular art—first of all, as a painter of advertisements and a producer of images with a social aim, such as the paintings that represent Mamy Wata—Moke very quickly acquired a certain fame beyond the borders of his immediate neighborhood.

Less ideological than the work of Cheri Samba (see pages 162–63), Moke's paintings provide a flattering view of the lower-middle class, the major patrons of his work, when the economic situation still allowed for disposable income. This is particularly true of the paintings depicting the nightlife of Kinshasa (notably in the Matenge district), in which women, music, and beer create an atmosphere of comfort and well-being. Sometimes striking studied poses, the men wear ties or the famous "Mao" jacket, which was brought into fashion by President Mobutu. Yet, Moke's work is not limited to the Zairean rumba and the *Sapeurs** of the Matenge district at night. He also has an interest in less sensuous subjects, such as prison, the running of ricksha men, mourning scenes, accidents, and parades of men of state with rejoicing crowds. His colorful paintings are able to communicate a message without the use of text. It is symbolist painting rather than realist, bolstered by the colorist talent of the artist, who uses warm, lively industrial colors and is not concerned with the clarity of the stroke, which can be unsure at times.

Certain of his paintings have met with a popular success that could well be compared to that of a hit musical. Several of his pieces have been reproduced on paper by the thousands and on the walls of some houses. Over the years, Moke's work has managed to acquire an identity that enables it to be recognized without hesitation; it is well known both in Zaire and outside its borders.

J. S.

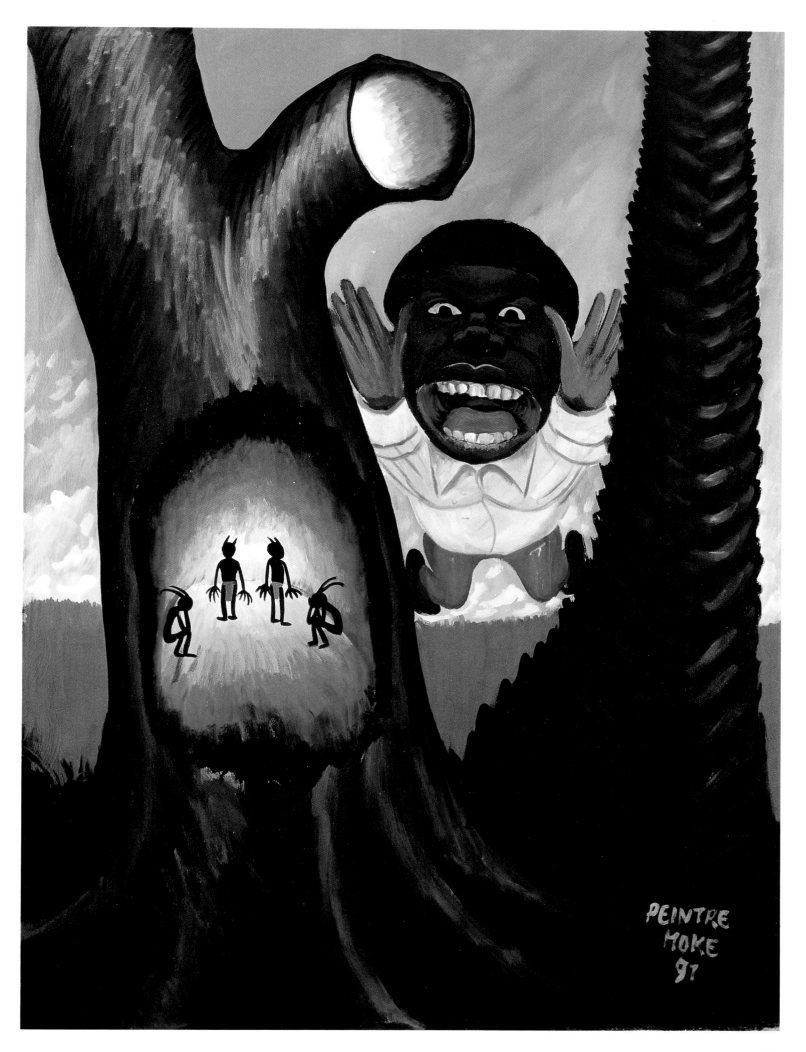

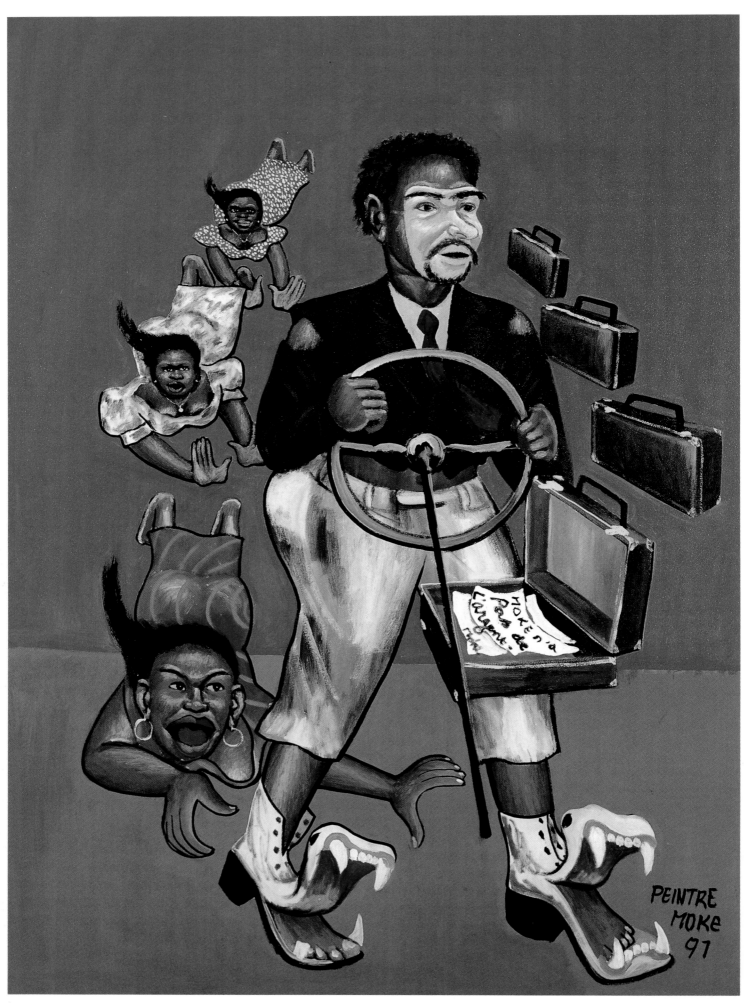

Moke Doesn't Have Any Money. 1991. Oil on canvas, 69⅝ × 51⅛″ (177 × 130 cm). Collection Jean Pigozzi

WORLD

Almighty God
(Antony Akoto)

Born 1950 in Kumasi, Ghana
Lives in Kumasi

Almighty God in Kumasi, Ghana. 1994

From early childhood, Antony Akoto showed an interest in drawing. At the age of sixteen he became an apprentice to two well-known commercial artists in Kumasi, who taught him to paint signs and decorate vehicles.

When he opened his own studio in Suame Junction (a section of Kumasi) in the mid-seventies, the style he developed removed him decisively from the traditional posters of barbers and hairdressers, even though these were becoming the object of a flourishing business among Westerners eager for images of a picturesque and reassuring Africa.

In turn he had apprentices who, under his supervision, also learned to paint signs for companies and shops in the surrounding area and to decorate trucks and taxis with proverbs, biblical texts, and extravagant figures. These figures seem to have been one of the first manifestations of what has come to be called "urban art," which, according to the art historian Bogumil Holas, appeared in Ghana right after World War II.

Today, because of his regular income, Antony Akoto lives in relative material comfort that allows him to perfect his technique and to express his social concerns in his art. He creates immense works depicting terrifying traffic accidents, which he envisions placing along the highways to make drivers more careful, or scenes that will caution of the danger of alcohol and tobacco.

At the same time, he continues the tradition of the portraitists, executing effigies of traditional Ashanti chiefs, of historical Ghanaian or African figures, and political or inter-national-showbusiness personalities. These works, painted on plywood or wooden panels, sometimes include short explanatory texts. Any magazines he chances to come upon are also a source of inspiration. From them, he chooses certain photographs that he repro-duces, and sometimes colors.

Antony Akoto's sensitivity to the suffering of others is evident in his choice of sub-jects: a man weeping over the loss of his wife, a procession of hired weepers, an Indian child who is a slave in a mine.

He now signs his work with the name Almighty God, thus bearing witness to the revelation that has come to him. His conversion to and involvement in Catholicism have deeply marked his work. Scrupulously respectful of the Church's interdicts, he has progressively done away with representations of such figures as reggae musician Bob Marley or the macho movie character Rambo in his paintings and now concentrates on scenes such as the triumph of good over evil, the fall of Satan, and the advent of God.

Jean-Michel Rousset

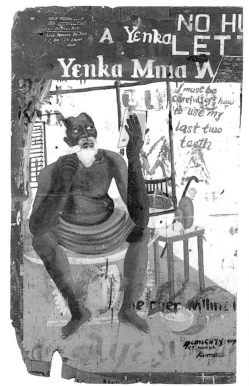
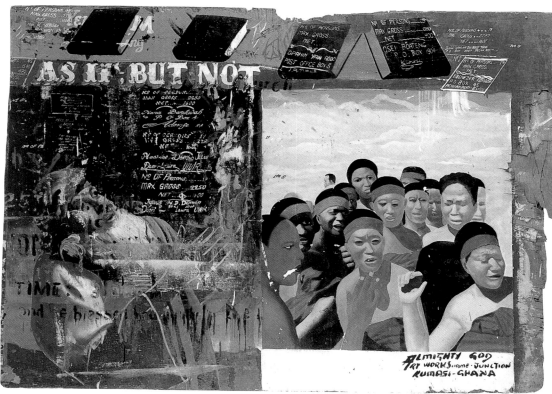

As If Not But (diptych). 1985–90. Enamel paint on plywood, overall 48 × 96½″ (122 × 245 cm). Collection Jean Pigozzi

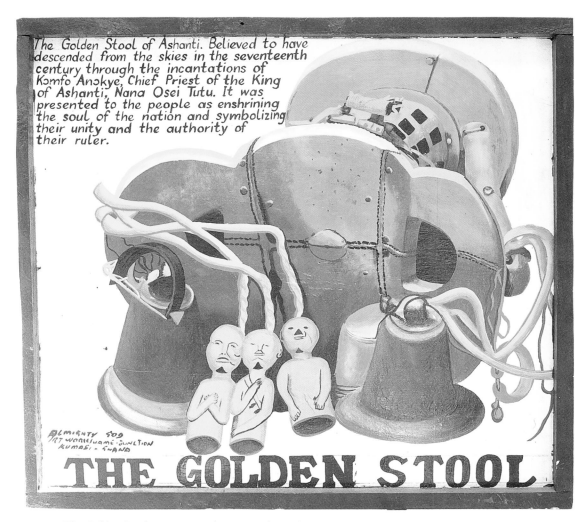

The Golden Stool. 1991. Enamel paint on plywood, 26 × 26″ (66 × 66 cm). Collection Lionel Adenis

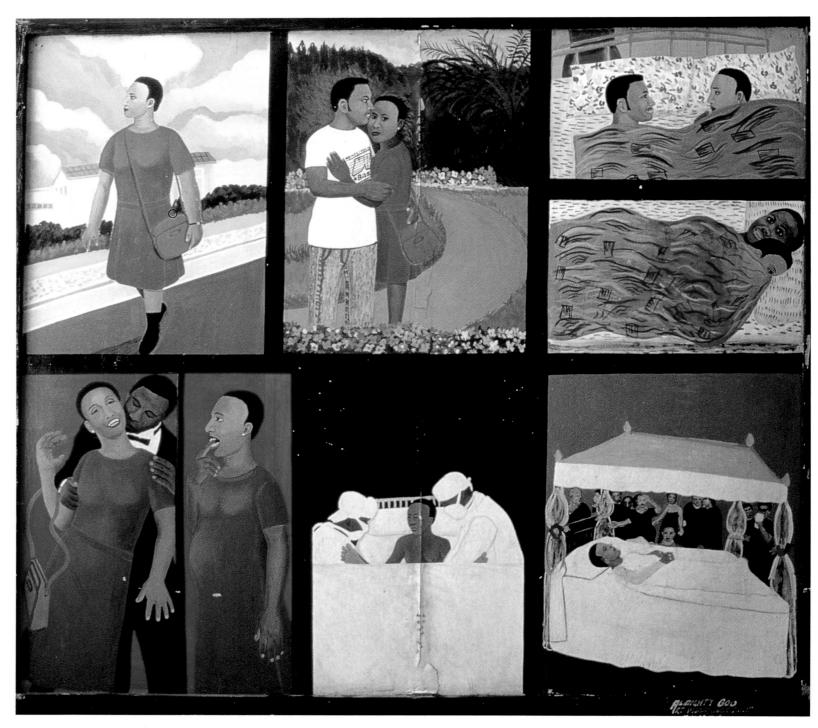

Destiny. 1988. Enamel paint on plywood, 42½ × 48″ (108 × 122 cm). Private collection

LA CRISE ZAÏROISE
CONFERENCE NATIONALE SOUVERAINE
BLOCAGE
GEOPOLITIQUE
THEORIE DE REPRESENTATIVITE OU UNE STRATEGIE DE DIVISER POUR REGNER
I. LA VRAIE FACE D'UN CHASSEUR ET SON CHIEN. II. LA CHASSE AUX CONFERENCIERS

BLOCAGE DU PROCESSUS DE LA DEMOCRATISATION, UN ACTE CONTRE LA
VOLONTE DU PEUPLE ET DE DIEU.

Botalatala
Bolofe
Bwailenge

Born 1951 in Yalisingo, Zaire
Lives and works in Kinshasa, Zaire

Botalatala in Kinshasa, Zaire. 1990

A student and teacher of mathematics, Botalatala worked at a bank before devoting himself completely to painting in 1981. At first he made small pictures in which painting served as background for a collage of objects composed of salvaged materials.

With its straightforward message and direct presentation, the work of Botalatala may be seen as a kind of antidote to the chaos that reigns in the great metropolis that Kinshasa is. Significantly, one of his pieces is titled *Plane Geometry*. In the closed space of the painting, "Everything has its place," as the proverb states, and each implement has a precise function.

Botalatala's work is presented as an anthropological view of urban and village culture. First, in the way in which it is constructed, based on recyclable materials—whose use has become entrenched in large African cities—which suggests another side of Botalatala's work: from the apparent chaos of things, from the various enigmas that the big city incessantly produces, almost to the point of suffocation, another syntax can be derived from which order emerges. Finally, from his field of research: Botalatala takes inventory in his pictures, of the implements linked to the techniques of a multitude of professions, whether industrial, craft, or agricultural.

However, beyond its taxonomic dimension, this work contains a double objective: to preserve (thereby functioning like a museum) objects and techniques that are threatening to disappear; and to educate by showing, in a popularized and synthetic form, what a technical sequence consists of.

These "visual auxiliaries," as the artist calls them, may thus serve as a means of teaching through visual representations—designed for illiterate populations. Furthermore, for the future, Botalatala envisions a collaboration with nongovernmental organizations, helping them in their training tasks and in disseminating artisanal know-how. Part of these "visual auxiliaries," imprinted with a political dimension that reminds us of Cheri Samba (see pages 162–63) and Cheik Ledy (see pages 121–23), are those pictures that describe a given aspect of contemporary Zairian history with, naturally, the theme of the Zairian crisis in the forefront.

J. S.

Above left:
**The Zairian Crisis Supreme National
Meeting, Geopolitical Obstruction.** 1991.
Wood, cardboard, and acrylic on plywood,
48 × 46⅛" (122 × 119 cm). Courtesy of
Galerie Jean-Marc Patras, Paris

*"Obstruction of the democratic process, an act
against the will of the people and of god."*

The Painter at Work. 1990. Wood, cardboard, and acrylic on plywood, 22¼ × 15¾" (56.5 × 40 cm). Collection Jean Pigozzi

"With his canvas and brush the painter defines himself and describes his universe" reads the inscription at the bottom.

December 4, 1991, at 0 Hour. 1991. Wood, cardboard, and acrylic on plywood, 33⅞ × 61" (86 × 155 cm). Courtesy of Galerie Jean-Marc Patras, Paris

Top: "Dawn or twilight. The resurrection or reinterment of a people."
Bottom: "The end of a mandate. The constitution of a state: A text that changes to improve with the times or a shield for the defense and maintenance of one kind of regime."

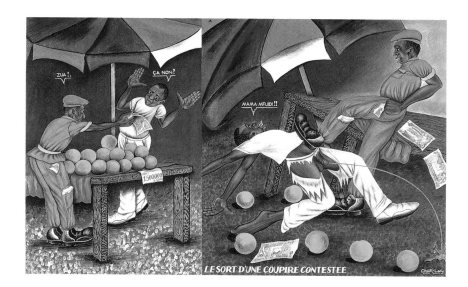

LE SORT D'UNE COUPIRE CONTESTEE

Cheik Ledy (Cheik Ndoluvualu)

Born 1962 in Kinto-MVuila, Bas-Zaire

Lives in Kinshasa, Zaire

Cheik Ledy in Kinshasa, Zaire. 1990

For almost thirty years now, primarily in Zaire, a whole new culture has developed taking off from the notion of "modernity." One of its most striking manifestations is a kind of "popular" painting, as it is called, that finds its sources in advertising signs. Moke (see pages 112–14) and Cheri Samba (see pages 162–63) have contributed importantly to staking out individual styles within this tendency, and in his own way, each of them has managed to divert it from its initial commercial function, raising it to the level of an original artistic practice. From the very beginning, the principal sources of its content have been religion, political life, and the life of urban society. The paintings were to be exhibited at every street corner to provoke or entertain passersby.

Actually, these two artists might be said to have started a school. Indeed, in these last few years "popular" painters can be found in almost every district; they compete to be the first to report the significant facts of the sociopolitical situation and of everyday news. These new themes may then be taken up again by any number of others and thus come to enrich the repertory of this painting.

Cheik Ndoluvualu, known as Cheik Ledy, joined his brother, Cheri Samba, in Kinshasa in 1977 and worked alongside him in his studio in Kasa Vubu. After ten years of "schooling" as his brother's assistant, Cheik Ledy went out on his own, opened a studio, and developed his own painting. Cheik Ledy has profited from the experience, the precision, and the artfulness his brother taught him, as well as from ready access to all the quality materials that give his works the sophistication that already stamped Samba's pieces.

Cheik Ledy is especially careful with the organization of the painting—composition, color, the relationship between text and image—as well as with the details that set it apart. A chronicler, he paints stories and accounts, essentially inspired by political, economic, and social events. He analyzes ongoing events in the community from day to day and then illustrates them, often in images that are not supposed to be disseminated in his society. The texts, in Lingala mixed with French, sometimes serve as simple commentaries, sometimes plead a cause or make a demand, or even all of these at once. Without any ambiguity, they indicate what has been "forgotten" in the painted picture.

Cheik Ledy seems to be both provocative and moralistic, reflecting the complexity of Zairian society at a particularly tense moment in its history. Neither just photographic records, nor outright criticisms of the Zairian system, his paintings are an exhortation to the inhabitants to take responsibility personally for the current situation. He presents them with political, psychological, and artistic confrontations, and suggests solutions to the local public when his canvases are exhibited on the facades of his studio.

J. S.

Above left:
Fate of a Disputed Banknote. 1992. Acrylic on canvas, 36¼ × 55⅜" (92 × 140.8 cm). Collection Jean Pigozzi

"Take it."
 "No! Not that."

"Jealousy!"
 "Mother, I'm dying!"

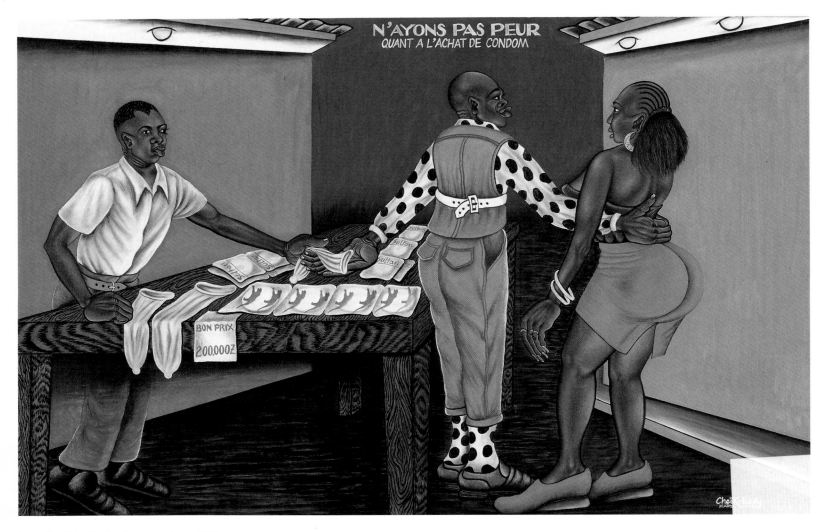

Let's Not Be Afraid to Buy Condoms. 1992.
Acrylic on canvas, 36¼ × 55⅜″ (92 × 140.8 cm).
Collection Jean Pigozzi

Opposite above:
Harmonizing with the Second Republic. 1992. Acrylic on canvas,
48¾ × 78¾″ (123.8 × 200 cm). Collection Jean Pigozzi

*"Victory of August 15, 1992. I, Etienne Tshisekedi, have been selected.
For the C.N.S., it's democracy now. Good-by to the 2nd Republic."*

"Why he (or she)? As long as it is he, so much the worse for us."
"Never, big lie. I believe that now I shall eat well."

Below:
Just Like in School. 1992. Acrylic on canvas, 51¾ × 77⅞″
(131.4 × 197.8 cm). Collection Jean Pigozzi

*"Hey! Hurry up, I want to get in too. . . . Enough space for everyone? . . .
Driver, let's go!! . . . The bus is full. Where are you going to put these
people? And anyway, it's 11 o'clock already, when are we going to get to
work? . . . It's hard."*

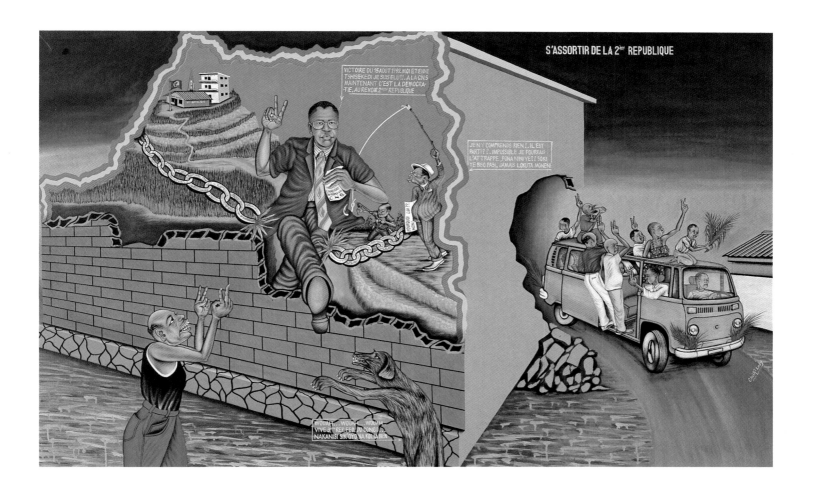

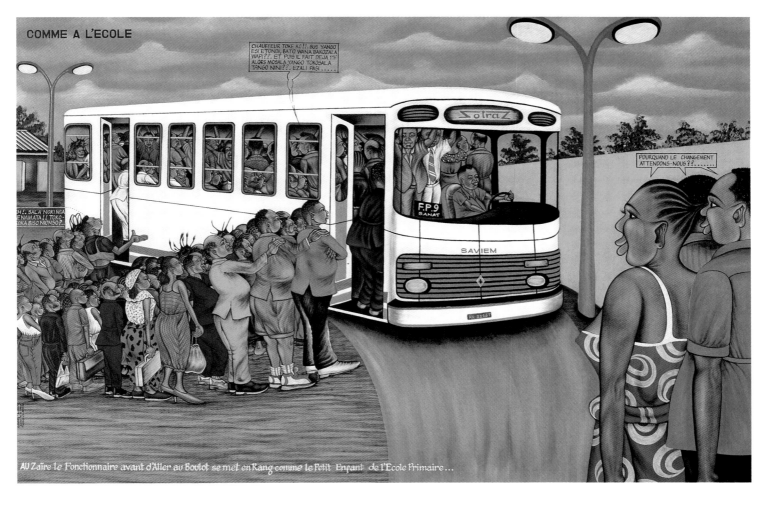

Jean-Baptiste Ngnetchopa

Born 1953 in Nkongsamba, Cameroon
Lives in Bafoussam, Cameroon

Jean-Baptiste Ngnetchopa in
Bafoussam, Cameroon. 1991

Above right:
Dial M for Murder. 1993. Carved wood,
17⅜ × 27⅝ × 1³⁄₁₆″ (44 × 70 × 3 cm).
Collection Jean Pigozzi

Jean-Baptiste Ngnetchopa comes from a family of traditional sculptors. His grandfather Mube Massagoung was an artist of some renown, and it was through him that Jean-Baptiste was initiated into the art of wood sculpture at the age of sixteen. For a large part of his early career, until 1984, Ngnetchopa's subject matter focused on the traditional Bamileke culture into which he was born. The Bamileke, a farming people organized in chiefdoms, live in the western part of Cameroon.

Funerals, war, the building of large huts, and marriage are some of the themes represented in Ngnetchopa's sculptures, made of huge blocks of mahogany or iroko wood. Extremely pious, Ngnetchopa has also created many religious scenes in which he gives free rein to his mystical imagination.

Ngnetchopa quickly gained recognition and won several medals at the annual government-organized Agricultural Fair. He could have gone on to pursue a comfortable and honored career, if he had not been interested in more worldly and historical subjects. This interest led him to make realistic portraits of people of state such as François Mitterrand, Elizabeth II, and Mao Zedong, and heroes of modern Cameroonian history such as Sultan Njoya and Martin Samba, using photographs to aid him.

In 1983, maintaining the realistic style of his portraits, Ngnetchopa began to create a series of bank bills. Beginning with a one-dollar bill, he continued with African bills and then bills from around the globe. These carvings of banknotes may seem incongruous with Jean-Baptiste's earlier work. However, in the context of everyday contemporary African life, in which banknotes appear on dishes (he may have seen these in the Douala market on dishes from Nigeria that bore representations of the local currency, the Naira), on fabrics for clothes, and on objects such as key rings, his use of bills is not surprising. (It is also interesting to note that bills issued by the central banks of African governments very frequently carry images of traditional art objects.)

The temptation to dismiss this imagery as Pop art is checked by the considerable amount of work involved in creating each bill, the details of which are sometimes colored on the block with ink. Once the drawing has been traced onto the wood, Jean-Baptiste leaves the tedious work of carving out the parts that will have to appear hollow to his apprentices.

Jean-Baptiste's use of monetary iconography implicitly declares that *value* derives from the investment in work time and from the creation of a unique object. The work of art seems to claim to be the equivalent of this value but without the mediation of a market, what is called the artistic assessment, established according to the parameters of its presence in collections, exhibitions, etc. There is a form of fetishism in this representation of money to the extent that the work seems to claim that it has *immediate* value through what it stands for, something that no work of art can ever claim since it is a symbolic asset, based on the agreement of others who either do or do not assign it value. By representing a

1,000 Yuan. 1991. Carved wood, 20½ × 48⅜ × 1⅜" (52 × 123 × 3.5 cm). Collection Jean Pigozzi

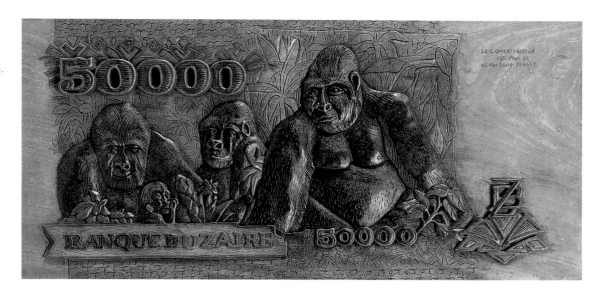

50,000 Zaires. 1992. Carved wood, 19⅛ × 39⅜ × 1⅜" (48.5 × 100 × 3.5 cm). Collection Jean Pigozzi

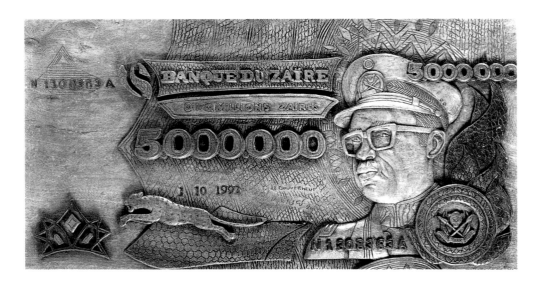

5,000,000 Zaires. 1993. Carved wood, 17⅜ × 32¾ × 1³⁄₁₆" (44 × 83 × 3 cm). Collection Jean Pigozzi

banknote, a symbolic bid for power is made: if what I sculpt represents value *par excellence*, then my representation will draw *de facto* profit from that. All the more so since it concerns a unique object whose realization requires an important expenditure of time.

During a more recent stage, Ngnetchopa has enriched his repertory with a new subject—record covers—a dynamic form of popular imagery in Africa.

J. S.

Abdallah Salim

Born 1958 in Mambrui, Kenya
Lives in Mambrui

Abdallah Salim in Malindi, Kenya. 1993

Starting at a very young age, Abdallah Salim cut figures out of thin strips of wood, a technique that he has incorporated into his art today. His sculptures are life-size silhouettes captured in motion and painted in brilliant colors flatly applied in traditional African style.

Following another African tradition, Abdallah Salim creates group "installations." These installations are stage scenes, and it is permissible to move the lighter-weight characters around on their pedestals, playing them one against the other, as one does with pawns in a chess game. The village itself is a stage with people crossing the square, women chatting, children and goats disappearing behind houses and then reappearing—and theater as elegant as those who have not yet discarded their traditional dress for ready-to-wear or jeans, but who wear a kind of native clothing such as the plumage of birds or the coats of gazelles.

His most recent installations include *Dancing Masai Alphabet*, *The Gor Mahia Soccer Team*, and *Love and Indifference*. *Dancing Masai Alphabet* illustrates mobile motionlessness. This alphabet is reminiscent of the column-sculptures of certain ethnic groups and forms a brotherhood of twenty-six letters, tall and slender, constructed from geometric forms in dazzling colors. The letters are distinguishable from one another by the slight intervals or clear dissonances in their forms, in the manner of Rimbaud's poem *Voyelles* (*Vowels*), if one adds to each basic color the series of images that accompanies it. As the twenty-six letters are here situated in space, they take on a changing and unassailable reality.

The Gor Mahia Soccer Team (1992) represents the best-known Nairobi soccer team. Just like the soldiers cut out of wood or cardboard we had in childhood, which we moved around on their bases, here is the soccer team of Nairobi. The personality of each player is revealed by his frozen movements and in the way each figure wears his shirt and shorts. However, naturalism stops there. The clothes are light blue and green, and are inscribed with supple, plantlike lines. This motionless team appears ready to jump into a motion-filled game. Yet in the end, it is the viewer who is playing, leaping, flying off, and shooting the sphere of light that rises up high above his or her head.

Love and Indifference is a game of three playing cards carved out of painted panels. The theme is well known around the world: a boy loves a girl who loves another; the third, in turn, loves someone else—leading to broken hearts. Abdallah Salim picks up this old story and has the cards themselves recite it: the King of Clubs hands a clover (in French, this word also means trefoil or club) to the Queen of Hearts, who offers a heart to the Jack of Spades, who remains indifferent. The King of Clubs's desire is made clear by an arrow-arm that clumsily holds a clover. This same arrow blocks the Queen of Hearts, who is handing her heart to another, and there is drama of sorts in this long yellow arm that is bent and cut. This game of love is the white man's game: that is what the playing cards and the light-colored faces lead one to think.

Of particular interest are the slenderness and fluidity of the line. For Abdallah Salim, an art of a single, perfectly flat surface, neither convex nor concave, giving life to geometry, is what corresponds to lines, something that seems altogether new to me.

Pierre Garnier

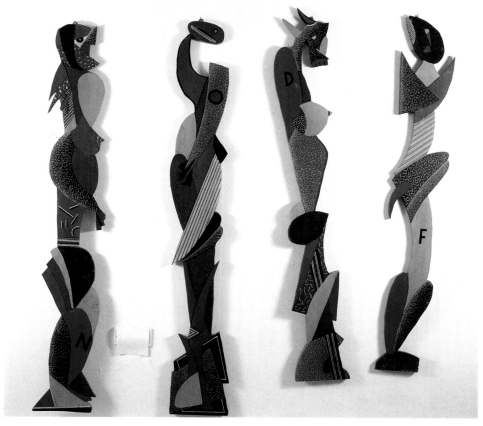

Detail of **Dancing Masai Alphabet (N, O, D, F).** 1991–92. Acrylic on carved wood, each 78¾ × 15¾" (200 × 40 cm). Courtesy of Isaia Mabellini-Sarenco, Malindi, Kenya

A Gor Mahia Soccer Player. 1992. Acrylic on carved wood, life-size. Courtesy of Isaia Mabellini-Sarenco, Malindi, Kenya

Below left:
Love and Indifference (Queen of Hearts). 1993. Acrylic on wood panel, 43¼ × 63¾" (110 × 162 cm). Courtesy of Isaia Mabellini-Sarenco, Malindi, Kenya

Right:
Love and Indifference (King of Spades). 1993. Acrylic on wood panel, 43¼ × 63¾" (110 × 162 cm). Courtesy of Isaia Mabellini-Sarenco, Malindi, Kenya

Vohou-Vohou

Yacouba Touré

Born 1955 in Mankono, Ivory Coast
Lives in Abidjan, Ivory Coast

Brahima Keita Ibak

Born 1955 in N'Zerékoré, Guinea
Lives in Abidjan, Ivory Coast

Youssouf Bath

Born 1949 in Tabou, Ivory Coast
Lives in Abidjan, Ivory Coast

Théodore Koudougnon

Born 1951 in Gagnoa, Ivory Coast
Lives in Abidjan, Ivory Coast

Kra Nguessan

Born 1954 in Daoukro, Ivory Coast
Lives in Chevry-Cossigny, France, since 1991

Yacouba Touré. **Didiga.** 1988. Mixed mediums, 36¼ × 29" (92 × 73.5 cm). Private collection

This refers to music played on an arc-en-bouche, an instrument characteristic of the Bete people. It refers also to a theater troupe of that name.

The Ivory Coast artists of the Vohou-Vohou group, most of them formed in art schools following the Western model, define their art in reaction to the European academicism of oil painting, "whence the return to springs, to soil, to surroundings, which is translated into the use of local materials. . . . Technically, the palette of the Vohou painters is almost lacking in brightness. They use mostly earth colors, shades of ocher, sienna, or dark brown, to which they add the bark from trees or lianas, patches of cloth, bamboo."

These sentences are quoted from "L'aventure du Vohou," a statement by the group, whose numbers are larger than the selection here indicates. Another such manifesto follows, revealing its debt to Dada, but speaking even more powerfully of its own Black-African identity:

The Vohou Revolution

If there is an emergency today, it is good to take a Vohou cure. If, saturated with the fare of "Dynasty" or "Rambo," you feel your soul has become "polluted," take a Vohou cure. If you find that the camembert you ate has a bad flavor, or that it gives you indigestion: Vohou is the SALVATION, the road to follow.

Vohou is a cultural rebellion (Youssouf Bath, Vohou painter). It consists of pragmatic Ivorian painters who . . . have pinpointed the disturbing effect of colonialism in their creation and suggest a therapy born from the encounter between traditional African society and the

modern world. Indeed, if political independence has unshackled the chains of colonialism, the spiritual essence that flows from the Black-African aesthetics, they claim, is the only remedy open to unshackle the invisible chains, aftereffects of this colonialization. Applying contemporary methods to the deep sources of tradition is not a negation of the latter, but rather a means for a person fragmented by the obligation to live within several cultures to regain the integrity of his being and to find the authentic areas within himself.

Vohou is not a school, it is a SPIRIT. It is not opposition (Nguessan Kra, Vohou painter), it is POSITION. . . . It is the third road between that of tradition and that of the modern world. IT IS VOHOU. It is not suicide, it is REBIRTH. IT IS VOHOU. It is not stagnation, it is the path to the summit of EVOLUTION. IT IS VOHOU. It is not visible, it is INTANGIBLE. IT IS VOHOU. It is PRIMITIVE, it is MODERN. IT IS VOHOU. It is PAST, it is PRESENT, it is FUTURE. IT IS VOHOU. It is not FRENZY, it is AWARENESS, it is THINKING. IT IS VOHOU. It is without a Mao collar, it is IDENTITY, it is LIBERTY. IT IS VOHOU. It is NATIONAL, it is INTERNATIONAL. It is BLACK-AFRICAN, it is WORLDWIDE. IT IS VOHOU. It is ACTION, it is DECOCTION. IT IS VOHOU. It is AFFIRMATIVE, it is NOMINATIVE. IT IS VOHOU. IT IS POSITIVE.

The capacity of Vohou is so huge that it can hold Japanese, Aborigine, Chinese, American, Papuan, obviously provided that these are in the possession of the Vohou spirit (Auguste Mimi Errol, art critic). Convinced that the problem of cultural identity is a debate that will dominate the world of ideas in the coming years . . . Vohou artists have set themselves the goal of rehabilitating African art by creating canvases in which the spectator can receive the shock of the material and of the color directly, although these nevertheless are wedded to signs and references within the spirit of the people. Technically, they are not concerned with the representation of the third dimension the Italian Renaissance established. They mean to be original and free in the choice of their materials (Théodore Koudougnon, Vohou painter).

Yacouba Touré (Vohou painter)

Yacouba Touré in Abidjan, Ivory Coast. 1993

Brahima Keita Ibak in Abidjan,
Ivory Coast. 1993

Brahima Keita Ibak. **Bulletin Board.** 1992. Mixed mediums, 31½ × 59″ (80 × 150 cm). Private collection

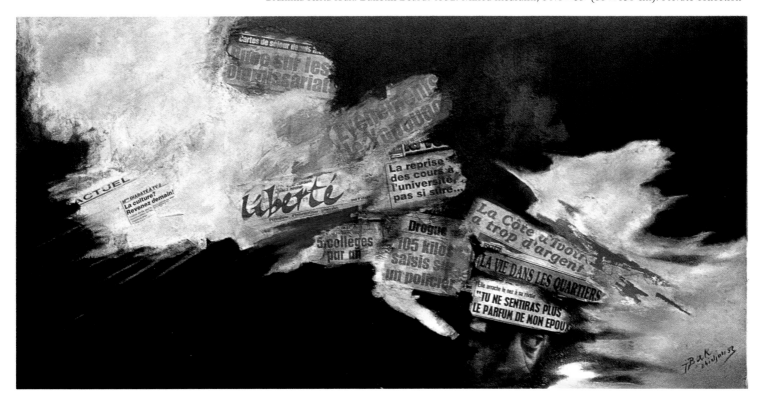

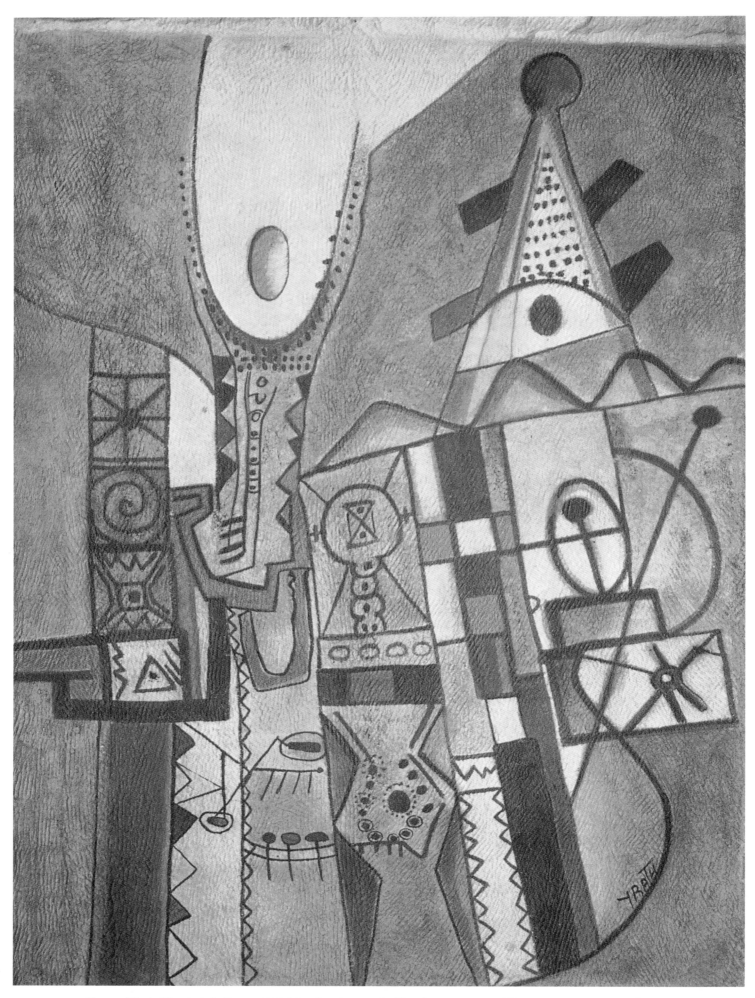

Youssouf Bath. **The Attic Is Empty.** 1980. Mixed mediums and self-made paint, 54 × 42½" (137 × 108 cm). Private collection

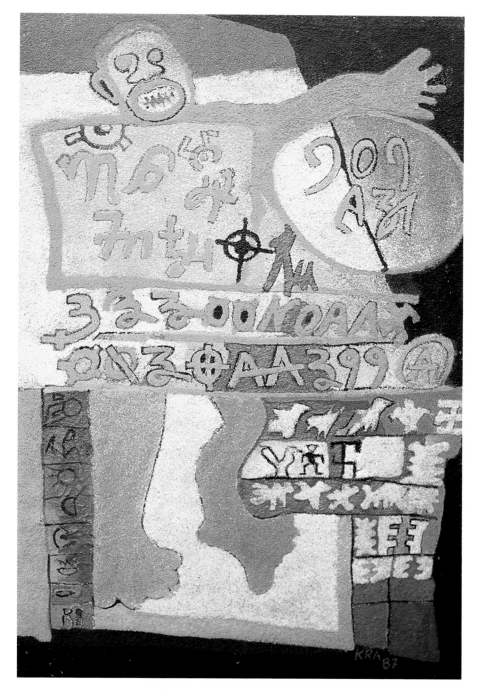

Youssouf Bath in Abidjan,
Ivory Coast. 1993

Kra Nguessan in Abidjan,
Ivory Coast. 1990

Théodore Koudougnon in Abidjan,
Ivory Coast. 1993

Top left:
Kra Nguessan. **The Madman of the Plateau.** 1987. Mixed mediums on canvas, 27½ × 19⅝" (70 × 50 cm). Private collection

Bottom left:
Théodore Koudougnon. **Beads.** 1988. Papier-mâché, oil paint, and beads, 25⅝ × 45¼" (65 × 115 cm). Collection the artist

Romuald Hazoume

Born 1962 in Porto Novo, Benin
Lives in Porto Novo

Romuald Hazoume in Porto Novo,
Benin. 1992

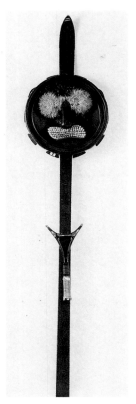

Avali Tolegba. 1992. Ski, brushes, and tennis
racket handle, 80¾ × 16⅞ × 4¾"
(205 × 43 × 12 cm). Collection Jean Pigozzi

Traditionally a legba* *is installed at the
entrance to a village.*

Although he was born into a Catholic family, Hazoume is of
Yoruba descent and has maintained contact with the traditional West African religion,
vodun,* especially through the cult of Ogun, one of the *orishas*.* His affiliation with two
religions may explain the atmosphere of conflict evident in his performances, in his totems
(made with a power saw), and in his recent series of masks, made with found objects used
as if in rebuses. A link between traditional mask culture and modern materials, he uses
collage to treat all these ceremonies, totems, and masks iconoclastically.

Picking up on the expression, often used in Africa where masks are concerned,
Hazoume states that he sees his masks "coming out," becoming visible. Literally, the masks
are coming out of hiding. They are kept hidden in certain houses until the day of the
festival. When the dancers put them on (a mask includes both a face and a body covering),
they are empowered, they assume the powers of the spirit they represent. In the words of
Y. Tata Cissé, this is an action that refers to the recapitulation of "all stages of creation."

Today in Africa, as for thousands of years—and particularly for the Yoruba of the
*Gelede** cult—masks are a part of the felicitous unfolding of life from its origins until the
end of time. The mask that disguises and terrifies is also an instrument of metamorphosis.
Following a strictly codified liturgy of initiation rites and tests, the mask wearer incarnates
the being personified by the mask.

Hazoume's interest in masks began in his youth. "As a child," he says, "I made many
masks, put together from salvaged materials meant for the *katela*, a kind of primary
apprenticeship school for mask making and learning proverbs through play. I know very
well that the initiated take care that tradition is respected." Thus, before the opening of
each one of his exhibitions, Hazoume invokes the spirits and the great priest who controls
access to them.

The extraordinary freedom to which this work attests, even in a form that is both
material and spiritual and plays a central role in African cultures, is respected by the rest
of the community (both animist and Christian). *My General, The Inspirer, Bagdad City,
Walkman,* and *Dan* are all examples of assemblages that constitute the exploration of
societies, civilization, and worldly events. These masks might pass for a modern reinterpre-
tation of the phenomena of trances meant to reveal the madness of today's world.

Unlike traditional masks in which the wearer is called upon to abdicate all personality
in order to take on that of the mask, Hazoume's masks express the personality of the wearer.
Whether they amuse or terrify us, these masks, constructed from a vacuum cleaner, an oil
can, or an old TV set, refer to what we are, do, think, and say. They assume the heritage
of the *Gelede* masks by integrating the "lesson" of the found object with the ideology of
uninterrupted planetary information.

A. M.

Vodun. 1992. Plastic can, terra-cotta, feathers, and found objects, 18⅞ × 6¹¹⁄₁₆ × 4⁵⁄₁₆″ (48 × 17 × 11 cm). Collection Jean Pigozzi

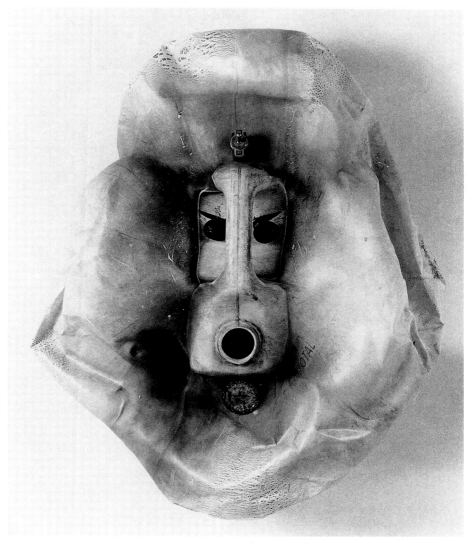

On/Off. 1992. Plastic can and found objects, 18⅞ × 15⅜ × 9⅞″ (48 × 39 × 25 cm). Collection Jean Pigozzi

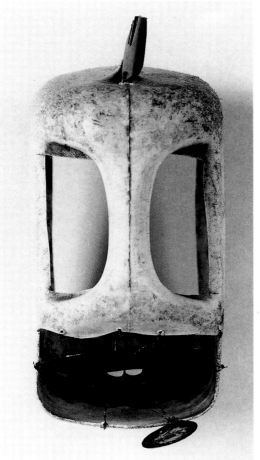

His Buddy. 1992. Plastic can and found objects, 10¼ × 4¾ × 8⅝″ (26 × 12 × 22 cm). Collection Jean Pigozzi

Meek Gichugu

Born 1968 in Ngecha, Kenya
Lives in Ngecha

Meek Gichugu in Nairobi,
Kenya. 1993

Born John Mburu Njenga, Meek Gichugu—as he prefers to be known—grew up in the small village of Ngecha, close to the capital of Kenya, Nairobi. Although he had been drawing and painting since childhood, it was not until 1985—when Sane Wadu's success as an artist (see pages 142–43) was becoming known through the newspapers—that Gichugu realized he could pursue a career in art. After leaving school in 1987, he started to paint seriously.

Initially Gichugu received encouragement from other artists in Ngecha; Sane Wadu soon gave Gichugu money to purchase paint and canvas. A short time later, Meek's work was included in two small group shows and in the 1990 exhibition *Ngecha—A Village of Painters*, at Gallery Watatu in Nairobi.

Though Meek's work has undergone gradual changes in style since his first exhibition, many aspects of his painting have remained the same. His palette of muted tones of yellow, ocher, blue, red, and green has retained a familiar softness throughout all his work. Over time he has steadily moved from loose, impressionistic brushstrokes to much tighter and more precise work, and the overall effect is one of refinement, the removal of extraneous detail.

Meek says that he rarely plans a painting; instead they tend to evolve on the canvas out of the stream of consciousness that grows from his initial idea. Often after completing a painting, he will realize that there are several unintended meanings. He claims it is his primary intention to entertain; the clarity of the forms, the colors, and sometimes the humor of the scenes are his attempts to catch the eye.

In many of the paintings—especially in his most recent works—a pile of interlocking figures spreads up from the foreground like a plant. People are fused together into a tree that stretches out across the face of the canvas, woven with vines and branches and creepers. Often the group stands ankle deep in a pool that perfectly reflects them and the sky above. Though these figures are rarely smiling, and his compositions are often unsettling, Meek explains that the water is for happiness, and the people seen in it are having "best time." Certainly the water makes a striking contrast to the desert-like landscape behind.

Among his recurring symbols, his "trees of people" usually sprout the spheres of an unknown fruit. Meek interprets these as the human goal, the reward for all endeavor. Within the tree, therefore, it would seem there is a hierarchy determined by relative closeness to the fruit, a hierarchy confirmed by titles like *Self-Elevated One*.

In many paintings, Meek mixes human figures with the limbs, haunches, necks, and ears of zebras, giraffes, and lizards. He finds humor in his creatures, saying, "Sometimes people are like animals." The creatures certainly share the poise, position, and perspective of his human figures—calmly turning their heads to face the viewer and reinforcing the impression that we are spying on another world—and this serves to make them highly disconcerting. There is a tension in all of Meek's paintings beneath the calm colors and statuesque placidity of the scenes that becomes manifest at first only in an unconscious, visceral response.

While Meek is interested in the acceptance of his work and wants people to like it, he does not worry about being misinterpreted. He offers little insight into the meaning of his work and says it is up to the viewer "to learn what I am doing." Fortunately, there are many who are prepared to learn.

Rob Burnet

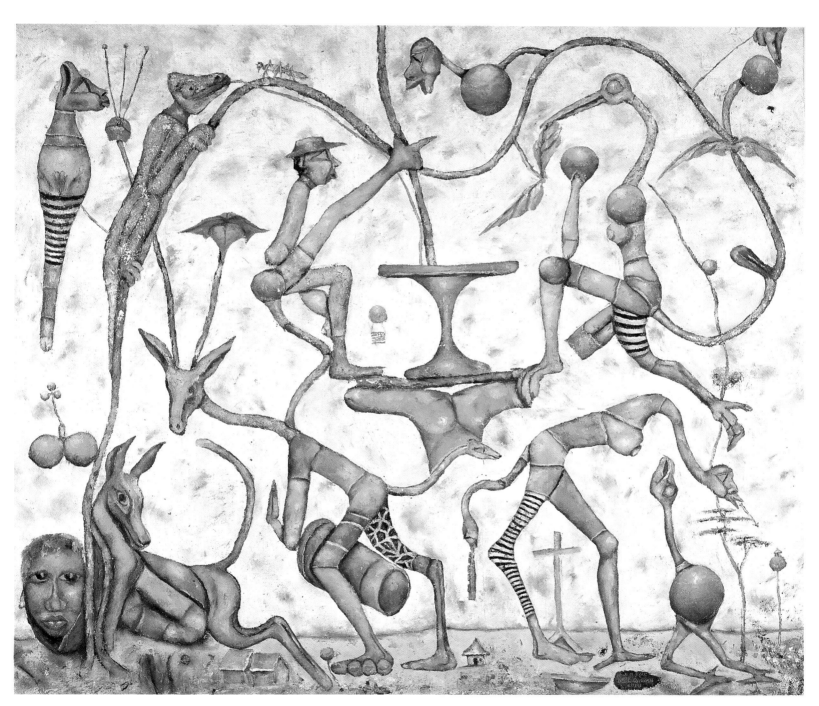

What a Fight. 1992. Oil on canvas, 19⅝ × 25⅝″ (50 × 65 cm). Collection the artist

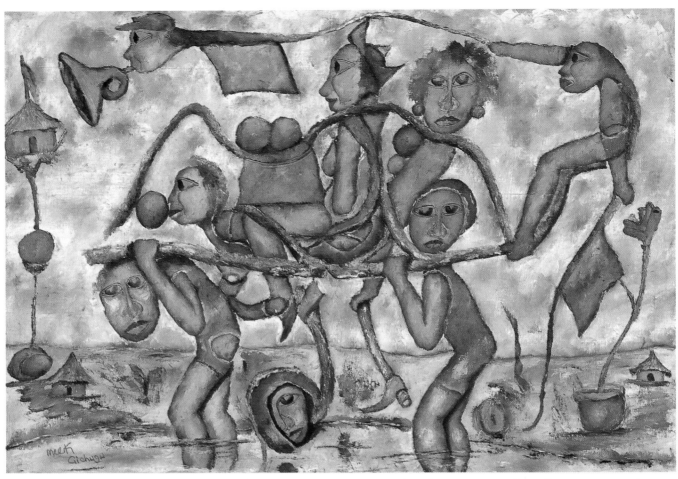

Self-Elevated One. 1991. Oil on canvas, 10⅝ × 15″ (27 × 38 cm). Collection Marc Van Rampelberg

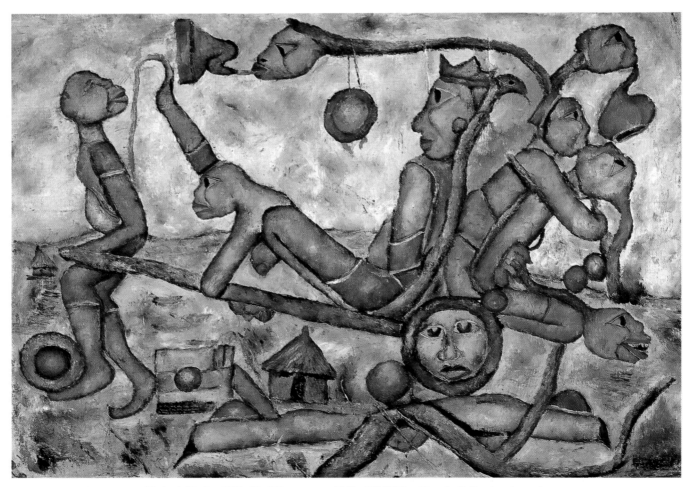

Nation's Fruits. 1991–92. Oil on canvas, 13¾ × 15¾″ (35 × 40 cm). Collection the artist

Mor Faye

Born 1947 in Dakar, Senegal
Died 1985 in Dakar

Mor Faye in Dakar, Senegal.
Early 1980s

In many ways the artistic career of Mor Faye is parallel to that of Christian Lattier, who also died too soon (see pages 104–5). Both of them engendered, under quite similar circumstances, a true legend which borrows some of its characteristics from the Western *artiste maudit* (accursed artist). Like his Ivory Coast predecessor, Mor Faye died in poverty and having known only indifference to his work.

Mor Faye studied at the Maison des Arts in Dakar under the painter Iba N'Diaye and others. He then divided his time between teaching art during the day and his secret creative life at night. Often painting by candlelight, he is said to have created an impressive oeuvre of some eight hundred pieces. Because his production was so vast, it is difficult to find a single adjective, such as "abstract" or "figurative," for the entire body of work. Many of the pieces display an energy and freedom of abstraction that one is tempted to call "expressionist"; they are well-nigh exemplars of "action painting." But an equal number employ a figuration that goes as far as caricature.

Until 1974, much of Mor Faye's work was influenced by the often violent paintings of Iba N'Diaye and the official Négritude* style. But Mor Faye had too strong a personality merely to follow diligently in the path of a master or to obey the canons of a state aesthetics.

In 1982, Mor Faye was sent to a psychiatric hospital in Dakar, where he remained on and off for two years. Did he die of malaria or of insanity, as is sometimes claimed? If madness is evidenced by the "absence of works," as literary theorist Michel Foucault has stated, Mor Faye could hardly have died of madness. Liberated from material worries, he was able during those two years of confinement to devote himself entirely to his art. Nobody has better described this period of his life than his friend Issa Samb (see pages 152–54), when he declared: "In any case, at the end of his life, one sees him descend into a well of colors, as if he wanted to commit suicide down there." Finally, it appears that the real parallel in careers was between Mor Faye and the American painter Jean-Michel Basquiat (who also died young) in a mutuality of approach which, from one side of the ocean to the other and without their having encountered one another, secretly connected their works. And both were consumed not like a candle but like a wick, promising joyous fireworks. A happy thought.

J. S.

Above left:
Untitled. 1982. Gouache and ink on paper, 19⅝ × 25⅝" (50 × 65 cm). Collection Atlantic Joint

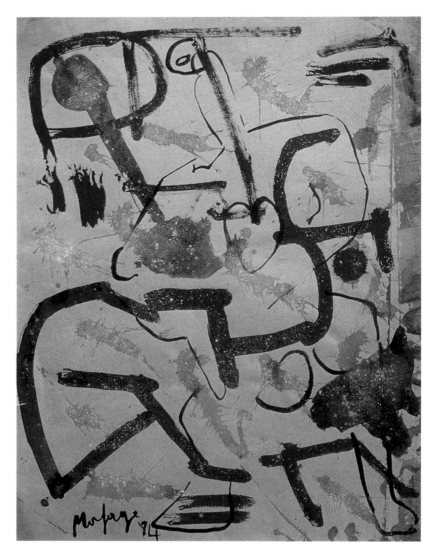

Untitled. 1984. Gouache and ink
on paper, 19⅝ × 25⅝″(50 × 65 cm).
Collection Atlantic Joint

Untitled. 1983. Gouache and ink
on paper, 19⅝ × 25⅝″(50 × 65 cm).
Collection Atlantic Joint

Thomas Kgope

Born 1954 in Delmas, the Transvaal,
South Africa

Lives in the Transvaal

Kgope's mother was from the Ndebele tribe (see pages 46–49) in the Transvaal, and his father was a Tswana. Kgope loves the bright colors of the Ndebele and grew up with their patterns and designs as part of his experience. He still lives a simple life in the rural areas and has never lived in the city.

Trained as a freelance photographer, Kgope later established himself as an electrician. While working at this trade, he encountered Norman Catherine, a leading South African artist. After an accident in which Kgope fell from Norman's roof, King Norman, as Kgope refers to him, instructed the younger man in the basic principles of painting. Thomas had never seen actual art before meeting Catherine, who showed him how to use a paintbrush. He also introduced Kgope to the wonderful fantasy world of Fook Island, which had been invented in the late 1960s by an artist named Walter Battiss. He was the first king of Fook and soon appointed Norman Catherine as another king. Fook Island has its own alphabet, stamps, Bible, flora and fauna, etc. Fook Island was launched in the Goodman gallery in Johannesburg in 1975, where it has continued to preach its philosophy of love, harmony, and permissiveness. Kgope lived with Catherine during the launching of Fook Island.

Norman Catherine feels his main contribution to Kgope's development was to tell Kgope that he did not have to copy what he saw. Instead he encouraged him to put down the many images and patterns stored in his fertile imagination, giving rise to busy, colorful, and occasionally bizarre work. Kgope suffered a great deal from nightmares, particularly after falling from the roof at Catherine's home, and he was unable to distinguish between reality and dreams. The fantasy Fook Island was, therefore, a natural inspiration for him.

Kgope gave Fook Island a character of his own. Kgope's sculpture is created from found objects—unusual stones, snakelike twigs, and other objects which he animates. Several of his other works depict people dancing toward the Ladysmith Black Mambasa Church, which he joined after leaving the Pentecost Church. Kgope also integrates myths from Ndebele culture with those from Christianity and Eastern religions.

Kgope is very involved with and influenced by the South African media, in particular television, and has an ongoing love affair with Coca-Cola. Keren Leigh, a student of Kgope's work, says, "He is allied with the Pop Art movement of the U.S.A. although from the other side. Pop in the States was a comment on the media's influencing the intelligent and educated public with the mind of advertising. Kgope comments on the political use of media as the ideological weapon directed against the uneducated in South Africa in the same manner. With humorous satire he undermines anything from children's television programs to advertising campaigns."

Kgope mixes imagery of tradition with imagery of innovation. His art tells a story of the lives, loves, and fears of a black nation struggling to find identity inside a culturally foreign world. Filled with highly personal experiences and illusions, it is situated on the indeterminate border between Ndebele art and the Western tradition.

Kgope also employs the Ndebele style of incorporating elements from the alphabet into his paintings. Letters become part of the design. Several of the works include Ndebele patterns which have been assimilated from the colorful murals in his environment.

The New Sticks illustrates his blending of the two cultures. The stick relates to the church and is also a symbol of power which the Ndebele carve out and use in their traditional and witch doctor practices.

I Love You is a sad work. He depicts a little dog and a fish hanging from a post, a projection of his own loneliness and feelings of being an outsider. On the right is Tommy— he usually draws himself as a star. He is not a part of the art world, nor is he a part of tribal life.

Kgope's works have received a mixed reception and not everyone can tune in to his naïve approach and lack of formal training. But there are many knowledgeable observers, like Catherine, who praise his wide range of creativity, originality, and unique vision of African life in the rural areas.

Natalie Knight

Thomas Kgope in the Transvaal,
South Africa. 1993

Coke Town. 1990. Poster paint on paper, 13⅛ × 20⅛" (33.5 × 51 cm). Courtesy Goodman Gallery, Johannesburg

The New Sticks. 1990. Poster paint on paper, 11 × 14¾" (28 × 37.5 cm). Collection Jean Pigozzi

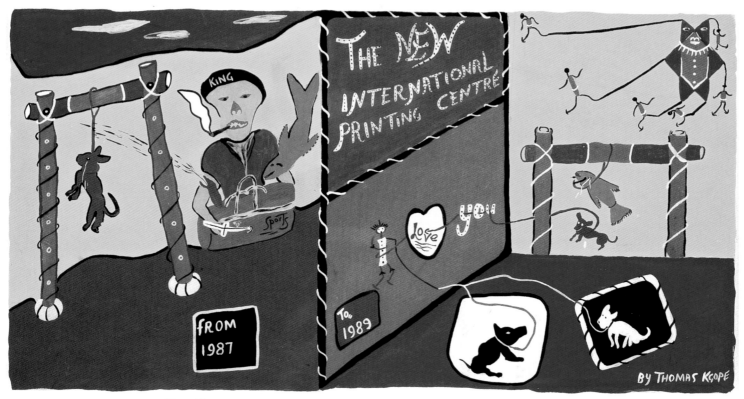

I Love You. 1990. Poster paint on paper, 11⅜ × 20⅞″ (30 × 53 cm). Collection Jean Pigozzi

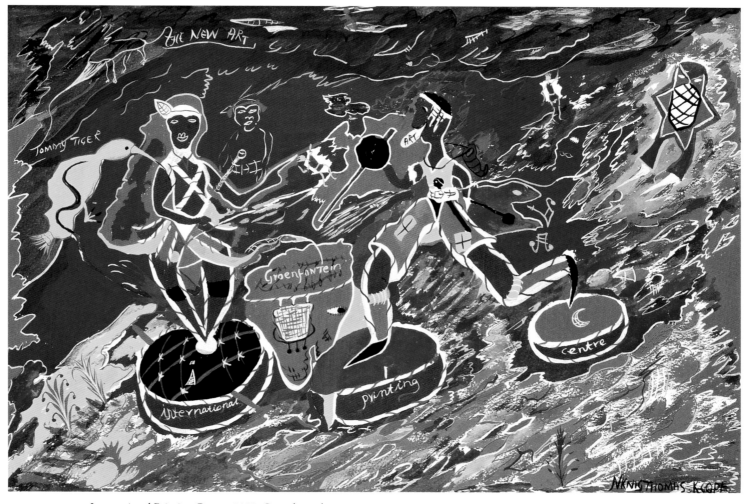

International Printing Centre. 1983. Gouache and poster paint on paper, 14⅛ × 21¼″ (36 × 54 cm). Collection Jean Pigozzi

Sane Wadu

Born 1954 in Nyathuna, Kenya
Lives in Kiambu, Kenya

Sane Wadu in Nairobi, Kenya. 1993

Growing up on the outskirts of Nairobi, Sane Wadu as a child experienced both urban and rural Kenya. In the early 1980s—after completing high school and working as a teacher—he left the classroom. He explains that it was boredom that forced him to change: as a teacher, he says, every year he would think the same thoughts; as an artist, "your head can jump." He has never returned to teaching.

Wadu's earliest creations were in poetry and prose. However, he was soon attracted to the ambiguities of painting, in the sense that pictures can be open to multiple interpretations. His early works met with such disdain that Wadu took on the name "Sane," in retort to accusations of his insanity.

Wadu's paintings first reached the Kenyan public in 1985. In those days he was working with household paint on plastic sheeting and even painting on the clothes he wore. A pair of trousers made at this time combine painting with poetry. On the front, among pictures of people and animals, he wrote: "Always remember it's your right to feel frustrated if you are," and on the back, "Tell me today whi's [sic] the nearer—tomorrow or yesterday?"

After his first successes, Wadu quickly adopted oil and canvas, the tools of European fine art. Though he had received no formal training, his creativity and drive quickly secured him a national and international audience. He has had a one-man exhibition in New York, and his work has been seen in California and Europe.

Formally, Wadu's paintings have alternated between structured single-point perspective and abstract, dreamlike compositions and forms. He has moved between a tight, impressionistic style and flowing, Surrealistic abstracts—sometimes applying paint in constrained impasto, and sometimes in bright, fluid washes.

Wadu's choice of subject matter has also followed a shifting and varied course. Early works often show the wildlife of rural Kenya; hyenas, buffaloes, leopards, and elephants are depicted in isolation in a characteristic wide landscape of distant horizons and soft, muted colors. Though he explains that his inspiration was often simply the sight of these creatures, the paintings are more than merely descriptive. Placing them in a wild, unpopulated landscape, Wadu says he also ponders the thoughts in the animals' heads.

Wadu paints the bush people as solitary figures, like his wild animals. Alongside camels, sheep, or cattle is the lone herdsman, the solo traveler. United through their labors with the environment in which they are set, the figures confront the viewer with a forthright gaze and open, naïve honesty—attributes paralleled by Wadu's style itself. In conception, his people are no different from his animals.

Just as he works to grasp the consciousness of wildlife, many works are self-portraits in the roles of his subjects in order to attain a closer empathy with the people he depicts. He is the Virgin Mary, the farm worker, the lover. In the same way, in works like *The Tower of Babel, Isaac and Abraham,* or *The Burden,* he explains that his intention is not religious or allegorical, but only to bring to the images his personal understanding of their meaning—often a sense of passive, inexorable fatalism. Man and nature are fused with their environments, bound to their physical circumstances, apparently all-knowing, but always in the end impotent.

Since the onset of the 1990s, Wadu's paintings have started to enter an urban environment and his compositions have become more abstract. On his increasingly crowded canvases the figures press forward and outward, their massed humanity laid ever more bare. As in the earlier rural scenes, the feeling of man's burden is all pervasive, but now his people are wiser and more corrupt in their congested new circumstances. Still fused to their surroundings—in a physical sense, since the emergence of a thick, richly colored, expressionistic technique—they retain their knowing and passive acceptance of the human condition.

Rob Burnet

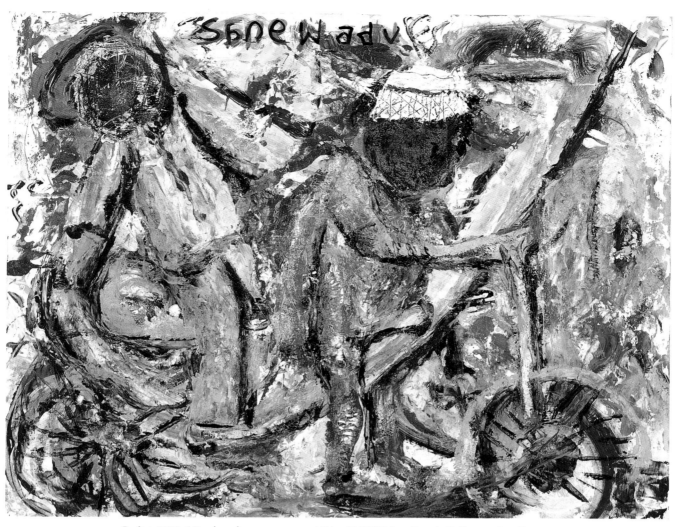

Cyclist. 1991. Mixed mediums on canvas, 15⅛ × 19¼″ (38.5 × 49 cm). Collection Jean Pigozzi

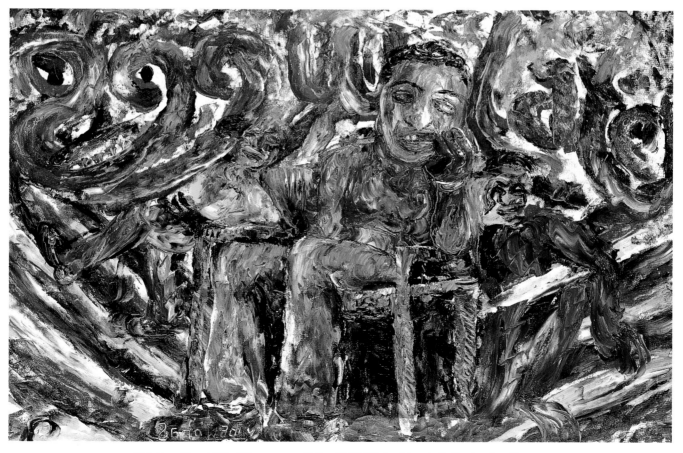

Thinking Man. 1990. Oil on canvas, 19⅛ × 29⅛″ (48.5 × 74 cm). Collection Jean Pigozzi

Abdoulaye Konate

Born 1953 in Diré, Mali
Lives in Bamako, Mali

Abdoulaye Konate in Bamako, Mali. 1993

Above right:
Design for a Political Event II. 1991.
Installation, car carcass, video monitor,
newspapers, stones, ashes, and glass, overall
78¾ × 236¼ × 118¼" (200 × 600 × 300 cm).
National Museum, Bamako

Opposite:
The Drama of the Sahel. 1991.
Installation, painting, mirror, sand, wood,
and found objects, overall 126 × 78¾ × 94½"
(320 × 200 × 240 cm). National Museum,
Bamako

Abdoulaye Konate began his artistic training in 1972 at the
National Institute of Arts in Bamako, in the department of painting. From 1978 to 1985,
Konate lived in Cuba, increasing his knowledge of Cuban culture. Konate's work interprets
his own Bambara culture, borrowing from traditional elements (ideograms, masks, music,
and instruments) that are an integral part of life in the villages. Konate seeks to introduce
everyday objects in his work, inspired by profound realities so that "the people will under-
stand and recognize themselves."

Without abandoning painting, since 1990 Konate has been making politically and
environmentally influenced installations. Struck by the great scourge of Africa—the gal-
loping encroachment of the desert in the Sahel—he created works such as *The Drama of
the Sahel*, presented in 1991 at the National Museum in Bamako. Konate wishes to remind
the public that the responsibilities of humankind in the transformation of the natural
landscape cannot be abandoned. He invests his work with the power that art possesses of
sensitizing the population to the necessity of protecting its ecological and cultural heritage.

For another of his installations Konate salvaged a car that was torched during the
political demonstrations of March 1991 in Bamako. It became the central element in a
work titled *Design for a Political Event II*. Inside the car Konate placed a television set that
broadcasts old news reports of the impending downfall of President Moussa Traoré.

Konate's works function like a sound chamber. They provoke an insistent questioning
of the political, social, and economic scene of contemporary Mali. They participate in a
concrete manner, aiming to foster the development of social awareness within the culture.

A. M.

David Koloane

Born 1938 in Alexandra, South Africa
Lives in Johannesburg, South Africa

David Koloane in Johannesburg,
South Africa. 1993

My Work, Its Role Within South African Art

When I started painting in 1974, my work like that of every artist living in the township evolved around the human condition.

The sociopolitical conditions created by the apartheid system within Black communities were characterized by deprivation and restriction.

I was guided in my training during this period by Louis Maghubela. Maghubela was amongst the finest group of Black professional artists. They were products of the Polly Street Art Center in Johannesburg. The Polly Street Art Center was the finest creative facility initiated for Black artists in South Africa in 1949.

Maghubela also became the first artist to break away from the social realistic genre common amongst artists in the sixties.

In 1972 Maghubela left South Africa to settle in self-exile in Spain and is presently in London. I later trained under the late Bill Ainslie who was recommended by Maghubela before he left. Bill Ainslie was a prominent artist whose early work comprised a more mental figuration. This work was reminiscent of the work of the Mexican muralists early in the century. This work gradually assumed a nonfigurational approach until it became large scale and decidedly nonobjective.

In 1985, Bill Ainslie and myself founded the Thupelo Art Project. The primary objective of it was to conduct an annual two-week workshop. The aim was to encourage the development of the artists' creative potential. The workshop became a forum which enabled artists to explore and experiment with relatively new materials, techniques, and approaches. Participants were creators from different parts from the country.

The workshop concept has enabled artists [to experience] a renewal process of their expression. . . .

My work of the period has been largely nonobjective as I experienced varied techniques, colors, and formal concerns.

The workshop endeavor has inspired artists to venture beyond stereotyped expression in a manner only paralleled by Louis Maghubela's innovative work of the late sixties. The concept has since been initiated in Zimbabwe, Botswana, and Mozambique and is about to be launched in Zambia. In my present work I have returned to the fundamental discipline of drawing. I strive to integrate the technical experience and formal relationship acquired from extensive workshop participations into a figural expression based on the human condition.

David Koloane

Made in South Africa No. 8. 1992. Graphite and charcoal on paper, 25¼ × 36″ (64 × 91.5 cm). Collection Jean Pigozzi

The series of drawings Made in South Africa *constitute a narrative sequence executed in graphite.*

The drawings are based on the tragedy of South African politics and how the violence resulting from this has engulfed the existence of communities.

The events in the drawings are interpreted through an amalgam of metaphorical animal symbols. The most dominant symbol employed is a predator in the form of a rabid dog or mongrel. I attribute this symbol to the mgodoyi *or mongrel, which roams the township in packs which do not appear to owe allegiance to anyone and as such [are] unaccountable for their actions. The predator symbol is in essence the personification of unleashed terror and destruction which plagues the communities. The animal is depicted in a number of varied frenzied and savage poses with snarled teeth, leaping and lunging at the viewer in contorted body motions, advancing menacingly with head alertly turned back like an antenna. In some sequences it is contorted with one front leg lifted and caught between savage*

teeth. In another its head is twisted back and the tail is clamped between its vicious teeth.

The apparent reference in the . . . drawings is the self-destructing carnage which plagues the communities. The predator form is invariably set against the hazy nondescript township background with a shimmering sun/moon disk. The shimmer of light is intended to expose the dark deeds of the predator.

My technique employs intense tonal contrasts created by layered swirls of line which are often aggressive. The swirling lines are anchored by the solid shape of the sun/moon disk above the township settlement, the predator, and the accumulation of tipped garbage cans and debris. At first glance the swirling lines lend the drawing a nonfigurative image. Gradually however details unfold surreptitiously until the drawing is coherent.

D. K.

Made in South Africa No. 7. 1992.
Graphite and charcoal on paper, 25¼ × 36"
(64 × 91.5 cm). Collection Jean Pigozzi

Made in South Africa No. 17. 1992.
Graphite and charcoal on paper, 25¼ × 36"
(64 × 91.5 cm). Collection Jean Pigozzi

Made in South Africa No. 18. 1992.
Graphite and charcoal on paper, 25¼ × 36"
(64 × 91.5 cm). Collection Jean Pigozzi

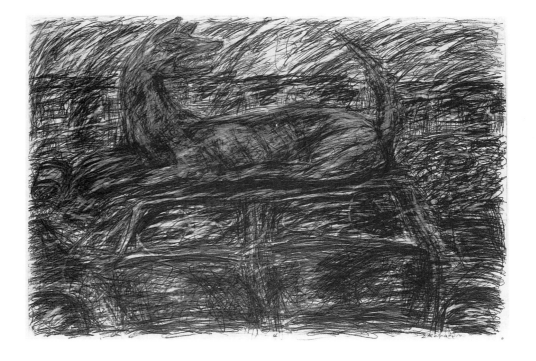

Tommy Motswai

Born 1963 in Johannesburg, South Africa

Lives in Johannesburg

Tommy Motswai's richly colored pastel drawings offer highly personalized commentaries on contemporary urban South African life. It is not activist art or didactic protest art. Motswai sees and describes the activities of a kaleidoscope of people, each a fully realized character as well as a member of a crowd. The recurring themes of his narratives are the responses of the individual, the behavior of the individual in the group, and the social responses of the crowd.

Whilst it can be argued that visual narrative depends on the inclusion of significant detail, the close observation of people and objects in Motswai's work indicates more than a concern with structuring spatial sequences that will allude to time and action. For this artist, signs—written words, body language, facial expressions, and clothing codes—assume a special communicative significance. Motswai is deaf; he *sees* reality and his pictorial interpretations are unmediated by beguiling words or the cacophony of sound.

Deaf from birth, Motswai—unlike Goya—did not have to adjust to the loss of hearing. He has had little formal art training, although he was fortunate to get his schooling at the Kutlwanong School for the Deaf, where he later returned to teach.

Impregnated with humor and an affectionate regard for the foibles of women and men, Motswai's images are beguiling. But it would be a mistake to read them as realist images. They are not objective and impartial representations of the real world but constructed visions. They are passionately subjective, and declare themselves as products of invention, imagination, and selection. They are colored drawings, not life.

Tommy Motswai in Johannesburg, South Africa. 1993

A close study of his characters indicates that he has created a family of types that recur in different situations. In common with the caricaturist, Motswai exaggerates and manipulates idiosyncratic details. He describes appearances, taking nothing for granted and expecting the viewer to locate meaning by making connections between people and objects.

His egalitarian treatment of forms gives each its value. Objects indicating taste and material affluence, or signifying achievement, feature prominently in his imagery. In *The Winter Soup Party* each picture on the walls tells its own story and contributes to the ambience of the middle-class urban home. *The Last Supper* hangs above a naïvely rendered rural landscape. An elaborate clock divides these images from a series of portraits dominated by a nervous groom and ecstatic bride. The wall beyond the arch is occupied by a portrait of a graduate in cap and gown surrounded by his framed university degrees. Having had to battle to achieve, Motswai depicts the winners in society and not the losers. He does not portray scenes of desperation but those of celebration.

Devoid of the wish to engage in rhetoric or to pass moral judgment, Motswai does not treat his people as concepts but as vulnerable human forms possessed of their own dignity, silliness, and self-importance. His people are city dwellers. They have absorbed Western values and transformed them for their own needs. In depicting his own wedding, Motswai, his bride, Evelyn, and the attendant children are resplendent in white, but next to the proud groom is a gap-toothed character in overalls, gum boots, and a woman's hat who is entertaining the crowd as he might have done at a rural ceremony. The ceremony becomes a particularly African one, free of stiff European etiquette and replete with goodwill. It is a triumphant demonstration of transculturalism.

His works give many indications that he enjoys observing people *en masse*. He portrays the many ethnic groups, cultures, and life styles that constitute South Africa. As much as any other artist, Motswai tells one side of the social story of the complex South African society. He chooses to depict people with humor and compassion. This may well be what he sees but it is also indicative of Tommy Motswai's own personal strength, serenity, and refusal to indulge in self-pity.

Dr. Marion Arnold

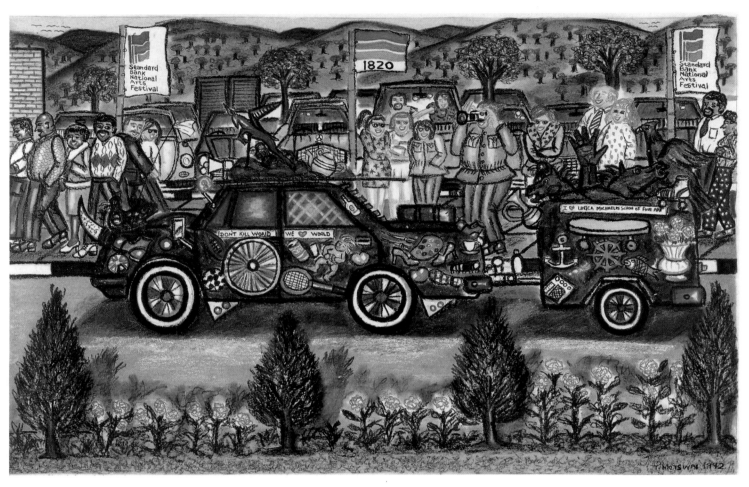

Excellencies Show Sculptor Resin on the Car Experience Party Happy. 1992. Pastel on paper, 26 × 40″ (66 × 101.5 cm). Collection Jean Pigozzi

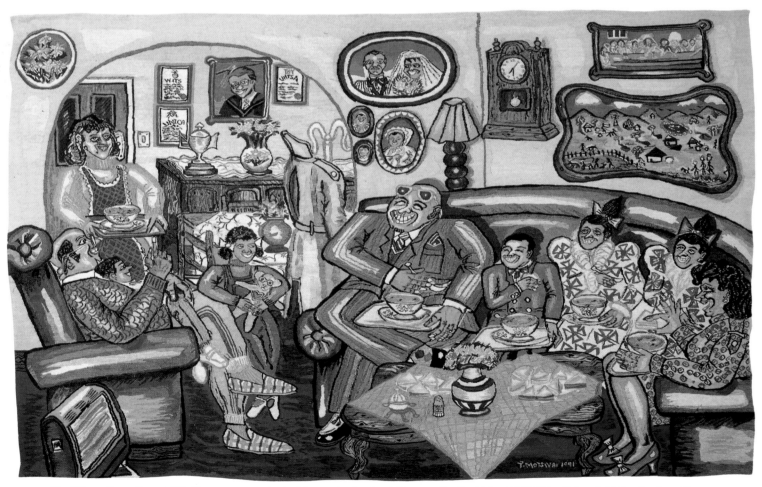

The Winter Soup Party. 1992. Tapestry woven in the Marguerite Stephen's Tapestry Studio, 81⅛ × 126″ (206 × 320 cm). Collection Jean Pigozzi

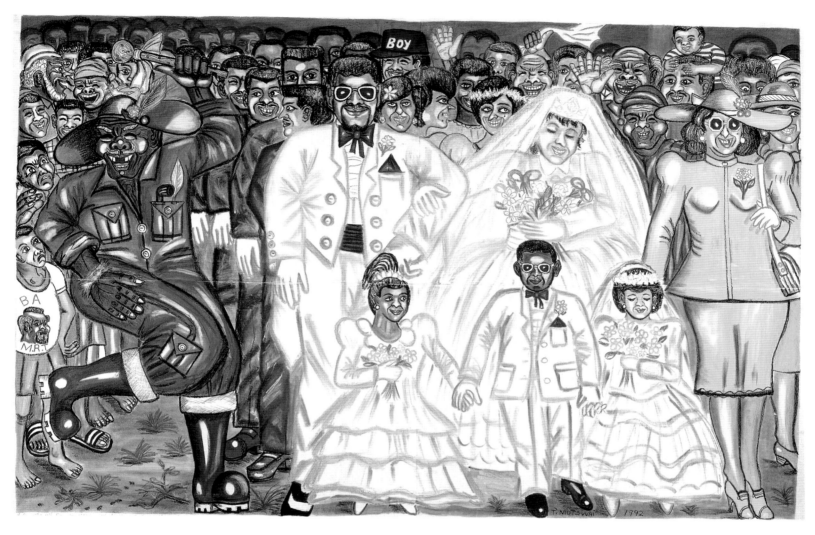

On 8th to 9th December 1990, Married Mr. T and Mrs. Evelyn Motswai. 1992. Pastel on paper, 41 × 26¾" (104 × 68 cm). Courtesy Linda Goodman Gallery, Johannesburg, South Africa

Issa Samb
(Joe Ouakam)

Born 1943 in Dakar, Senegal
Lives in Dakar

Issa Samb in Dakar, Senegal. 1992

Issa Samb, also known as Joe Ouakam, belongs to that generation of African artists that came out of the art academies created right after independence and committed to a direction that radically reformulated the role of the artist in contemporary African society.

Because of the high level of national consciousness that the state in Senegal managed to promote through the arts (the Festival des Arts Nègres and the Musée Dynamique from 1966 on, the Village des Arts until 1983), that country provided a unique terrain in sub-Saharan Africa (with the exception of South Africa, no doubt) for tackling this question anew. As recently as 1990, the movement called Set-Sétal,* to which Samb refers often, gave proof of the fact that Senegal (despite its recovery, that is, its manipulation by the authorities) offered a field favorable for the implementation of "agit-prop" style experiments.

Wishing to end "Negro-African" academism, in favor with the powers and widely promoted outside of Senegal under the pompous name of the School of Dakar, Issa Samb joined the Agit-Art movement, created by, among others, the painters El Hadj Sy and Amadou Sow and the photographer Bouna Seye.

A painter by training, Issa Samb is developing creative work today that goes well beyond a strictly plastic problematics and looks more like what an artist such as Joseph Beuys produced during the sixties and seventies (with Samb, the utilization of the blackboard is particularly significant in this connection).

Very close to the Mali artist Abdoulaye Konate (see pages 144–45) in this aspect, Issa Samb has a strongly structured perception of the role of the artist in contemporary society: no longer a creator of beautiful objects, whose aim it is to fortify social strategies and power (prestige, patronage) under the label "aesthetics," but an *experimenter* who makes use of everything that society and the history that cuts across it can possibly put at his disposal. Thus, in the courtyard of his studio in the Rue Jules Ferry, in the center of Dakar, one can see paintings on unstretched canvas haphazardly tacked to the wall next to a vast inventory of signs and objects that serve as both framework and implements for this experimentation: portraits of Che Guevara, Lenin, or Mandela; a Senegalese flag; road signs with the Polish logo "Solidarnosc" or with the directive "Walk!"; manuscript notes, photographs, objects of metal wire, wooden statuettes, heaps of stone, chairs, and so forth.

In an unpublished interview with the author in December 1992, Samb summed up one of the central objectives of his work: "Showing that, in ways other than being psychiatrically committed, other than the indifference some people are beginning to show in this country where deviants are concerned, where the so-called insane are concerned, there can be a way to be sociologically integrated through art, which often is more effective." This is the appropriate moment to recall that Senegal is the cradle of one of the experiments of so-called traditional psychiatry (as opposed to psychoanalysis or so-called hospital psychiatry, of Western origin), among the most creative on the African continent, the Ndöp, a ritual ceremony practiced by the Lebou, which takes place on the edge of the beach, during which the group takes charge of a deviant, socially maladjusted person. A "psychiatry" without walls, which has not gone unnoticed by the practitioners of hospital psychiatry, and which Issa Samb, himself a Lebou, is perhaps continuing.

Refusing to sell, denouncing the shortcomings of the art market in Africa, where the creative artist must also be a dealer, Issa Samb is a kind of modern cynic, always guarding against ways of coopting subtly put into play by those in power.

J. S.

Agit-Art Group. Installation view, mannequin, signs, fragments of sculptures, hand-written notes, assemblages, and found objects. Compound of Laboratoire Agit-Art, Dakar, Senegal, 1980 to present

Agit-Art Group. Installation view, painting, hand-written note, and mixed mediums. Compound of Laboratoire Agit-Art, Dakar, Senegal, 1980 to present

Agit-Art Group. Detail of installation
view, chair, and Christmas decorations.
Compound of Laboratoire Agit-Art,
Dakar, Senegal, 1980 to present

Agit-Art Group. Detail of installation
view, mannequin, and mixed mediums.
Compound of Laboratoire Agit-Art,
Dakar, Senegal, 1980 to present

Willie Bester

Born 1956 in Cape Town, South Africa

Lives in Mitchell's Plain, Cape Coast Region, South Africa

Willie Bester in Cape Town, South Africa. 1993

Willie Bester, and the works he makes, are like two halves of different oranges. Try to put them together, and they do not fit at the edges. The man himself is gentle, almost apologetic, but his work is grindingly strident. The eldest of three brothers and three sisters, Willie Bester was born in a farming town in the Cape. He was six months old before his parents married, and so he was able to keep his mother's Afrikaans surname and privileges. Under South Africa's apartheid system, "colored" spelled many privileges over "black" privileges his mother (and siblings) lost when she married Willie Fagele, Sr., an African.

Bester's father worked as a fence maker, picking up work from local fruit and wine farmers. His mother sold liquor to other farm workers from her backyard. Willie was ten years old in 1966 when black families were required, under the Group Areas Act, to move into an all-black township. His mother was arrested often and fined for selling liquor. A conviction in 1969 led to the family losing their "scheme" house (government-run low-cost housing) and the Bester/Fagele family once again became tenants. Willie left school after the sixth grade to help with the family finances and took work where he could find it.

What work Bester could find was seasonal, and he was drafted into the Eersterivier Cadet Rehabilitation center for not having held down a job for more than six months at a time. This brought him to the outskirts of Cape Town, for a year of *strafkamp* (punishment camp), after which he entered the employ of Frikkie Freeman, as a dental technician earning $40 a month (at the time of writing $1.00 = R3.120). He quickly learned the job and fifteen years later, when he resigned in 1991, he was earning $450 a month.

His artwork is influenced by these experiences and the strong identification he has with the people. *Migrant Miseries* is one such work (see Bester's commentary on page 156). The impetus for this large work is a *trompe-l'oeil* passbook (an identity document which black South Africans were required to carry at all times; among other controls, their right to work in certain areas was prescribed by this document) belonging to a Mr. Stanford Semekazi. The real one was bought from Semekazi. Until 1985, failure to produce one's passbook on demand could result in a prison term, and Bester says that Semekazi found it hard to part with his. The legend in the top right-hand corner is repainted from a scrap of paper on which Semekazi had written a lament concerning the inadequacy of his $38-a-month pension.

The dead-center portrait, the screamingly obvious metaphor of barbed wire, the real chain bolted to the "constructed" bible (*ibhayibhile*) do not bother him. "I learned from the struggle that the people developed a kind of language," "one which is simple and direct." The No Jobs sign on the factory wall is part of the language of the bosses. His compilation of a factory out of an aerosol can, spark plug, and bird wire is the language of those who have to make do. However, Bester acknowledges the Pollock influence (evident in the dribbled paint) and uses its aleatoric script to integrate his surfaces.

This *bricoleur* approach is evident also in the motif of the guitar (see *Homage to Steve Biko*) and the flattened bottle-top rattle found in nearly all his works. Bester says the guitars symbolize control. He is very definite about the meaning of each element in his compositions and sees music as part of the self-control adopted by working-class people. Opposed to the misuse of *dagga* (marijuana) among the youth, Bester mounts a complex, if not entirely sympathetic, critique of white South African society. *Kakebeen* includes one of his own photographs (most of the rest are lifted from newspapers and magazines) of a lunch party on the terrace outside a Cape Dutch homestead. The lunch party seems to share the same perspectival frame as a group of black men carrying one of the 28 bodies

yielded by military intervention at Bisho in 1992. Bester points out that "everyone is involved in the violence." In previous works (he first exhibited in 1990), Bester allowed textual information to anchor his images in their historic detail. In later works, the images float more freely. Behind the flag, or contained within its fabric, five political ghosts haunt the "new" South Africa. Each partially obscured photograph tells a story. Teachers confronted in Cape Town; police action in Grabouw. In the foreground against the flag and these images is a Christian—in Bester's words, "one who thanks God for what White rule has brought him." Below this image, two ox wagons face each other, laager-like (like the early Afrikaans-speaking farmers who left the Cape under British rule and parked their ox wagons in a circle, or laager, as a form of defense). Made of the jawbones of a sheep, these wagons make a pun on the Afrikaans word for this type of wagon, which has a jawbone shape, and underline the reference to the *baasskap* (white supremacy) policies of the National Party. Flanking this archetypal image of the conservative faction of Afrikanerdom are two photographs taken by Bester: set-up shots of money changing hands (a reference to the "buying off" of mixed-race middle classes) and the opening of a padlock and chain (a reference to freedom).

In *Homage to Steve Biko* Bester returns to a canonical subject. The death in 1977 of Steve Bantu Biko whilst in detention, and the inquest exonerating the two doctors in whose care he had been placed, reverberated around the world. Credited with being the founder of the black-consciousness–aligned South African Students Organisation in 1969, Biko was a gifted medical student and leader. His compassion was recognized by all those with whom he came in contact.

In Bester's collage, Minister of Police J. Kruger and the infamous Landrover (in which Biko was required to travel the 1,100 kilometers [nearly 700 miles] to police headquarters in Pretoria) occupy center stage. The layering process for which Bester is known collages several details made public during the inquest (such as the tagged foot of Biko's body in the state mortuary) into a rectangle which is, in turn, superimposed over a conglomeration of details drawn from township and political life. Thus the letters BAT32 (which refer to the so-called Bushman Battalion of the Angolan front) and the sign "Stop Apartheid" contextualize the work's central content. From within the heart of the machine, Bester has found his voice.

Gavin Younge

The Story of a Migrant Worker
By the Artist

Mr. Semekazi sells wire and other cast-off scraps he collects from the streets and dumps around the town of Crossroads. In this self-instigated business he can earn R3 [about ninety cents] per day. Even with the additional income of R60.74 [about eighteen dollars] per month from a state pension, Mr. Semekazi can hardly afford to care for himself and his family.

When I met him in early 1992, I was photographing daily life in the township area and he was filling his handcart with the items to sell for his business. He had been earning his living in this manner for about three years—ever since his employment as a laborer for Dorman Long Company was terminated due to his age. He is still waiting to receive the pension he was promised from them.

The work *Migrant Miseries* is my way of telling Mr. Semekazi's story. Since 1961, he has lived in this township area, renting only a single bed for himself. This bed is represented in the center of the work with the crossed barbed wire. It is the only thing that he can call his own.

He shares his room with two other families, and each family raises its children on a single bed, just like his own. Mr. Semekazi feels a particular love and concern for the young children he watches growing up in these township conditions.

Kakebeen. 1993. Oil, enamel paint, and mixed mediums on board, 49¼ × 47⅝″ (125 × 121 cm). Collection Jean Pigozzi

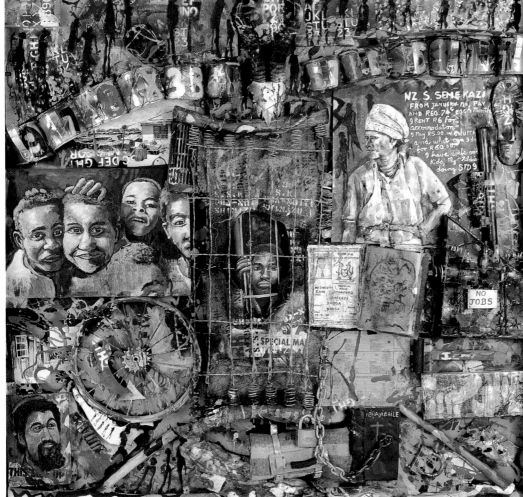

Semekazi (Migrant Miseries). 1993. Oil, enamel paint, and mixed mediums on board, 49¼ × 49¼″ (125 × 125 cm). Collection Jean Pigozzi

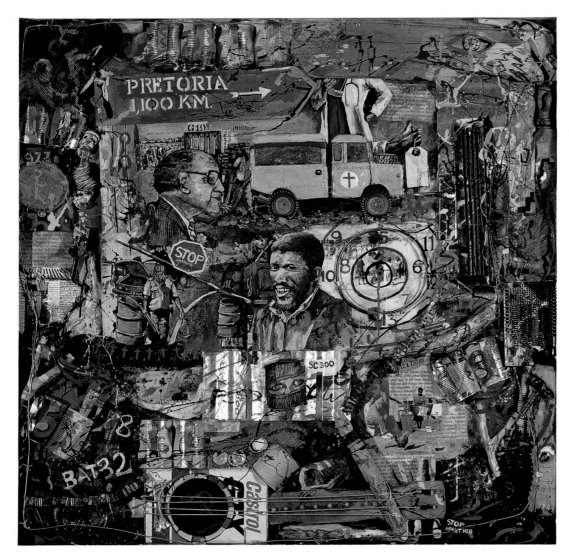

Homage to Steve Biko. 1992. Oil, enamel paint, and mixed mediums on board, 49⅝ × 49⅝″ (126 × 126 cm). Collection Jean Pigozzi

Mr. Semekazi's family remain in a rural village in their designated "homeland" area of the Transkei. Ever since he began his work as a migrant laborer more than thirty years ago, Mr. Semekazi has seen his family only during the three-week vacation period allotted to African workers once a year.

His priorities are his family and his faith; he is a deeply religious man who has worked diligently his whole life to provide for his wife and children. As can be seen from the reproduction of an original handwritten note to me, it is not easy to come up with enough money to do this.

His life has been rigidly structured by the labor laws of the past in this country. Fingerprinting pads, police dockets, and tear gas are the realities he knows of the authorities and law enforcement. Even though passbook laws were abolished in 1985, the fear of being caught without one was never abolished in his mind. Mr. Semekazi slept with his passbook until 1992, when he finally consented to sell it to me, after six months of friendship. Even now that he works for himself, he only allows himself three weeks' holiday to see his family each year.

Despite the fact that migrant laborers were reduced to mere numbers, like the numbers which label the tin mugs in this piece, Mr. Semekazi has never lost sight of his personal devotion and his sense of persevering African tradition. Like the painted dark figures standing at the top of the work, this man stands and faces every challenge, every day.

As a result of my efforts, Dorman Long has finally sent Mr. Semekazi some money, but the amount is only a fraction of what he is owed. It is my hope that someday this man who has dedicated a lifetime as a diligent worker will receive the pension he has earned.

Richard Onyango

Born 1960 in Kisii, Kenya
Lives in Malindi, Kenya

Two men were struggling with a large piece of cloth on the veranda of a villa. They were trying to attach the cloth to a wobbly wooden stretcher. To accomplish this task, they drove nails through the middle of old bottle caps, teeth down.

They carried the crudely stretched cloth to an improvised sun shelter near the swimming pool. The young black man took off his dusty cowboy boots and began priming the cloth. Then he started outlining. Before long there appeared on the cloth the detailed outline of a large Leyland lorry. The realistic lorry would soon be rolling along on a convincing new asphalt highway under a blue African sky.

I walked over and introduced myself to the young painter. He was Richard Onyango, and on that very day, in the cool August of 1990, in Malindi, Kenya, he started his career as a "serious" artist. Through the wisdom and generosity of a Malindi businessman and supporter of the arts, Feisal Osman, and the owner of the villa, the Italian poet Isaia Mabellini-Sarenco, who is also director of the Malindi Artist's Proof colony of visiting foreign artists, Richard had been freed from the pressures and uncertainties of odd jobs: painting signs, driving heavy trucks and buses, and a hundred and one other ways of making a scant living, including carving and carpentry, building model trucks and cars, designing dresses and furniture, farming, animal taming, and at a pinch, playing in jazz bands on the tourist nightclub circuit.

In 1992, two years and a hundred large paintings later, Richard had his first exhibitions in the West. The reviews were generally enthusiastic. In New York there were words of praise for his "urban African kitsch and scenic stereotypes with perfectly observed details."

I asked myself, "What kitsch?" In my dictionary, kitsch is pretentiously bad taste in art. Richard's painting is not intended to be anything of the kind. He is a very serious artist, and these so-called stereotypes that abound in his paintings are part of the landscape that he grew up in and indeed celebrates.

When Richard was very young, his family moved from the western highlands of Kenya, near Lake Victoria, to the developing coastal region, where his father, after a long job search, found a position with the government's Tana River Irrigation Scheme. Richard has described, in both words and pictures, his fascination with this brave new world of machines—the Massey-Ferguson tractors and bulldozers, Leyland lorries and buses, government Landrovers and insecticide planes. He was, he remembers, overwhelmed by what he saw, and started drawing "whatever my eye could see." The world of technology viewed by Onyango presents the two faces of infallibility and fragility, of possible disorder, which threatens the entire machine and ends in an accident.

He calls these early drawings his "photo pictures." As he explains it, "To keep things properly in mind I had to draw them since I didn't have a camera to record what I would like to put in memory." The "photo pictures" led him into painting, and the paintings in turn "led me to the fine art I do up to this day."

Thus, by the age of sixteen, when he had his first lessons in painting at school—against the wishes of his father, who dreamed his son would go on to university and become a government official someday—he had already developed a vocabulary of these "photo pictures" that appear and reappear in the paintings. The character Drosie, a young white woman, happy and very jealous, occupies an important place (see *The Day of Permission*). Far from being "urban African kitsch," they are the real thing.

These images continue to stand him in good stead. The last time I saw him, I asked him for his impressions of the bustling cities of northern Italy he was seeing for the first time. "I haven't really seen them yet," he answered. "I'm too busy painting." "Painting what?" I wondered. "African paintings," of course.

Emmett Williams

Richard Onyango in Malindi, Kenya. 1993

Airport 77 in the Pacific. 1993. Acrylic on canvas, triptych, overall: 63 × 141¾″ (160 × 360 cm).
Collection Jean Pigozzi. Courtesy of Isaia Mabellini-Sarenco, Malindi, Kenya

**Caution to Drivers: If All "Drivers" Could Carefull "No" Such Things or Such Names Could Exist Ever on Our Roads!
(On Behalf of Road Safety Kenya).** 1992. Acrylic on canvas, 46⅞ × 62¼″ (119 × 158 cm). Collection Jean Pigozzi

The Day of Permission. 1990. Acrylic on canvas, 46⅞ × 62¼″ (119 × 158 cm). Collection Jean Pigozzi

Cheri Samba
(Samba Wa
Nbimba)

Born 1956 in Kinto-MVuila, Bas-Zaire
Lives in Kinshasa, Zaire

Cheri Samba in Kinshasa,
Zaire. 1990

In 1972, after the interruption of his secondary studies (in which he ranked in the 99th percentile in drawing), Cheri Samba decided to settle in Kinshasa. He first put his talent to work for different studios making signs before he set up his own place, in 1975, in the district known as Kasa Vubu. His renown spread rapidly, and his first paintings, exhibited in front of his studio, attracted large crowds. He then began to take his subjects from everyday life and popular myths, such as the famous Mamy Wata.*

Cheri Samba is an artist who paints events; he is avid for caustic anecdotes and tales of personal experiences, a chronicler full of zest and truculence. He observes with a humor that hides the serious look he directs at Zairian society. Corruption, prostitution, and AIDS figure among the themes he treats in the manner of comic fables in which there is always a touch of moral education. Bright images, vivid colors, effective staging: he borrows his cutouts from the cartoon strips, whose mastery of focus and message he also knows how to appropriate. The characters in his paintings sometimes exchange long and racy dialogues in which French and Lingala alternate. Sometimes it is the artist himself who speaks and comments upon the picture.

The paintings Cheri Samba did in Paris during a trip in 1982 have the freshness of the discovery of another culture with its inevitable misunderstandings: the habits of the other are laughed at and caricatured. His other paintings transcribe the scenes and environment of Kinshasa with pitiless exactness. Involved himself in many of the little scenes he depicts, he also recounts both his own amorous tribulations and his career. Never lacking inventiveness, Cheri Samba embellishes some of his paintings with clever bits of artifice, such as the real curtain attached to the canvas that hides the sexual organs of a man, which a little girl is not supposed to see.

The charm of his painting and its success are largely explained by the clarity of his images, by the obvious ingenuity of the narration that does not deviate from the reality around it, and by the admitted ambition he exhibits in his self-portraits. He sticks to the image of the Western painter, all the while adding the freshness of a truculent verve and his unconcealed dreams of power and glory.

Jean-Hubert Martin

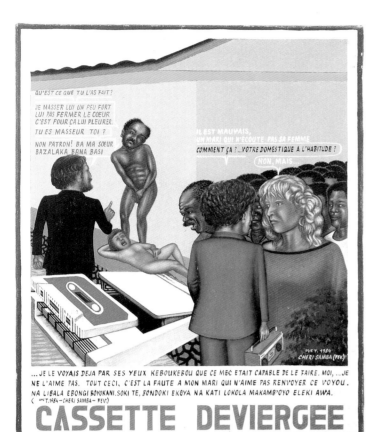

Deflowering of a Virgin Cassette. 1984. Oil on canvas, 33⅛ × 27⅛″ (84 × 69 cm). Collection Jean Pigozzi

Zaire Memorial. 1992. Acrylic on canvas, 25⅝ × 32¼″ (65 × 82 cm). Collection Jean Pigozzi

*We have no fear of the truth;
we study the Congo/Zaire of yesterday
so that we may erect that of tomorrow*

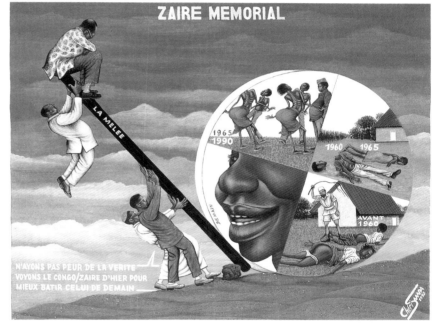

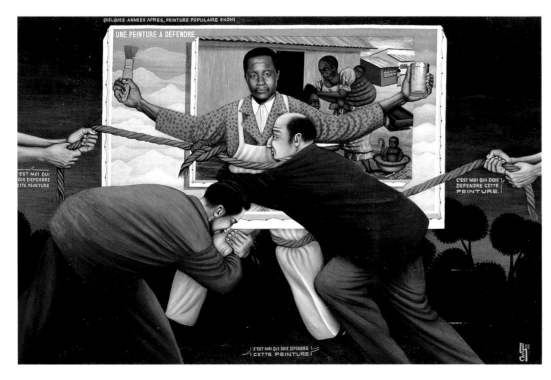

A Painting to Fight For. 1993. Acrylic on canvas, 49¼ × 70⅞″ (125 × 180 cm). Collection Jean Pigozzi

Abu-Bakarr Mansaray

Born 1970 in Tongo, Sierra Leone
Lives in Freetown, Sierra Leone

Abu-Bakarr Mansaray in
Freetown, Sierra Leone. 1992

Abu-Bakarr Mansaray creates unique machines that might be called "metatechniques." Completely visible, their mechanisms are meant to produce sound as well as movement, light, fire, air, or ice. There is an elemental dimension always present in these technological constructions, whose "specifications" do not provide any gauge of the machine's actual capabilities. Thus, *Secure Mechanism*, a half-organic, half-technical work designed "to prevent access to Paradise by anyone coming from Hell," develops "great energy to drive away the undesirables by unleashing its enormous artillery, its superpowerful explosives, and its lethal claws."

Yet, the instructions for its use are surprisingly rudimentary:

"Insert the batteries in the back, taking care to orient the positives and negatives correctly.

"Start it by flicking the 'ON' switch." . . .

Similarly, *Isomerism*, "the most powerful fighter plane," uses "eight 1.5-volt R20 batteries."

Besides the mechanical elements, Mansaray's machines also put mental energy into play. In this way, his work in actuality continues that spiritual appropriation of technique one encounters even in some manifestations of traditional African religions where an airplane or an automobile on a tomb (as can be seen in Zaire) or a telephone in an Ibo *mbari* (a large shrine in Nigeria housing several different anthropomorphic divinities) stands for instantaneous communication with the spirit world through the mechanical object.

A metatechnical construction has nothing to do with technological rationality, according to which, given certain objectives to be attained under certain conditions, the implement to be conceived will have to have specific characteristics and obey specific constraints. Its aim is an *immediate* effectiveness not subservient to the mediations of technology.

Abu-Bakarr Mansaray's work, on the one hand, belongs in the vein of mechanical imagery, found in many different guises in sub-Saharan Africa (from "toys" to creations that call for the most sophisticated technical know-how), and on the other hand, its imagery has a cosmic dimension, as one can see in the construction entitled $T E R R O R$, for example. With its reference to gas (as in *Hell Extinguisher*), this work also evokes some mechanisms devised by Marcel Duchamp and Francis Picabia. Mansaray's technical drawings, kept in a notebook, also bring the notebooks of Leonardo da Vinci to mind. Did not Leonardo, too, dream of machinery that in his time was altogether unrealistic, in other words metatechnical? Besides their playful aspect, these creations envelop a symbolics of the object, of the high-performance machine, that wishes to be a kind of "challenge to Western inventors and to those who do not believe in the technological future of Africa," to use Abu-Bakarr Mansaray's own words.

J. S.

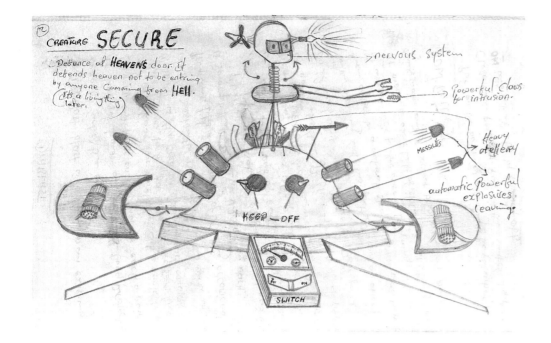

Study for **The Secure.** 1992. Pencil and ballpoint pen on paper, 8½ × 11" (22 × 28 cm). Collection Jean Pigozzi

The "Secure Mechanism" is a living organism that cannot be found on Earth. It exists only at Paradise's doors.

Its role is to prevent access to Paradise by anyone coming from Hell.

It functions automatically, develops great energy in order to keep away the undesirables, when they fire their formidable artillery, their powerful explosives, and their deadly claws. When their bombs explode, they destroy everything except the animal itself.

Look at the diagram.

How to Use

Insert the batteries in the back, taking care to orient the positives and negatives correctly.

Start it by flicking the "ON" switch. Stop it by flicking the "OFF" switch.

When inserting the batteries, make sure that the cover of their compartment is firmly in place.

Isomerism. 1992. Metal wire, sheet metal, and mixed mediums, 33½ × 53⅛ × 37⅜" (85 × 135 × 95 cm). Collection Jean Pigozzi

This machine has been constructed for multiple uses. It is very sophisticated, contains electronic and computer parts of my own fabrication. It is a spaceship with multiple uses.

It is also the most sophisticated radar of the moment.

It is the most powerful fighter airplane, the fastest spaceship. It moves at 93,000,000 miles per minute when it is heading toward outer space.

It also launches missiles, detects and destroys mines.

It also scrambles communications and other radar instruments that try to surpass it.

This machine is a feat of computer technology, it is filled with magnetism and electronic power.

We are now going to discover the many uses this machine has.

Instructions for use

Proceed as follows:

1.) It uses eight 1.5-volt R20 batteries.

2.) Place the batteries in their recess, respecting their polarities.

3.) Turn the motor on and watch the terrifying actions.

4.) Turn on the other button and watch the inside of the "Conquering Center." You will notice certain electronic signals one after the other. These signals are codes that I alone am able to understand, as the builder. These signals communicate different information on the screens of the "Conquering Center."

5.) To open the "Conquering Center," take off the springs that hold the cover down. Then take out the card and change the bulbs by unscrewing and rescrewing them as indicated on the diagram.

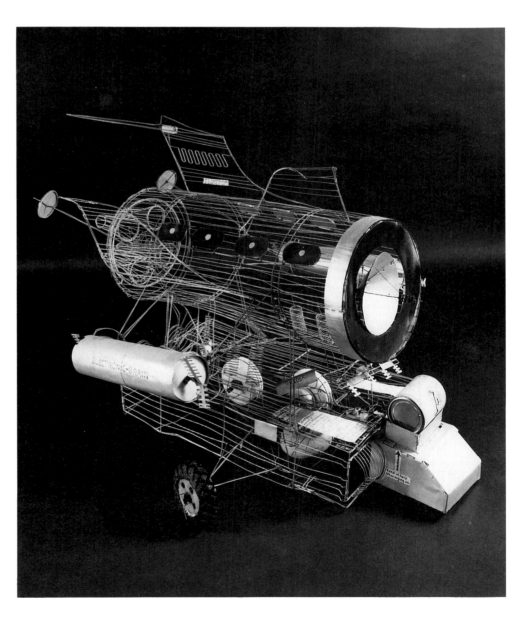

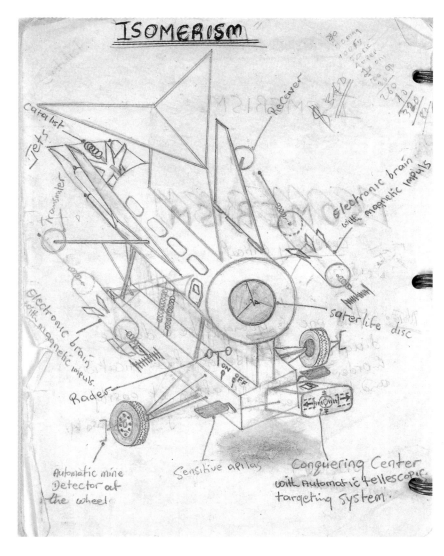

Study for **Isomerism.** 1992.
Pencil and ballpoint pen on paper,
11 × 8½" (27.8 × 21.5 cm).
Collection Jean Pigozzi

The Caterstrophy. 1992. Metal wire,
sheet metal, and mixed mediums,
15 × 41⅜ × 36⅝" (38 × 105 × 93 cm).
Collection Jean Pigozzi

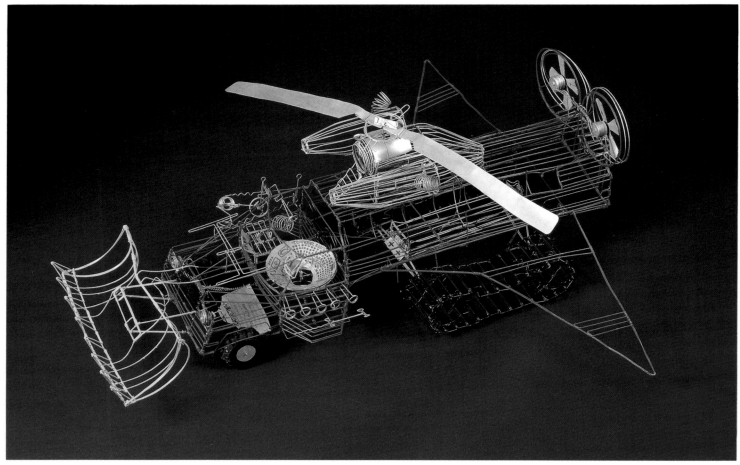

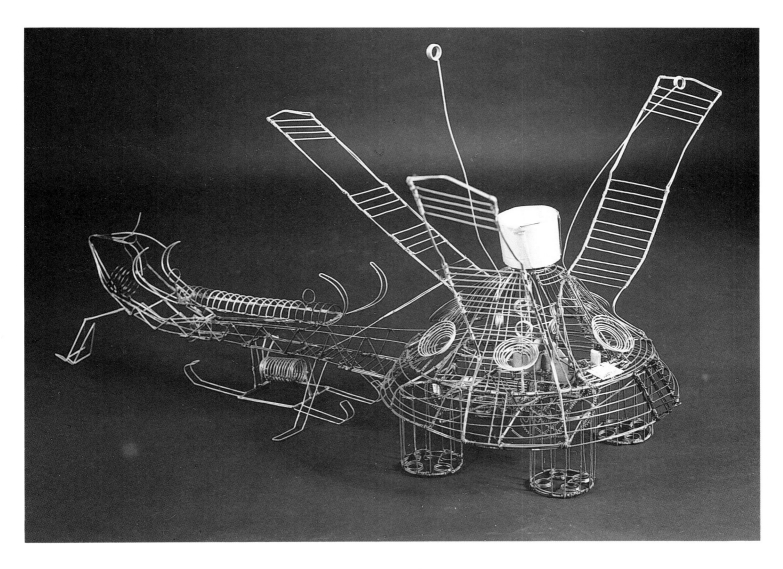

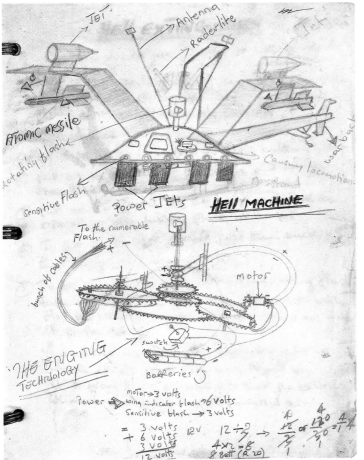

Above:

Hell Extinguisher. 1992. Metal wire, sheet metal, and mixed mediums, 23 ¼ × 39 ⅜ × 33 ½″ (59 × 100 × 85 cm). Collection Jean Pigozzi

This machine has been built to extinguish the fires of Hell. Its extinguishing power is extremely great and allows the fires of Hell to be put out.

One part of the gas that it uses to extinguish the fire is condensed and falls back down on Earth. These are the rains by which Africa is watered during what we call the rainy season. One part of these gases freezes and falls back on the European countries as snow. Every cold element that can be encountered in the atmosphere is, in fact, a residue of the gases this machine uses to extinguish the fires of Hell.

The power of this machine is such that some of the angels of Heaven quarrel with it.

Continue reading to learn more about it.

Instructions

1.) Place five 1.5 volt R20 batteries in the appropriate compartment.
2.) Press the button for the motor and watch what happens.
3.) Press the button for the lights and watch what happens above.
4.) Press the "OFF" buttons to turn the power off.
5.) To change the bulb of the rotating flash, take out the silver-colored cylinder and unscrew the bulb, put in a new one, and put the silver-colored cylinder back in place.
This machine has four extremely powerful propelling rockets that also serve as legs on which it rests.
"The Hell Extinguisher" gets its gas from these four rockets.

Study for **Hell Extinguisher.** 1992. Pencil and ballpoint pen on paper, 11 × 8½″ (27.8 × 21.5 cm). Collection Jean Pigozzi

Georges Adeagbo

Born 1942 in Cotonou, Benin
Lives in Cotonou

Georges Adeagbo in Cotonou,
Benin. 1994

While he eludes artistic categories, Georges Adeagbo employs in his installations a technique of assemblage that calls to mind that of certain Western artists. At the same time, the installations relate to the way objects are placed around the altar in *vodou* ceremonies. Moreover, unlike the work of Western artists, Adeagbo's work reveals no underlying preoccupation with the problematics of twentieth-century art or the status of the object in a consumer society. It aims, above all, to declare an existential situation or protest in relation to the world, both near (people close to him) and far (great historical figures, for example).

Turning his back on the comfortable life he could have fashioned after finishing his studies in law and political science in France, Georges Adeagbo has devoted himself to his art since he returned to Benin, in 1971. At the root of his work is an emotional conflict with his family concerning issues of inheritance. The fierce opposition of his relatives to the kind of "response" that he had been led to formulate under the pressure of events—his work would be destroyed in many instances and he himself placed in psychiatric hospitals many times—would never get the better of his determination to protect what he considers his vocation and his basic mission: to explain the world and the paths humankind has taken through history. The therapeutic aspect of that vocation is an element that contributes in some way to the overall arrangement of the work.

Realized "in place" (in the courtyard of the communal compound he shares with several families), his installations, which he calls exhibitions, present all the possible objects, according to a logic of proximity, that confirm by their juxtaposition the postulate from which he begins the "research" that he carries on alone: multifarious notes (interweaving summaries of personal events and references to history ranging from the liberation of Paris to relations between Africa and Europe and the history of Benin) written on the pages of lined notebooks and fixed on the ground with small stones, objects from *vodou* rituals (horns, statuettes), trinkets, clothing, sometimes even live animals and objects from other countries and other cultures, such as magazine articles, books, or records. These disparate objects, most often gathered during walks that frequently take him far from his neighborhood, Aïdjedo, come together by reason of their symbolic relationships, sometimes anecdotal. It is striking to observe the parallels between the way Adeagbo uses language, in long sequences in which repetition plays a central role, and the way he places on the ground the objects he has retrieved. The two levels, the writing of notes and the spatial organization of objects, create a morphological element essential to this highly original work. Adeagbo treats his installations as if they were a text he never ceases to rewrite, never placing a period to them. Thus, they are always "open" to the world around them, as well as connected with his interior world.

Georges Adeagbo is simultaneously historian, philosopher, teacher, and archaeologist. The references that embellish his work express his fascination with history. It is somewhat reminiscent of what Cheikh Anta Diop referred to in *Civilisation ou Barbarie* as the "historic factor, [the] cultural cement that unites the disparate elements of a people to create a whole."

In its richness and multiplicity, which sometimes make reading and interpretation tricky, the work of Adeagbo constitutes a keen reflection of the contemporary world: complex, sometimes unsettling, following rules that must be decoded with the help of keys, the principal one being history.

Régine Cuzin and Jean-Michel Rousset

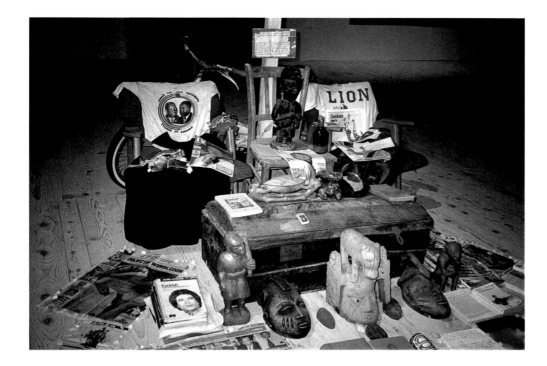

Archaeology (detail). 1994. Mixed mediums, 78¾″ × 13′1½″ × 49′3″ (200 × 400 × 1500 cm). Cotonou

It's No Use to Run, You Must Leave at the Right Moment. 1994. Newspapers, stones, mixed mediums, 23⅝″ × 78¾ × 78¾″ (60 × 200 × 200 cm). Cotonou

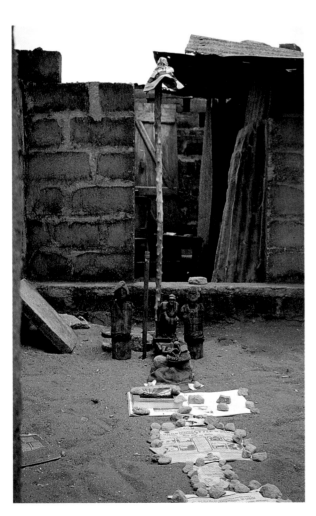

Royalty. 1994. Newspapers, stones, mixed mediums, 70⅞″ × 39⅜″ × 9′10″ (180 × 100 × 300 cm). Cotonou

Bodys Isek Kingelez

Born 1948 in Kimbembele-Ihunga, Zaire
Lives in Kinshasa, Zaire

Bodys Isek Kingelez in Kinshasa,
Zaire. 1988

I have never met Bodys Isek Kingelez, but from what I understand of his works and his descriptions of them, he truly seems an unusual man, a nice man, a vulnerable man, and a trusting man. He also seems to me a man whose curiosity is aroused by the jumbled, rushing, uncontrolled, and uncontrollable landscapes of Western cities, which the landscapes of African cities now resemble.

It also seems to me that he views those landscapes with the curiosity of an angel who might have fallen out of an ordinary, faraway, blue sky with white clouds, at most colored by the silence of an aurora borealis, an angel who suddenly landed in the nighttime Ginza, amid clusters of motionless taxis, into barriers of phosphorescent neon lights, amid the endless bows of geishas and pseudo gentlemen in black.

What binds together the landscape, I mean the innumerable figures of the physical and social urban landscape?

The sun? The rain? Winds? Sounds? The heavy, eternal-seeming cement? The glass in the windows? The dark rivers of people heading in every direction toward unknown destinations according to mysterious combinations and timetables? What holds together the horizonless urban lakeside landscapes?

There must be some glue to bind together these interminable, innumerable, incomprehensible mounds of events, there must be some more or less logical, more or less diabolical network of gravitational energy. Everyone thinks there must be some kind of logic, even if you can't see it, don't know where it is, or how it functions.

I must also admit that I too fail to see this supposed logic and I think that Bodys Isek Kingelez sees it even less than I do, he doesn't even seem to care about finding the strings of the puppeteers who may move us around. Bodys Isek Kingelez seems to me to be a man so basically trusting that he imagines those strings in his own way, he invents them, he builds them and all the devilish tricks that you see around, he burns in the future anyway and for the moment he seems to be gently steering his way, on his own course, in the area of the world that surrounds him, navigating from one fair booth to another in the huge amusement park that surrounds him. It is said that he thinks of the general confusion that surrounds him as an unconnected series of fair booths, of amusement park stands, each one "amusing," as they say, in its own way, each one loaded with curiosities, with offerings, with enticements, or maybe also loaded with deposits of ancient memories, of quotes from lost literatures, of archaeological remains of ancient annals and ancient hopes, but anyway fair booths that have no other reasons, whose only logic for remaining together is a simpler logic, so simple as to seem the logic of fatality, and it is by means of fatalistic logic and nothing else that these fair booths are located beside each other, within a precinct that isn't even defined, or even planned, or sought for.

I think that the most modern aspect of Bodys Isek Kingelez's work is the description of this kind of new logic of fatality, that is to say, of a nonrational logic, of a nonmemory, of a "nonhistory," the description of a space in "nonhistory," within which the only things that can and will be able to copulate, coexist, mingle, agitate themselves, form themselves, unform themselves, and then vanish, are things like the past, the present, and the future, culture and kitsch, the high and the low, hopes and delusions, entrances and exits, Europe and Africa, Russia and Mongolia, Zaire and Disneyland, seafront guesthouses in Miami and buildings in Hiroshima.

There's no doubt that to sail on a sea flat as a sheet of laminated plastic, of space without history, of a space without a system of coordinates, of a space where everything can appear and disappear as suddenly, in which everything can form into groups and

Papitheca. 1992. Paper, cardboard, and mixed mediums, 16⅛ × 26⅜ × 16⅞″ (41 × 67 × 43 cm). Collection Jean Pigozzi

Kimbembele City. 1993. Paper, cardboard, and mixed mediums, 20⅛ × 34 × 108″ (51 × 86.5 × 108 cm). Collection Jean Pigozzi

disengage without remorse, without danger, can provoke an irresistible feeling of euphoria, a rare incorruptible courage, a special sense of freedom, can produce a special uncontrollable sense of excitement, an uninterrupted sense of joy, a curious almost childlike control over memory, of its dimensioning, hierarchy, form, registration, acceleration, coloration, speed of usage.

I think that Bodys Isek Kingelez is able to travel within a history-less space, with "his" memories sailing like clouds in a windless sky. I think that Bodys Isek Kingelez can regroup his memories without needing to consult what has already been, what is now, or what will be, without having to wait for the wind to rise, for even the faintest breeze. Simply by organizing his memories along paths that are located within his very memories, by organizing them into magical pathways, he winds up with an absurdity justified by its own fatality.

The fact remains that the catalogue of Bodys Isek Kingelez's memories is a catalogue that, alas, has its origins in history, because in the end, if you ignore the pathways of

Zaire. 1989. Paper, cardboard, and mixed mediums, 29⅞ × 32⅝ × 38¼" (76 × 83 × 97 cm). Collection Jean Pigozzi

Ihunga Palace (Chicodi Stars). 1992. Paper, cardboard, and mixed mediums, 19¼ × 27½ × 15" (49 × 70 × 38 cm). Collection Jean Pigozzi

Opposite:
Detail from **Kimbembele Ihunga (Kimbéville).** 1993–94. Paper, cardboard, plastic, and mixed mediums, 51¼ × 94½ × 72¼" (130 × 240 × 184 cm). Collection Jean Pigozzi

history, even if you want to ignore them, even if you think of traveling within history as within a succession of fatalities, you can never evade the origins of fatality, they're always there, always imprisoning us, holding the fatal cases inside that vaster fatality that is history itself.

The memories of Bodys Isek Kingelez are those that are possible, maybe even those that are foreseeable, to a traveler who leaves an ancient, dark, tiring, fierce world of African nature and finds he's being aroused by, that he's falling in love with, and understandably so, that part of the Western modern landscape, in fact that part of the American landscape that is most brightly lit, most colorful, noisiest, most artificial, most "antinature," the very part that is precisely "history-less," the part that is projected to reassure everyone, to transport everyone, if possible, toward happiness, toward a total Existential blessing. Aren't Las Vegas, Miami, Atlantic City, divine places, blessed by good fortune, places where time doesn't exist, places without history, places to dream, rainbow places, places with tall plastic palm trees and celestial breezes?

Ettore Sottsass

Frédéric Bruly Bouabré

Born 1923 in Zéprégühé, Ivory
Coast

Lives in Abidjan, Ivory Coast

Frédéric Bruly Bouabré in his studio,
Abidjan, Ivory Coast. 1992

A Text for Frédéric

I am writing for F[rédéric] B[ruly] B[ouabré]. I've always had
trouble pronouncing his name—a kind of difficulty he creates for me from afar, from the
Ivory Coast where he lives, an area of the world I don't know at all. There is time for great
attractions, when one is somewhere between immobility and mobility, an object of
attraction. My attention was first drawn to the East, toward the mountains of Tibet, tea, Zen
monks, and their gardens—the search for the essential, the moment: one of illuminations.
These were things and images I looked for in illustrations in books. Then I was lucky
enough to live in Paris for two years in 1960–61. There I saw my first exhibition of
Japanese monks and their Zen paintings—the circle drawn in one gesture with a big brush
dipped in black ink, and I imagined this gestural realization to be immediate and
instantaneous.

That was my first bit of luck. Then another event marked my view of the world. I
understood only later that it was the exhibition André Malraux, at the time Minister of
Culture, held at the Fondation Maeght in Vence, France, which brought together all the
beautiful things he had encountered in his travels around the world. For me it was my first
global vision of art. I remember a white marble Babylonian sculpture with a full beard
and eyes of lapis lazuli, then a Khmer sculpture of gray granite, and the perfect life-size
Egyptian scribe made of wood. I also remember a medieval Japanese painting whose
stylistic perfection reminded me of Piero della Francesca. This extraordinary exhibition
was due to Malraux's exceptionally broad artistic vision, and various countries had agreed
to lend him their masterpieces. For me it was a concentration of completely unknown
worlds, new images, new desires, new ideas, and new cultures. . . .

In African works of colored wood, I recognize a great emotional force, a strong
energy radiating forth, but most of all I divine a layer of anthropology or sorcery, a deep
implication of the physical body rather than the qualities of thought we know and recognize
in Western art. For example, I remember a little animal, a wooden boar covered with long
iron nails driven into him all over his body. In this case, the emotional force of the object
was enormous. He emanated a feeling that was quite strong. It was like an antenna in
reverse, a dark spot. But it is difficult for me to recognize any aesthetic value in it.

In the case of FBB, it is just the opposite. With the postcard format and the temporal
continuity of the work, he shifts his attention from one theme to another and from one
point in time to another, around a territory in which he can do and say *everything*. He uses
colored pencils and paper, the minimum means necessary, with which he wishes to create
a form. This poverty of means, like their essentialness, precludes any bluffing or fraud. On
these pieces of paper, there is manifest neither technological prodigy nor any particular
virtuosity. An essential language is spoken there, and it speaks of everything. Collected,
these cards make up a game, like playing cards, a naked and unknown game, a deck of cards
for describing the world, and for communicating with it.

These little colored cards have a border. Now this border, in popular images, is essential. It is the wall that encloses the property. Before anything else, you build the wall, and then in the space created you build the house itself. In an Oriental carpet, the border (or rather the many borders that adorn its edges) . . . [forms] a kind of frame or mat that creates a blank and neutral space around the central image in order to make it more precious and to better define what is inside and what is outside.

These are some thoughts about FBB. I have not written about the images. I simply wanted to bring out the structure that he has constructed in order to be able to then play inside it.

The idea is always the same: to create a system, create a world in which the discoveries of life and its wonders can reproduce, in which the enormous potential of our brains and the prodigious possibilities of our imaginations can be lightly intuited; to go down the paths of thought together; to find ourselves nose to nose with happy coincidences or be present at the meeting of two parallel lines after an eternity of running alongside each other; to follow a number series in its sometimes unforeseen and fleeting (in any case never linear) movement; to be present at the dance of numbers, or listen to its singing; to perceive the slow creation of a quartz crystal in the darkness of a cave with its perfect angles modeled on mathematical structures; in the silence of the centuries, to discover the rhythm of life—in other words, discover together, that is, severally, the science of rhythms.

Alighiero e Boetti
Translated by Warren Niesluchowski

Knowledge of the World

(this is the general title for all the illustrations)

By Frédéric Bruly Bouabré

1. **A Curious Ball Representing the Spirit of the Earth Hanging in Space!** December 2, 1991. Colored pencil and ballpoint on cardboard, 5⅞ × 3¾″ (15 × 9.5 cm). Collection Jean Pigozzi

2. **A Comb Born Out of Impersonating a Jaw.** 1990–92. Colored pencil and ballpoint on cardboard, 5⅞ × 3¾″ (15 × 9.5 cm). Collection Jean Pigozzi

3. **China: Temple of Great Swellings.** 1990–92. Colored pencil and ballpoint on cardboard, 3¾ × 5⅞″ (9.5 × 15 cm). Collection Jean Pigozzi

4. **A (French?) Ship Called "The Globe" Sailed Nonstop on the Red Line for Four Months: December, January, February, and March.** 1990–92. Colored pencil and ballpoint on cardboard, 3¾ × 5⅞″ (9.5 × 15 cm). Collection Jean Pigozzi

5. **Four Chicken Footprints Reveal the Chicken Crossroad.** 1990–92. Colored pencil and ballpoint on cardboard, 3¾ × 5⅞″ (9.5 × 15 cm). Collection Jean Pigozzi

6. **The Holy Signs of the Destiny of an Orange.** December 30, 1991. Colored pencil and ballpoint on cardboard, 5⅞ × 3¾″ (15 × 9.5 cm). Collection Jean Pigozzi

7. **Holy Signs Represented by an Orange Yellowing with Age: Could It Be an Underlined 9?** 1990–92. Colored pencil and ballpoint on cardboard, 3¾ × 5⅞″ (9.5 × 15 cm). Collection Jean Pigozzi

8. **The American Continent Came to Me by These Holy Traces of Cola: From Which I Drew the "Blue Sea."** 1990–92. Colored pencil and ballpoint on cardboard, 3¾ × 5⅞″ (9.5 × 15 cm). Collection Jean Pigozzi

9. **The Lofty Diplomacy of the Council of Europe.** 1990–92. Colored pencil and ballpoint on cardboard, 5⅞ × 3¾″ (15 × 9.5 cm). Collection Jean Pigozzi

1

2

3

(UN NAVIRE (FRANÇAIS?) BAPTISÉ LA "GLOBE", PENDANT 4 MOIS: DÉCEMBRE, JANVIER, FÉVRIER, MARS, SANS ARRÊT, A PARCOURU LA "LIGNE ROUGE"

4

CES 4 EMPREINTES DE POULETS NOUS RÉVÈLENT LE CARREFOUR DES POULETS

5

LES DIVINS SIGNES DU DESTIN D'UNE ORANGE

DATE: 30-12-1991

6

LES DIVINS SIGNES FIGURÉS PAR UNE ORANGE JAUNISSANT DE MATURITÉ: SERAIT CE LE N°9, "SOULIGNÉ"

7

CES DIVINES MARQUES DE COLA M'INSPIRÈRENT "LE CONTINENT AMÉRICAIN"? D'OÙ J'EN FIGURAI LA "MER BLEUE"!

8

LA HAUTE DIPLOMATIE DU CONSEIL D'EUROPE

9

10. **That's Why God Doesn't Like War.** 1990–92. Colored pencil and ballpoint on cardboard, 5⅞ × 3¾" (15 × 9.5 cm). Collection Jean Pigozzi

11. **The City of Egyptian Pyramids.** December 14, 1991. 1990–92. Colored pencil and ballpoint on cardboard, 5⅞ × 3¾" (15 × 9.5 cm). Collection Jean Pigozzi

12. **The Holy Painting Revealed on an Orange Peel.** June 27, 1992. Colored pencil and ballpoint on cardboard, 5⅞ × 3¾" (15 × 9.5 cm). Collection Jean Pigozzi

13. **Accidental Creation: The Shape of My "Prayer" Candle Melted into a Cup.** January 23, 1992. Colored pencil and ballpoint on cardboard, 5⅞ × 3¾" (15 × 9.5 cm). Collection Jean Pigozzi

14. **Africanness and Shoes.** July 8, 1991. Colored pencil and ballpoint on cardboard, 3¾ × 5⅞" (9.5 × 15 cm). Collection Jean Pigozzi

15. **The Exhibition of Humanity Setting Its Feet on the Earth.** 1990–92. Colored pencil and ballpoint on cardboard, 5⅞ × 3¾" (15 × 9.5 cm). Collection Jean Pigozzi

16. **Holy Marks Appearing on a Cola Nut.** April 11, 1992. Colored pencil and ballpoint on cardboard, 5⅞ × 3¾" (15 × 9.5 cm). Collection Jean Pigozzi

17. **Here the Hatchet Is Only the Drawing of a Small "Bone," from Which We Discover a Source of the Ancient Models Copied by the Blacksmith.** 1990–92. Colored pencil and ballpoint on cardboard, 5⅞ × 3¾" (15 × 9.5 cm). Collection Jean Pigozzi

18. **In the Bowels of the Verdant Earth, the Subterranean Blue Sea Washes Our "Dead" Before Being Reborn as Drinking Water.** 1990–92. Colored pencil and ballpoint on cardboard, 3¾ × 5⅞" (9.5 × 15 cm). Collection Jean Pigozzi

19. **To Say That Man Is Conceived as a "Spiral" Indicates the "Palpitating Cranial Apex."** 1990–92. Colored pencil and ballpoint on cardboard, 5⅞ × 3¾" (15 × 9.5 cm). Collection Jean Pigozzi

20. **Fourteenth of July at Daloa.** 1990–92. Colored pencil and ballpoint on cardboard, 5⅞ × 3¾" (15 × 9.5 cm). Collection Jean Pigozzi

21. **The Supplements to Beauty Are the Tattoos "OA": Light.** 1990–92. Colored pencil and ballpoint on cardboard, 5⅞ × 3¾" (15 × 9.5 cm). Collection Jean Pigozzi

10

11

12

13

14

→ L'EXPOSITION DE L'HUMANITÉ

SE DONNANT LES PIEDS
* SUR LA TERRE *

15

SUR UNE NOIX «LES DIVINES MARQUES FIGURÉES DE COLA» DATE: 11-4-1992

* * * * *

16

"OS" DESSINÉ · D'OÙ NOUS DÉCOUVRONS UNE "SOURCE" DES ANTIQUES MODÈLES "ICI, LA HACHE N'EST QU'UN PETIT IMITÉS DU FORGERON"

17

L'ENSEMBLE DE NOS "MORTS" AVANT DE NAÎTRE EN EAU BUVABLE" «AU SEIN DE LA TERRE VERTE, LA MER BLEUE SOUTERRAINE LAVE

18

EN «SPIRALE» INDEXE LE "POINT-PALPITANT CRANIEN" «DIRE QUE L'HOMME EST CONÇU

19

→ «14 JUILLET à DALOA»

«LES ADDITIFS à LA BEAUTÉ» SONT LES TATOUAGES "OU" "LUMIÈRE"

20

21

Additional Artists of Sub-Saharan Africa

Artist	Date and Place of Birth	Lives and Works in
Benin		
Franck Dossa, painter	1966, Cotonou	Cotonou
Amidou Dossou, sculptor	1965, Coué	Coué
Kouassi Dominique Gnonnou (Kouas), sculptor	1951, Porto Novo	Porto Novo
Dominique Zinkpe, sculptor	1969, Cotonou	Cotonou
Botswana		
Mokwaledi Gontshwanetse, painter	1965, Serowe	Serowe
Qwaa Mangana Geelbooi Swarthaak, painter	c. 1920, D'Kar	D'Kar
Burkina Faso		
Guy Compaore, sculptor	1953, Ouagadougou	Ouagadougou
Koffi Fekpe, painter	1950, Ghana	Ouagadougou
Siriki Ky, sculptor	1953, Abidjan	Ouagadougou
Noufou Ouedraogo, painter	1950, Gourcy	Ouagadougou
Raya Benjamin Sawadogo, painter	1950, Ouagadougou	Ouagadougou
Cameroon		
Pascal Kenfack, sculptor/painter	1950, Foto Dschang	Yaounde
Sommy Nzante (Spee), painter	1953, Mbem	Bamenda
Jean-Marie Tenandjang (Black Moses), painter	1953, Bangang Ekam Ndee	Douala
Congo		
Josias Dinga Eliezer, sculptor	1963	Brazzaville
Marcel Gotene, painter	c. 1939, Brazzaville	Brazzaville
Trigo Piula, painter	1950, Brazzaville	Brazzaville
Gabon		
Gratien Koumba, painter	1965, Libreville	Libreville
Zéphirin Lendogno, sculptor	1930, Lambaréné	Libreville
Marcelin Minkoe-Minze, painter	1953, Lake Anengue, Ogooué	Libreville
Christian Ndong Menzamet, sculptor	1959, Libreville	Libreville
Antonio Pepin, painter/sculptor	1956, Mayumba	Libreville
Ghana		
Ato Delaquis, painter	1945	Kumasi
Ablade Glover, painter	1934, Ghana	Kumasi
Guinea-Bissau		
Gregorio Alberto Monteiro (Galoga), painter	1954, Bissau	Bissau
Ivory Coast		
Joseph Anouma, painter	1949, Dabre	Abidjan
Christophe Dadie, sculptor	1948, Agboville	Bingerville
Tamsir Dia, painter	1950, Bamako, Mali	Abidjan
Zirignon Grobli, painter	1939, Gagnoa	Abidjan
Kodjo James Houra, painter	1952, Melekoukro	Abidjan
Michel Kodjo, painter	1935, Aboisso	Grand-Bassam
Koffi Kouakou, sculptor	1962, Tiebissou	Grand-Bassam

Artist	Date and Place of Birth	Lives and Works in
Kouame Kouassi (Youssef), painter/sculptor	1946, Degbezere	Yamoussoukro
Bou Monne, painter	1948, Anyama	Abidjan
Mathilde Moreau, painter	1958, Grand-Bassam	Abidjan
Gérard Santoni, painter	1943, Divo	Abidjan
Were Were Liking, painter	1950, Cameroon	Abidjan

Kenya

Rosemary Karuga, painter	1928, Meru	Nairobi
Jak Katarikawe, painter	1940, Uganda	Nairobi
Zachariah Mbutha, painter	1948	Nairobi
Kiure Francis Msangi, painter	1937, Usangi	Nairobi and Dar es Salaam
Lucy Njery, painter/sculptor	1964, Nyathuna	Nairobi
Etale Sukuro, painter	1954	Nairobi

Mali

Mahamadou Coulibaly (Some), painter	1938, Bamako	Bamako
Ismaëlo Diabagate (Ismaël Diabate), painter	1948, Kayes	Bamako
El Hadji Mansour Ciss, sculptor	1957, Senegal	Bamako

Mozambique

Alberto Chissano, sculptor	1935, Chicavane	Maputo
Mathias Ntundu, sculptor	1947, Nandimba	Nandimba

Namibia

Joseph Madisia, painter	1954, Lüderitz	Windhoek
Themba Masala, painter	1963, Gobabis	Lüderitz
John Muafangejo, printmaker	1943, Angola	d. 1987, Windhoek

Niger

Paul Ahyi, painter/sculptor	1930, Niger	Lomé, Togo
Boubacar Bourëima, painter	1950, Birni N'Gaoure	Niamey

Nigeria

Jimoh Buraimoh, painter	1943, Oshogbo	Oshogbo
El Anatsui, sculptor	1944, Ghana	Nsukka
Demas Nwoko, painter/sculptor	1935, Idumoje Ugboko	Ibadan
Rufus Ogundele, painter	1948, Oshogbo	Oshogbo
Uche Okeke, painter	1933, Nimo	Nsukka
Augustin Okoye (Middle Art), painter	1936, Agukwu, Nri	Onitsha
Asiru Olatunde, sculptor	c. 1922, Oshogbo	Oshogbo
Bruce Onobrakpeya, painter	1932, Agbara Otor	Lagos
Obiora Udechukwu, painter	1946, Onitsha	Nsukka

Senegal

Amadou Bâ, painter	1949, Agnam Thiodaye	Dakar
Alpha Wally Diallo, painter	1927, Rufisque	Dakar
Léon-Paul Diatta, painter	1960, Ziguinchor	Dakar
Viyé Diba, painter	1954, Karantaka	Dakar
Moustapha Dime, sculptor	1952, Louga	Dakar
Cheik Diouf, painter	1949, Fatick	Dakar

Artist	Date and Place of Birth	Lives and Works in
Ibou Diouf, painter	1953, Tivaouane	Dakar
Kan-Si, painter	1968, Dakar	Dakar
Souleymane Keita, painter	1947, Dakar	Gorée
Mohamadou M'Baye (Zulu), painter	1954, Thiès	Dakar
Magatte Ndiaye, painter	1940, Gorée	Dakar region
Ismaila Manga, painter	1957, Kamùoya	Dakar
Serigne Mbaye Camara, painter	1948, Saint Louis	Dakar
Pape Youssou N'Diaye, sculptor	1963, Burkina Faso	Dakar
Seringe Ndiaye, painter	1953, Tivaouane	Dakar
Amadou Seck, painter	1950, Dakar	Dakar
Philippe Sene, sculptor	1949, Diouroup	Dakar
Madeleine Senghor, painter	1937, Dakar	Dakar
Ousmane Sow, sculptor	1935, Dakar	Dakar
El Hadji Moussa Babacar Sy, painter	1954, Dakar	Dakar
Moussa Tine, painter	1953, Ndiame	Dakar

Sierra Leone
Chernor Bah, painter	1952, Freetown	Freetown
Osman Sankoh (Tollo), painter	1963, Moyamba	Freetown

South Africa
Johannes Fanlo Mkize (Chicken Man), sculptor	1959, Richmond	Willowfontein
Noria Mabasa, sculptor	1938, Tshigalo	Vuwani
Patrick Mautloa, painter/sculptor	1952, Ventersderp	Alexandra
Anthony Nkotsi, painter	1955	Johannesburg
Bonnie Ntshalintshali, sculptor	1967, Winterton	Winterton
Derrick Nxumalo, painter	1962, Natal	Natal
Phuthuma Seoka, sculptor	1922, Modjadji	Modjadji
Tito Zungu, painter/sculptor	1946, Mapumulo	Durban

Tanzania
Jaffary Aussi, painter	1955	Dar es Salaam
Martin Dastani (Agostino), sculptor	1940, Mozambique	Dar es Salaam
Kashimiri, sculptor	1944, Mueda	Dar es Salaam
Christiano Madanguo, sculptor	1942, Mtwara	Dar es Salaam

Togo
Paul Ahyi, sculptor	1930	Lomé
Idrissou Motou, painter	1952, Dako	Lomé
B. Komi Sokemawou, sculptor	1960, Zafi Yoto	Lomé
Massimo Wanssi, sculptor	1955, Ghana	Lomé

Zaire
Nkusu Felelo, painter	1914, Muanda	Kinshasa
Kamba Luesa, painter	1944, Basangana	Kinshasa
Maître Syms, painter	1954, Kinsundi	Kinshasa
Nsingi Ndosimau (Sim Simaro), painter	1952, Kilumbu	Kinshasa
Vuza Ntoko Kinkonda (Cheri Cherin), painter	1955, Kinshasa	Kinshasa

Zambia
Stephen Kappata, painter	1936	Lusaka

Glossary

aziza: Fon word with two meanings: (1) A spirit of the forest, tiny in size but with long locks (like Samson) from which it derives its power. (2) The fifth incarnation of the Vodun* Tohossou, who presides over communication and presides over order as well as destruction.

colon: name given to a kind of statuary that came into being at the end of the nineteenth century along with the establishment of colonialism. *Colon*-style statues depict Europeans or Africans in colonial dress.

Gelede: Yoruba cult of Nigeria and the Yoruba and Nago people from the Porto Novo region. It is characterized particularly by its polychrome "head" and "torso" masks in a ritual that includes dance, song, and music. It is designed to restore the social cohesion imperiled by the disastrous or ambivalent actions of certain individuals or spiritual entities.

gris-gris: word of French-speaking Africans signifying talisman or amulet. A verse of the Koran carefully folded and inserted into a leather case that is worn around the neck or the waist is a particularly popular form of *gris-gris.*

High-life: word from English-speaking Africa designating a kind of popular music very much in vogue after World War II; it is similar to the rumba.

Kpogo: initiation mask worn during the *poro.**

Legba: In an elaborate version of the Fon pantheon, or *vodun,** Legba appears in the guise of a person seated on a throne, with an erect phallus. A protean spirit, Legba plays the role of intermediary and messenger between gods and humans. It is found at crossroads and at the entrance to a domestic compound. The corresponding figure in the Yoruba pantheon is the *orisha* (see under *vodun*) Eshu.

Mamy Wata: a form of belief and cult very popular everywhere in Africa and embodied in the figure of Mamy Wata, a divinity of aquatic origin ("wata" is pidgin English for "water") who is reputed to bring good luck and prosperity to anyone it favors. Mamy Wata is often represented in popular painting as a young, pretty, often white, siren. The origin of this largely syncretic cult has been ascribed to varying sources, among them the figurehead in the form of a siren that frequently adorns the prow of a ship.

mapico (plural: *lipico*): a dance performed at male and female initiation rites in traditional Makonde society. *Mapico* refers to the components of the dance as a whole: the masks, the costumes, the music, the movements of the dancers, etc. The *lipico* masks are carved by male initiates, who also perform the dances.

mpisoro: the spiritual father of a clan. The name of Efiaimbelo's clan is Temaromainte. In this context, *mpisoro* is Temaromainte's spiritual father and the descendant of the founding ancestor of the clan.

ndombu (plural: *n'dobb*): a very popular Senegalese talisman which consists of a hollow leather ring containing verses from the Koran. It may be worn on the head or around the neck, wrist, waist, or ankle. *ndombu baat:* necklace (*baat* means "neck"). *ndombu bopp:* crown (*bopp* means "head"). Traditional warriors wear the *ndombu bopp.*

Négritude: a movement of African intellectuals—the two most famous being the poets Léopold Senghor and Aimé Césaire—that emerged after World War II that affirmed the originality and uniqueness of the contribution of the black African civilizations to world culture.

orisha: see *vodun.*

Pangols: Senegalese word for a cult of spirits known as *rab,* who are led by Rok Sene, the supreme force. The cult can be compared to that of the *vodun** and the *rab* to the *orisha** of the Yoruba pantheon. "Pangols" also refers to the traditional altar set in the rear courtyard, far from public view, where one can make one's *toilette* and where there are jars filled with water mixed with blood from sacrificial animals. This water is supposed to cure if used on the skin or drunk. Each jar represents a different spirit.

poro: initiation rites practiced by the Senufo of the Ivory Coast.

Sape/Sapeur: Movement created by youths in the Congo and Zaïre centering around a total preoccupation with dressing in clothes ("sapes" in slang) from the great European couturiers and bearing their famous labels. *Sape* is also an acronym for the French for Society of Ambiencers and Elegant People.

Set-Sétal: A term originating among the Wolof people of Senegal, meaning cleanliness, the action of rendering clean. It is also the name of a teenagers' movement that, in 1990, in the space of a few weeks, covered the walls of the Senegalese capital and its outskirts with some 600 frescoes, some painted by individuals, others by a group. Many of them had political content.

shetani: a term designating grotesque anthropomorphic sculptures that evoke spirits and demons of the spiritual country of the ancestors.

Tingatinga: after the name of the Tanzanian painter Eduardo Tingatinga, who in the late 1960s started painting in Dar es Salaam, using square board 23⅝ × 23⅝" (60 × 60 cm). Hence the name of his style: "square art." Soon after his first exhibition, in Scandinavia in 1972, he died. His works, as well as those of the so-called Tingatinga School, are figurative with themes related to life in its natural state, not yet affected by urbanization.

ujamaa: a sociological concept that refers to the fraternal bonds existing between members of the society where what is important is not to possess but to participate.

vodou: see *vodun*.

vodun: A word of Fon origin designating the "gods" of the *vodou* pantheon. It corresponds to the words *orisha*, used by the Yoruba of Nigeria, and *vodu*, used by the Ewé of Togo. The *vodun* manifests itself through possession of a person's spirit, evidenced by the phenomenon of ritualized trance. It is represented in its most rudimentary form as a mound of earth with a piece of wood (referring to the phallus) planted upright in it. The *vodun* are considered like ancestors from whom the obligation of service is transmitted from generation to generation by means of rites.

Selected Bibliography

Africa Explores: 20th Century African Art. New York: The Center for African Art, 1991. Exh. cat.

Africa Hoy (Africa Now). Las Palmas de Grande Canaria: Centro Atlántico de Arte Moderno, 1991. Exh. cat.

"Afrika." *Kunstforum* no. 122 (May–June 1993).

Afrikus: Johannesburg Biennale. Johannesburg, 1995. Exh. cat.

Airport Art—Das exotische Souvenir. Stuttgart: Institut für Auslandsbeziehungen, 1987. Exh. cat.

Amandebele (Signals of Color from South Africa). Berlin: Haus der Kulturen der Welt, 1991. Exh. cat.

Art Makonde, tradition et modernité. Paris: Association Française d l'Action Artistique/Musée des Arts Africains et Océaniens, 1989. Exh. cat.

Art nègre et Civilisation de l'universal. Dakar: Les Nouvelles Editions africaines, 1975. Exh. cat.

Art from South Africa. Oxford: Museum of Modern Art, 1990. Exh. cat.

Art from the Frontline (Contemporary Art from Southern Africa). London: Karia Press, 1990.

Axt, Friedrich, and El Hadji Moussa Babacar Sy, eds. *Bildende Kunst der Gegenwart in Senegal.* Frankfurt am Main: Museum für Völkerkunde, 1989. Exh. cat.

Badi Banga Ne-Mwine. "Peinture populaire zaïroise." *Sura dji, Visages et racines du Zaïre.* Paris: Musée des Arts Décoratifs, 1982. Exh. cat.

Bamba Ndombasi Kufimba and Musangi Ntemo. *Anthologie des sculpteurs et peintres zaïrois contemporains.* Paris: Fernand Nathan-ACCT, 1987.

Bay, Edna G. "Cyprien Tokoudagba of Abomey." *African Arts* 8, no. 4 (Summer 1975): 24–29.

Beier, Georgina. *Modern Art in Nigeria.* Canberra: Hemisphere, 1973.

Beier, Ulli. *Art in Nigeria.* Cambridge, Eng.: Cambridge University Press, 1960.

———. "L'Art moderne dans une ville africaine." *Tendenzen,* no. 32 (1965).

———. *Contemporary Art in Africa.* London: Pall Mall Press, 1968.

———. *Neue Kunst in Afrika.* Berlin: Dietrich Reimer Verlag, 1980.

Bender, Wolfgang. *Commercial Popular Art: Painters in Sierra Leone, Art from Another World.* Rotterdam: Museum of Ethnology, Snoeck-Ducaju & Son, 1988.

Berman, Esmé. *Art and Artists of South Africa.* Cape Town: Balkema, 1983.

Bonneau, Richard. "Les artistes ne sont pas reconnus dans la plupart de nos pays africains: Entretien avec Christian Lattier." *L'Afrique littéraire et artistique,* no. 37 (1975): 75–80.

Bouabré Bruly, Frédéric. *On ne compte pas les étoiles.* Saint-Jean d'Angély, France: Bordessoules, 1989.

———. *La grande vérité: les astres africains.* Heidelberg: Braus, 1993.

Boulefroy, Nicole. "Vers l'art funéraire Malgache, Objets et Mondes." *La Revue du Musée de l'Homme* 16, no. 3 (1976): 95–116.

Brett, Guy. *Through Our Own Eyes: Popular Art and Modern History.* London: GMP Publishers, 1986.

Chesi, Gert. *Vaudou, Force secrète de l'Afrique.* Perlinger: Wörgl, Austria, 1980.

Cole, Herbert M. *Icons, Ideals & Power in the Art of Africa.* Washington, D.C.: Smithsonian Institution, 1989.

Cole, Herbert M., and Chike C. Aniakor. *Igbo Arts: Community and Cosmos.* Los Angeles: Museum of Cultural History, University of California, 1984.

Cole, Herbert M., and Doran H. Ross. *The Arts of Ghana.* Los Angeles: Museum of Cultural History, University of California, 1977. Exh. cat.

Congo Zaïre, Thango de Brazza à Kin. Paris: Musée National des Arts Africains et Océaniens, Cahiers de l'ADEIAO, 1991. Exh. cat.

Cornet, Joseph-Aurélien, Rémi De Cnodder, Ivan Dierickx, and Wim Toebosch. *60 ans de peinture au Zaïre.* Brussels: Art Associés, 1989.

Courtney-Clarke, Margaret. *Ndebele: The Art of an African Tribe.* New York: Rizzoli, 1986.

Crudo y cocido. Madrid: Museo Nacional de Arte Reina Sofia, 1994. Exh. cat.

"Dakar, Sénégal, Art et Littérature." *Revue Noire,* no. 7 (December 1992–January/February 1993).

Diop, Cheikh Anta. *Civilisation ou Barbarie.* Paris: Présence Africaine, 1981.

Faber, Paul. *Art History and Society: Popular Paintings in Shaba.* Lubumbashi, Zaire, 1976.

Fabian, Johannes. "Popular Culture in Africa: Findings and Conjectures." *Africa* 48 (1978): 315–34.

Fouquet, Roger. *La sculpture moderne des Makonde.* Paris: Nouvelles éditions Latines, 1975.

Fry, Philip, and Jacqueline Delange. *Introduction to Contemporary African Art.* London: Wers Mackay, 1969.

Gaudibert, Pierre. *Art Africain Contemporain.* Paris: Cercle d'Art, 1991.

Girard, Christian. "Les extrêmes architectures de Bodys

Kinguelez." *Art Press* 136 (May 1989): 47.

Hlungwani, Jackson. [Exchange with the Rev. Theo Scheider, January 1989.] In R. Burnett, *Jekiseni Hlungwani Xagani: An Exhibition.* Johannesburg, 1989. 58–62.

Identità e rappresentazioni cartografiche. Rome: Museo Nazionale Preistorico Etnografico Luigi Pigorini, 1994. Exh. cat.

Jackson Xidonkani Hlungwani. Johannesburg: BMW South Africa, 1989. Exh. cat.

Jacquemin, Jean-Pierre. *Saint Chéri Samba, vie et oeuvres (im)pies.* Ostende: Provinciaal Museum voor Moderne Kunst, 1990. Exh. cat.

Jewsiewicki, Bogumil. *Chéri Samba: The Hybridity of Art.* Edited by Esther A. Dagan. Quebec: Westmount, 1995.

Kasfir, Sidney L. "African Art and Authenticity: A Text with a Shadow." *African Arts* 25, no. 2 (April 1992): 40–53.

Kelly, Bernice. *Contemporary Nigerian Artists: A Bio-Bibliography.* Washington, D.C.: Smithsonian Institution, 1988.

Kennedy, Jean. *New Currents, Ancient Rivers: Contemporary African Artists in a Generation of Change.* Washington, D.C.: Smithsonian Institution, 1992.

Kleine-Gunk, Bernd. *Shona Skultur.* Wuppertal: Graphium Press, 1993.

Kuhn, Joy. *Myth and Magic: The Art of the Shona of Zimbabwe.* Cape Town: Don Nelson, 1978.

Künstler der Welt: Bodys Isek Kinguelez, Architekturvisionen aus Zaïre. Berlin: Haus der Kulturen der Welt, and Stuttgart: Cantz, 1992. Exh. cat.

Ludman, B. "Johannes Carves Out a Niche for Himself." *Tribune* (October 1989).

Magiciens de la Terre. Paris: Centre Georges Pompidou, 1989. Exh. cat.

Magnin, André. *Ny Afrikansk Billedkunst.* Copenhagen: Rundetarn, 1991.

———. "Romuald Hazoume." *Balcón Internacional,* no. 10 (1992).

———. *Bodys Isek Kingelez.* Paris: Fondation Cartier pour l'art contemporain, 1995. Exh. cat.

———. *Malick Sidibé.* Paris: Fondation Cartier pour l'art contemporain, 1995. Exh. cat.

———. *Seydou Keita 1949–1964.* Paris: Contrejour, 1995.

———. *Seydou Keita.* Paris: Fondation Cartier pour l'art contemporain, 1995. Exh. cat.

McEwen, Frank. "Shona Art Today." *African Arts* 5, no. 4 (1972): 8–12.

Mit Pinsel und Meissel, Zeitgenössische africakische Kunst. Frankfurt am Main: Museum für Völkerkunde, 1991. Exh. cat.

Mohl, Max. *Masterpieces of the Makonde.* Heidelberg: Gruth, 1990.

Monod, Théodore. "Un nouvel alphabet ouest-africain: Le Bété." *Bulletin de l'IFAN* (July–October 1958).

Mor, Fernando. *Shona Sculpture.* Harare: Jongwe, 1987.

Mor Faye. Dakar: Galerie 39, 1993. Exh. cat.

Mundy-Castle, A. C., and Vicki Mundy-Castle. "Twins Seven

Seven." *African Arts* 6, no. 1 (Autumn 1972): 8–13.

Ndiaye, Iba. "La jeune peinture en afrique noire." *Oeuvres africaines nouvelles.* Paris: Musée de l'Homme, 1969. Exh. cat.

Nicklin, Keith, and Jill Salmons. "S. J. Akpan of Nigeria." *African Arts* 11 (October 1977): 30–34.

9th Biennial of Sydney. Sydney, 1993. Exh. cat.

Nunley, John. "Images and Printed Words in Freetown Masquerades." *African Arts* 15, no. 4 (1982): 42–46, 92.

O'Brien, Glenn. "Saint Mor Faye." *Artforum* 29 (Summer 1991): 91–93.

Onobrakpeia, Bruce. *Symbols of Ancestral Groves: Monograph of Prints and Paintings.* Lagos: Ovuomaro Gallery, 1985. Exh. cat.

Onyango, Richard. *The African Way of Painting.* Verona: Adriano Pariso, 1992. Exh. cat.

Peus, Gunther. "Township Art." *Sudafrika* (April 1984).

Priebatsch, Suzanne, and Nathalie Knight. "Ndebele Figurative Art." *African Arts* 12 (Winter 1979).

Rencontres africaines. Paris: Institut du Monde Arabe, 1994. Exh. cat.

Schneider, Betty [Elizabeth Ann]. "Malangatana of Mozambique." *African Arts* 5, no. 2 (Winter 1972): 40–45.

———. "Malangatana: Artist of the Revolution." *African Arts* 21 (May 1988).

Shiraishi, Kenji. *Tingatinga.* Tokyo, 1990.

Soulillou, Jacques. *Sculptures en ciment du Nigéria.* Paris: Association Française d'l'Action Artistique, 1985. Exh. cat.

Soulillou, Jacques, and Girard Christian. "Une internationale de l'art urbain." *Capitales de la couleur.* Paris: Editions Autrement, 1984.

Stanislaus, Grace. *Contemporary African Artists: Changing Tradition.* New York: The Studio Museum of Harlem, 1990. Exh. cat.

Sultan, Olivier. *Genèse d'un mouvement: Sculptures contemporaines du Zimbabwe.* Paris: Musée National d'Art Moderne, 1990. Exh. cat. Trans.: *Zimbabwean Sculpture: Birth of a Contemporary Art Form.* Harare: Baobabs Books, 1992.

Surgy, Albert de. *Le système de ligieux des Evhé.* Paris, 1988.

Szombati-Fabian, Ilona, and Johannes Fabian. "Art, History and Society: Popular Painting in Shaba, Zaire." *Studies in the Anthropology of Visual Communication* 3 (1976): 1–21.

Thompson, Robert Farris, and Joseph-Aurélien Cornet. *The Four Moments of the Sun: Kongo Art in Two Worlds.* Washington, D.C.: National Gallery of Art, 1981.

Verin, Pierre. "Malgache qui es-tu?" *Présence de l'art malgache.* Neuchâtel: Musée d'Ethnographie de Neuchâtel, 1973.

Willett, Frank. *African Art: An Introduction.* London: Thames and Hudson, 1971.

Williamson, Sue. *Resistance Art in South Africa.* Cape Town: David Philip, 1989.

Worlds Envisioned: Alighiero e Boetti, Frédéric Bruly Bouabré. New York: Dia Center for the Arts, 1995. Exh. cat.

Younge, Gavin. *Art of the South African Townships.* London: Thames and Hudson, 1988.

Contributors

Alighiero e Boetti, artist and writer: Frédéric Bruly Bouabré

Marion Arnold, scholar: Tommy Motswai

Rayda Becker, curator, University of the Witwatersrand Art Galleries: Jackson Hlungwani

Willie Bester, artist: Willie Bester

Jürgen Blenck, curator: Zephania Tshuma

Louise Bourgeois, artist: Seni Awa Camara

Rob Burnet, art critic: Meek Gichugu, Sane Wadu

Simon Agbe-Capko: Zinsou

Régine Cuzin and Jean-Michel Rousset: Georges Adeagbo

Philippe David, historian: Agbagli Kossi

Guy de Plaen, curator: Ngoy Mukulu Muntu (Mode Muntu)

Pierre Garnier, poet: Abdallah Salim

Natalie Knight, gallery owner: Thomas Kgope

David Koloane, artist: David Koloane

Yacouba Konate: Christian Lattier

Grant A. Lyons: Zwelethu Mthethwa

Amadou Makhtar Mbaye, artist: Amadou Makhtar Mbaye

Jean-Hubert Martin, curator: Kane Kwei, Cheri Samba

Jacques Mercier, Centre National de la Recherche Scientifique, Paris: Gedewon

Julio Navarro: Valente Ngwenya Malangatana

Anitra Nettleton, History of Art Department, University of the Witwatersrand: Johannes Segogela

Paul Rabibisoa Ravoay, anthropologist: Efiaimbelo

Jean-Michel Rousset, curator: Esther Mahlangu, Francina Ndimande, Dakpogan, Almighty God

Yaya Savane, curator: Emile Guebehi, Nicolas Damas, Sekon Sekongo

Ettore Sottsass, architect: Bodys Isek Kingelez

Olivier Sultan, curator: Henry Munyaradzi, Bernard Matemera, Nicholas Mukomberanwa

Yacouba Touré, artist: Vohou-Vohou

Emmett Williams, poet and artist: Richard Onyango

Gavin Younge, artist and art critic: Johannes Maswanganyi, Willie Bester

Acknowledgments

The editors wish to thank the collectors for their help in making this book possible. Special gratitude is owed to Jean-Michel Rousset for his countless contributions to this project. We are grateful also to the following:

Lionel Adenis, Paris, France; Souleyman Baldé, Paris, France; Rayda Becker, Johannesburg, South Africa; Clémence de Bieville, Paris, France; Alain Bos, Tulear, Madagascar; Michel Boudon, Paris, France; Yves Bourguignon, Cotonou, Benin; Rob Burnet, Nairobi, Kenya; Yves Jacques Cabasso, Libreville, Gabon; Mamadou Cisse, Paris, France; Régine Cuzin, Paris, France; Philippe David, Paris, France; Denis Decraene, Bamako, Mali; Jacques de Mones, Lagos, Nigeria; Bara Diokhane, Dakar, Senegal; Philippe Dupriez, Lagos, Nigeria; Gérard Esmerian, Paris, France; El Loko, Duisburg, Germany; Lorna Ferguson, Johannesburg, South Africa; Emmanuelle François, Paris, France; Joël François, Paris, France; Suzan Glanville-Zini, Johannesburg, South Africa; Linda Goodman, Johannesburg, South Africa; Alex Graham, London, United Kingdom; Allen Gulka, Geneva, Switzerland; Michel Hardy, Accra, Ghana; Romulad Hazoume, Porto Novo, Benin; Brahima Keita, Abidjan, Ivory Coast; Bernd Kleine Gunk, Essen, Germany; David Koloane, Johannesburg, South Africa; Félix Leoz, Neuilly sur Seine, France; Meir Levy, Brussels, Belgium; Isaia Mabellini-Sarenco, Malindi, Kenya; Jean-Hubert Martin, Paris, France; Samuel Mdee, Paris, France; Jacques Mercier, Paris, France; Guy Mondineu, Paris, France; Musée d'Art Contemporain de Lyon, France; Oumar N'Diaye de Badalal, Paris, France; Serigne NDiaye, Dakar, Senegal; John Nzivo, Nairobi, Kenya; Pascal Ott, Lagos, Nigeria; Jean-Loup Pivin, Paris, France; Claude Postel, Paris, France; Paul Rabibisoa Ravoay, Tulear, Madagascar; Marc van Rampelberg, Nairobi, Kenya; Trend Read, Johannesburg, South Africa; Laetitia Roux, Paris, France; Ibrahim Sama Tcha Tchere, Lagos, Nigeria; Yaya Savane, Abidjan, Ivory Coast; Ruth Schaffner, Nairobi, Kenya; Kenji Shiraishi, Tokyo, Japan; Olivier Sultan, Harare, Zimbabwe; Fabienne Swanepoel, Johannesburg, South Africa; Danielle Tilkin, New York, United States; Janus Tsuk, Paris, France; Fernando Trueba, Madrid, Spain; Origenes K. Uiso, Dar es Salaam, Tanzania; Louis van Bever, Brussels, Belgium; Gavin Younge, Cape Town, South Africa

Index

Photograph Credits

© Lionel Adenis: 117 (bottom), 118; © Bruno Asseray: 15; © Jürgen Blenck: 79 (top); © Rob Burnet: 44, 134; © Bob Cnoops: 99 (bottom); © Thierry Dalban: 169 (top); © Peter Davidson: 139, 140 (both), 141 (both); © Guy de Plaen: 81; © Courtesy Bara Diokhané: 137 (right); © Aka Etchien: 128, 129 (top, bottom), 130, 131 (bottom left); © Jacques Faujour: 71 (both); © Fabrizio Garghetti: 126, 127 (all), 159, 160 (top); © Cathy Grundlingh: 67 (bottom); © Guido, Abidjan: 131 (center); © Themba Hadebe: 146; © Michael Hall: 96, 98 (bottom), 147, 148 (both), 149, 150 (both), 151; © Fanie Jayson (Goodman Gallery): 106, 107 (both), 108 (both); © Bernd Kleine-Gunk: 91 (top left, top right, bottom right), 92; © Abdoulaye Konate: 144 (right), 145; © Marc Latamie: 64 (both); © Laurent Lecat: 77, 119 (left), 120 (right); © André Magnin: 10, 11, 13, 24 (both), 25 (bottom), 26 (both), 27 (all), 28 (both), 29, 30 (both), 31, 34 (top), 40, 42, 46 (both), 47 (bottom), 49, 50 (left), 61, 73 (top), 84, 91 (center right), 99 (top), 100, 109 (top), 112 (left), 119 (right), 121 (right), 124 (left), 129 (center), 131 (top left, top right, bottom right), 132 (top), 142, 144 (left), 162, 164, 170, 174; © Jean-Hubert Martin: 9, 76 (top), 78 (top); © Irvine Meyer: 66, 67 (top), 68, 155, 157 (both), 158; © Koffi Michel: 104 (right), 105 (all); Archives du Musée National d'Abidjan: 104 (left); © Claude Postel: 2, 22 (bottom), 23 (all), 25 (top left, top right), 32 (all), 33 (both), 34 (bottom), 35 (all), 37 (both), 38 (both), 39 (both), 41 (all), 45 (all), 47 (top left, top right), 48, 50 (right), 51, 52–53, 55, 56 (both), 57, 62, 63 (both), 73 (bottom), 74, 75 (all), 79 (bottom), 80 (all), 85, 86, 87, 88 (right), 89 (all), 91 (bottom left), 94 (both), 97 (top), 98 (top), 112 (right), 113, 114, 117 (top), 120 (left), 121 (left), 122, 123 (both), 124 (right), 125 (all), 132 (bottom), 133 (all), 143 (both), 160 (bottom), 161, 163 (all), 165 (both), 166 (both), 167 (both), 171 (both), 172 (both), 173, 176–79 (all); © Linda Rorer: 97 (bottom); © Jean-Michel Rousset: 43 (both), 54, 70, 72 (all), 76 (bottom), 78 (center, bottom), 88 (left), 101 (both), 102 (all), 103, 116, 152, 153 (both), 154 (both), 168, 169 (center, bottom); © Yaya Savane: 22 (top); © El Sy: 137 (left), 138 (both); © Origines K. Uiso: 36; © Valente: 109 (bottom), 110 (both), 111; © Louis van Bever: 82 (both), 83; © Eric van Dieren: 93 (left), 95; © Guy Vivien: 58 (both), 59, 60 (both); © Chris Whiteman: 135, 136 (both); © Gavin Younge: 65